# OYSTERS
## A Celebration in the Raw

# JEREMY SEWALL &
# MARION LEAR SWAYBILL

# OYSTERS

## A Celebration in the Raw

Photography by Scott Snider

ABBEVILLE PRESS PUBLISHERS

NEW YORK   LONDON

p. 2: Bags of Aunt Dotty's oysters
p. 10: Aunt Dotty's grow-out site, Island Creek Oysters, Saquish, Massachusetts
p. 36: Island Creek Oysters, Duxbury, Massachusetts
p. 58: Oysters fresh from the bay, Row 34 Restaurant, Boston
p. 168: Taunton Iron Works & Co., trade card, late 19th century

Editor: Shannon Lee Connors
Copy editor: Ashley Benning
Designers: Misha Beletsky and Patricia Fabricant
Production manager: Louise Kurtz

First published in 2016 by Abbeville Press, 116 West 23rd Street, New York, NY 10011.

First edition

10 9 8 7 6 5 4 3 2

ISBN 978-0-7892-1249-8

Library of Congress Cataloging-in-Publication Data is available upon request.

For bulk and premium sales and for text adoption procedures, write to Customer Service Manager, Abbeville Press, 116 West 23rd Street, New York, NY 10011, or call 1-800-ARTBOOK.

Visit Abbeville Press online at www.abbeville.com.

## CREDITS

All photography by Scott Snider, with the assistance of Jonathan Cummings, with the exception of the following: Courtesy of Ballard Fish & Oyster Company: 39, 40, 46, 47, 56, 198; Kristen Dawn Bonvan, Courtesy of Chatham Shellfish Company: 205 top left, 205 bottom left; Ed Anderson Photography, Courtesy of Hog Island Oyster Company: 55; David Grossman, Courtesy of Island Creek Oyster Co.: 36, 38; Courtesy of Hama Hama Oyster Company: 41 top, 42; Courtesy of Hog Island Oyster Company: 54; Library of Congress, Prints & Photographs Division: 175, 183 middle and bottom; © Estate of Roy Lichtenstein: 188; Sam Luvisi, Courtesy of Hama Hama Oyster Company: 53; © The Metropolitan Museum of Art. Image source: Art Resource, NY: 195; Courtesy of Murder Point Oysters and the Zirlott Family: 43, 44, 45, 205 top right, 206; Nach Waxman Collection of Trade Cards, Division of Rare and Manuscript Collections, Cornell University Library: 168, 173, 177, 179, 180, 182, 183 top; National Gallery of Art, Washington, DC: 185, 187; © National Portrait Gallery, London: 194; © Renegade Airlines, Courtesy of Chatham Shellfish Company: 22; Jenn Repp, Courtesy of Hama Hama Oyster Company: 41 bottom, 52; Royal Picture Gallery Mauritshuis, The Hague: 186; Courtesy of Chatham Shellfish Company: 204; Marion Lear Swaybill: 13, 18, 19, 24, 25, 27, 35, 49 bottom, 51, 58, 196, 199, 201, 212, 216; Michael Harlan Turkell: 200; Courtesy of Kitty West: 191.

# CONTENTS

INTRODUCTION by Jeremy Sewall  7
AUTHOR'S NOTE by Marion Lear Swaybill  9

About Oysters 1. 11

Oystermen 2. 37

Simply Oysters 3. 59

Oyster Stories 4. 169

ACKNOWLEDGMENTS  200
NOTES  207
GLOSSARY  208
RESOURCES  211
INDEX  213

# INTRODUCTION

I don't quite remember the very first oyster I ate, but I am pretty sure of when I ate it. I was a culinary student, in fish class. I'm almost certain it was a Gulf oyster, and I don't think I liked it. I am *absolutely* sure it was a couple years before I ate my next oyster. It was not a very romantic start to my life in the oyster world.

Now, though, eating oysters is an almost daily occurrence for me. Whether I am tasting a new type or seeing how the seasons might change the flavor profile of some of the staple varietals at my restaurants, oysters are a huge part of my life, and they are a food that is truly special.

My connection with oysters grew over time. In the late 1990s I lived in the San Francisco Bay Area and was a chef in a restaurant that sourced local foods as much as possible. We shopped at local farmers' markets, and it was very common for farmers to drop by with freshly picked produce. Oysters became a big part of that time as well, and we exclusively served local Hog Islands from San Francisco's Tomales Bay. This is really when my relationship with oysters started—being in a boat on Tomales Bay and having Hog Island's owner John Finger reach into the water, grab an oyster, shuck it, and then hand it to me to eat. It was one of those food moments that I will never forget. That day, I felt like I had discovered something.

Not long after that I opened a small seafood restaurant with the group I was working for. I expanded my oyster horizons, seeking out and tasting as many different oysters as I could get my hands on. I slowly learned that not all oysters are created equal—they take time and care to grow, like most anything of quality. I found a few that I liked and kept the list small, but my knowledge and curiosity about oysters was growing.

In the early 2000s I moved back to Boston to open a seafood restaurant. That's when I met Skip Bennett and was invited to his oyster farm in Duxbury, Massachusetts. I took a few cooks with me, and we made our way to the farm where I was first introduced to Island Creeks. Skip and a few of his buddies were growing these amazing oysters, and meeting them was another moment of discovery for me. Skip's genuine passion for growing oysters and his love of the water made him easy to like, and I immediately admired him for his dedication to the craft. That day I had another chance to eat oysters pulled straight from the water, this time in my native New England, and my relationship with oysters began getting serious.

Even then oysters were not that common on restaurant menus; some places had them but few really put love into them. In that way, the evolution of the oyster bar is similar to that of the oyster itself. A look back at the history of the rise, fall, and rise again of the oyster shows the important part it has

Island Creek Oyster Bar, Boston

played as both a food source and a culinary ingredient. Only in the last ten years have oysters returned to their status as an iconic food that is more and more mainstream.

Now oyster bars are popping up in every major city in the world, and that interest in oysters has led to some great things. Fishermen who have made a living on the water for generations and have found it harder to catch enough fish to support their families have been able to turn to growing shellfish, like oysters. Some communities have taken it as a great opportunity to keep up working waterfronts they have known for generations. Chefs and restaurateurs, who have helped this revival by providing a place to serve oysters, as well as the people that eat them, all play an important role in that story.

Beyond their popularity, oysters do great things for the water they grow in, and even though I hate using the word "sustainable" to describe seafood, oysters are exactly that. Oysters, like anything that is farmed, face challenges from the environment, predators, the weather, and more. Watching how farmers have adapted and gotten better at the craft of growing has been an amazing experience. Skip Bennett is a great example of this; he is behind the famous Island Creek Oysters but has gone on to cultivate Row 34s and Aunt Dotty's, both from the same species but grown differently, giving them distinct flavors and appearances.

These days Skip and I have several oyster bars with our friends and business partners Shore Gregory and Garrett Harker. We source oysters from all over, and are always excited to taste a new one or hear the story of who grows them and how they got into it. I look at an oyster list like someone might approach a wine list: different geography, flavor profiles, and sizes. On our menus we list the grower along with the oyster, and we will talk endlessly about them to whoever will listen. Educating the staff on oysters is a big part of what we do at the restaurants, and I love hearing them talk to our guests as if they grew each oyster themselves. A couple days each year we put the staff on a bus and send them to Duxbury to experience the process firsthand. They always come back with a great appreciation for the farm and what it takes to grow an oyster. Someone always tells the story of how they ate their first oyster pulled right from the water—just like I did all those years ago.

Each oyster tells a story, and as you look through this book, I hope your love affair, or maybe just an appreciation for these amazing creatures, starts and grows. Experience oysters—the beauty of the shells, the effort that goes into growing them, and the dedication of those who serve them. With oysters, each step in the process is just as important as the next.

—Jeremy Sewall

# AUTHOR'S NOTE

I tasted my first oyster in January 1986, in New Orleans, Louisiana, where I was attending an international television conference. One evening, I waited in an impossibly long line at K-Paul's, the hottest spot in the French Quarter. My dinner companion, an impatient and hungry Brit, grabbed my hand, pulled me off the line, and said, "I have a much better idea." He led me around the corner to the Acme Oyster House.

We tucked into two seats at a crowded communal table — locals mostly. In a blink, a pitcher of beer and three-dozen oysters appeared. From the first ice cold, briny bite, I was hooked. In the decades since, I've indulged my oyster habit from Sydney, Australia, to Whitstable, England, the north of Ireland to the south of France, and across North America to Saquish, Massachusetts, where I recently had perfect, salty Aunt Dotty's straight out of the bay.

Not surprisingly, this book was conceived over a platter of oysters. Bob Abrams, Abbeville's publisher and a friend of many decades, and I had polished off a dozen delicious Dabob Bays, Totem Inlets, and Jenny's Petites, and were admiring the debris. As I snapped a photo for Instagram posterity, Bob turned over the empty shells and said, "Look how beautiful these are. We should fill a book with them."

From the start, we envisioned a feast of all things oyster — a visual celebration of oysters' sheer physical beauty and an anecdotal compendium of all else. Where oysters come from and why they taste the way they do, the dedicated men and women who grow them, and the exquisite places where they grow topped our list. We also wanted to equip oyster lovers and novices alike with the essentials for enjoying oysters out and at home.

Full appreciation of oysters would not be complete without a few stops on the oyster timeline and dips into the pond of mystery and mythology that surrounds them. Even if an oyster has never touched your lips and never will, we hope that our oyster stories will entertain and that — along with oyster lovers everywhere — you'll delight in the extraordinary beauty of one of nature's most bounteous gifts.

— Marion Lear Swaybill

# ABOUT OYSTERS

*The oyster — "greatly more complicated than a watch."*
— Aldous Huxley

# FROM UBIQUITY TO RARITY
# AND BACK AGAIN

For centuries, audacious eaters the world over have cherished oysters. Undeterred by the rough shell and impervious to the unctuous meat, oyster lovers invariably are rewarded by delicate textures and bright, briny flavors.

Plentiful in waters along the eastern coast of the New World and high in calcium, iron, and protein, oysters were a dietary staple of the indigenous population and European settlers. By 1763 a humble saloon had opened on Broad Street in New York City, the first public house to put oysters on the diners' menu. Soon Amboys, Jamaicas, and Rockaways were advertised—then, as now, they were named for their place of origin.

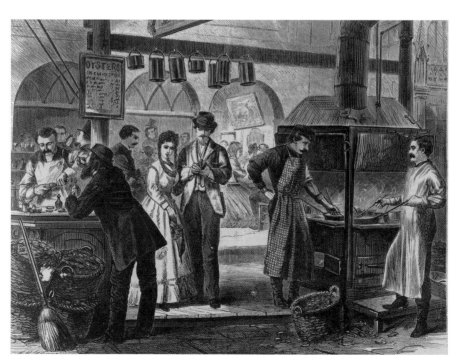

Oyster Stands in Fulton Market, 1870

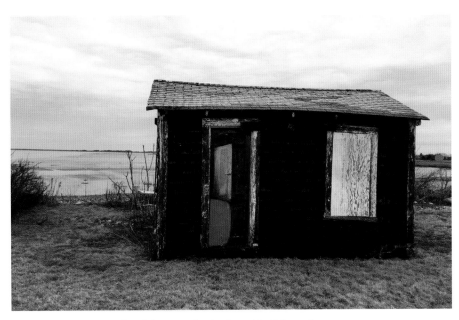

An old oyster shack, Saquish, Massachusetts

So it began in America.

As the nineteenth century unfolded, oyster establishments could be found in every town along the East Coast and, after the gold rush, on the West Coast as well. Thanks to new rail lines and refrigerated boxcars, oysters were now reaching eager diners in the middle of the country too. Fancy oyster parlors sprang up down the street from rowdy oyster bars and around the corner from oyster pushcarts. For some, a few slurps made a cheap meal. For others, oysters were an essential part of a leisurely dinner out or a sumptuous addition to a beautifully appointed table at home.

The United States was producing upward of two billion oysters a year. And then, oyster production crashed.

As hungry patrons demanded ever more oysters, the industry responded with aggressive overharvesting on the East Coast that resulted in extensive destruction. Suppliers also began importing common European oyster species to broaden the supply. Foreign breeds proved incompatible with local waters and rapidly spread disease.

Across the country, Washington State's native Olympia oysters were disappearing too. Again, overharvesting and disease were the likely causes. Eastern oysters were introduced to the West Coast with much anticipation but failed in the colder Pacific waters.[1]

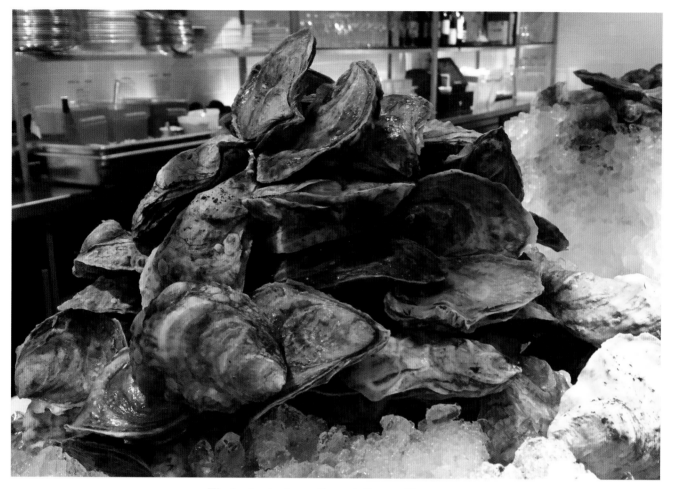

The fresh selection at Boston's Row 34 Restaurant

The once-abundant oyster supply was vanishing.

From the Industrial Revolution onward, factory debris, dangerous chemical waste, and increasingly damaging pollutants poured into estuaries and battered coastlines. Oyster reefs across North America were decimated, with some dying out altogether. By 1970, "Atlantic oyster culture fell to just one percent of its historical capacity."[2]

America's bountiful bivalves became a rarity, a culinary luxury enjoyed primarily by the rich.

To the delight of shellfish lovers everywhere, oysters are on the rebound. Over the past several decades, advancements in aquaculture, local food

entrepreneurship, concern for the environment, vigorous water quality regulations, and greater producer and consumer confidence have contributed to the great oyster revival.

Though wild oysters abound in the Atlantic and Pacific Oceans, almost all the oysters we savor are farmed and nurtured along the reinvigorated coasts. More and more are harvested with every passing year.

All over the United States upscale, trendy restaurants, neighborhood bistros featuring dollar-an-oyster happy hours, and chic, new raw bars are satisfying a demand for oysters not seen for almost a century.

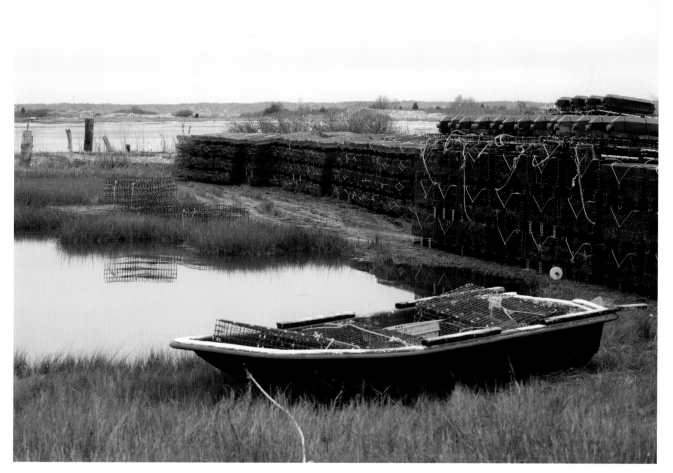

Oyster cages, Aunt Dotty's grow-out site, Island Creek Oysters,
Saquish, Massachusetts

# LOCATION IS EVERYTHING

*The flavor of an oyster depends on several things. . . . It will taste like a Chincoteague or a Bluepoint or a mild oyster from the Louisiana bayous or perhaps a metallic tiny Olympia from the Western coast. Or it may have a clear harsh flavor, straight from a stall in a wintry French town, a stall piled herringbone style with Portugaises and Garennes. . . . Or it may taste firm and yet fat, like the English oysters from around Plymouth.*

— M.F.K. Fisher

ike wine, oysters mirror their natural environment and draw overall flavor from the waters in which they live. There's the pure, sharp brininess of Atlantic oysters and the sweeter, kelpier smoothness of Pacific oysters. Aquatic micro-zones contribute the subtler flavor attributes. These highly individualized environments are the reason you hear so many different words used to describe the way oysters taste, look, and feel. Sublimely balanced Island Creeks. Sweet, fruity Hama Hamas. Creamy, herbaceous Hog Islands. Perfect, buttery Kumamotos. Earthy Olympias. Brassy Belons.

Water temperature is largely responsible for the texture of oysters. Oysters from the colder waters of Nova Scotia or Maine, for example, are firmer, crisper, and saltier than those from Virginia or the Gulf. Plumpness and toothiness are influenced by the quantity and quality of nutrients in the water — more nutrients mean more heft and more flavor.

The specific combination of water conditions that determines the flavor and character of oysters is called, somewhat tongue-in-cheekily, *merroir*,[3] reflecting wine lovers' use of the term *terroir* — the combination of soil, topography, and climate that produces different flavor profiles of grape varietals.

Though there are only five oyster species, *merroir* produces hundreds of varieties that are distinct in taste, texture, and appearance. Most often, these varieties are named for where they are harvested — for their *merroir*. Peter's Point, Glacier Bay, Blue Pool, Chatham, and Pemaquid are some of the best-known examples.

Understanding *merroir* is essential if you want to know which oysters you're ordering and how they will taste and feel in your mouth.

The road to Aunt Dotty's grow-out site, Island Creek Oysters, Saquish, Massachusetts

The saltiness of the seawater that courses over the oyster's body twenty-four hours a day has the greatest impact on its flavor. The Atlantic is saltier than the Pacific, so you can expect eastern oysters to taste more of the sea than their western counterparts. There are further flavor distinctions within these broad categories. Oysters from the Chesapeake Bay, for example, are considerably less salty than those grown nearby in deeper Atlantic waters. Firm, briny Island Creek oysters are considered among North America's best, in large measure because of the unique water conditions in Duxbury Bay, where they grow.[4]

As filter feeders, oysters extract algae, plankton, and other food particles from their immediate environment. Along with seawater these tiny organisms give oysters their nuanced flavor profiles and textures. Different seaweeds produce different notes—fruity, nutty, citrus, mineral, metallic, and vegetal among them. In general, oysters from the Pacific Northwest can be described as having hints of watermelon and cucumber, though flavors are more cucumber-like in British Columbia and more melony in Washington.

In essence, oysters are what they eat.

# AND WHEN THEY EAT IT

Oysters are highly seasonal. The algae that sustain them bloom in the spring when the water temperatures warm, proliferate in the full sun of summer, diminish in the autumn, and go dormant in the winter. Anticipating their dwindling food supply, oysters gorge in the fall, becoming plump and sweet, making autumn the prime time for both harvesting and eating oysters. Fueled by their autumn feast, oysters hibernate in the winter when their food supply disappears altogether. They emerge thin in the spring, ready to feed on the newly blooming algae. And so it goes.

Each year they spend in the water, oysters grow another inch or so. In the ancient piles of oyster shells—known as middens—identified by archeologists, there are oyster shells up to two feet long. Foot-long shells are more common and indicate a ten- to twenty-year growing cycle.

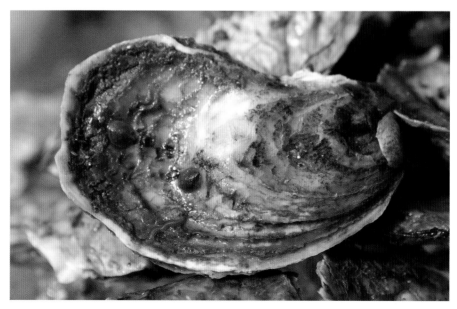

Every oyster shell is unique.

# A FEW WORDS ABOUT WORDS

In the beginning oysters were described simply as briny or sweet, and occasionally as kelpy or tinny. Today, with so many *merroirs* and varietals, and oyster aficionados waxing rhapsodic, the oyster lexicon has colorfully exploded.

anchovy
bacony
bacon-fatty
bold
brassy
celery
celery salt
chalky
clean
coppery
creamy
crisp
cucumber
earthy
fruity
funky
grassy
herbaceous
hints of iodine
jelly

melon
melon rind
mineral finish
miso
mossy
muddy
musky
mushroom
piney
savory finish
sea grass
sea mushroom
silky
smoky
tinny
umami
vegetal
velvety
watermelon
zinc-ish . . .
and more.

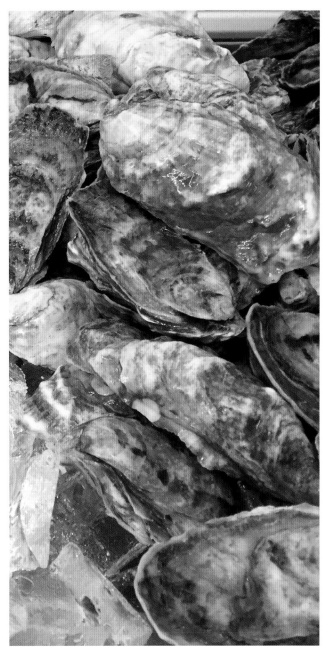

Ready for shucking, Island Creek Oyster Bar, Boston

# ENVIRONMENTAL ACTIVISTS

Far more than simply sublime bites, oysters also are environmental activists. Every oyster is a natural water filtration system, filtering up to thirty gallons of water in a single day. In purging the water of agricultural and man-made pollutants, these bioremediators (along with mussels and clams) enable numerous other species to thrive. Increasingly, oysters are being reintroduced to clean up dirty harbors and coastal areas where they once thrived.

In addition to keeping waters clean, oysters can protect flood-prone areas from storm damage and coastal erosion. This is particularly true around Manhattan where, before oysters gave way to overharvesting and twentieth-century pollution, their indestructible shells formed natural fortifications against the ocean.

Seaweed at Aunt Dotty's grow-out site, Island Creek Oysters, Saquish, Massachusetts

# FIVE SPECIES OF
# NORTH AMERICAN OYSTERS

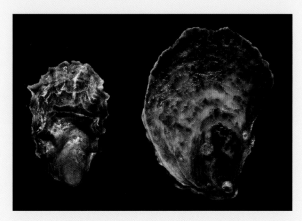

West Coast and East Coast varieties

Oysters used for food (distinct from pearl oysters) belong to the Ostreidae family. The most popular and heavily harvested species on North American shores are Atlantics and Pacifics. Atlantic oysters, or *Crassostrea virginica,* breed from northern Canada down the East Coast and across the Gulf. They comprise approximately 85 percent of all the oysters harvested in the United States and Canada. Pacific oysters, *Crassostrea gigas,* were introduced to the United States from Japan in the early 1900s and are grown from British Columbia down to California.

Kumamotos, *Crassostrea sikamea*, and Olympias, *Ostrea lurida* or *Ostrea conchaphila*, come from the Pacific coast, while European Flats or Belons, *Ostrea edulis*, are farmed on both coasts.

Oysters are farmed elsewhere in the world as well, notably in the waters of Australasia. Sydney Rock Oysters, *Saccostrea glomerata*, are compared to the small, sweet Kumamoto. New Zealand Flats native to Chile as well as New Zealand, *Ostrea chilensis*, resemble European Flats though they are often bolder and brassier.

Stringent government regulations,[5] costly treaties, and the fact that raw oysters don't travel well keep most, if not all, foreign oysters on their own shores. Fortunately for oyster lovers from coast to coast, the United States and Canada produce among the very best oysters in the world.

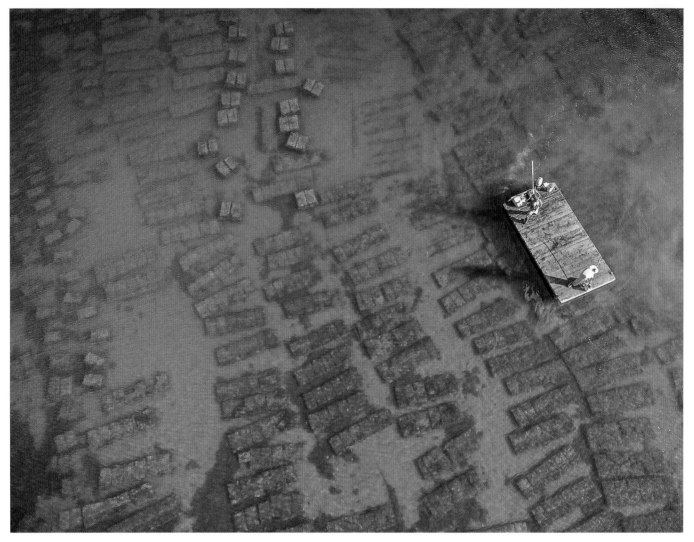

Oyster beds, Chatham Shellfish Company, Chatham, Massachusetts

When Hurricane Sandy devastated parts of the East Coast in 2012, Manhattan came face-to-face with the extent of the island's vulnerability. As civil engineers ponder how best to protect the coast, they are considering recreating oyster reefs. Over time reefs can form living seawalls, providing the region with a defense that is self-sustaining.

As native species and natural wonders, oysters hit the sweet spot where environmental activism, the local food movement, cutting-edge chefs and restaurateurs, and aspirational foodies meet.

| | EASTERN/ATLANTIC | PACIFIC | KUMAMOTO | OLYMPIA | EUROPEAN FLAT |
|---|---|---|---|---|---|
| SPECIES | *Crassostrea virginica* | *Crassostrea gigas* | *Crassostrea sikamea* | *Ostrea lurida / Ostrea conchaphila* | *Ostrea edulis* |
| WHERE THEY LIVE | From northern Canada to the Gulf of Mexico | From British Columbia to Baja California | Native to Kumamoto Bay, Japan, and farmed from British Columbia to Northern California | Uniquely native to the Pacific Northwest | Originally from France, now farmed in small batches in New England, California, and Washington |
| HOW THEY TASTE | Clean, crisp, briny, mineral, savory finish | Sweet, less briny, kelpy, creamy, herbaceous, fruity or vegetal finish, hints of cucumber or melon rind | Buttery sweet, creamy, melon-scented | Strong, intense, coppery, sweet, celery salt, mushroom, with the taste of grass and earth, rather than the sea | Bold, brassy, smoky, hints of iodine and anchovy |
| HOW THEY LOOK | Strong gray-brown shell, smooth shell ridges, relatively uniform in color | Fluted, often rough and jagged shells, with streaks of pink, purple, white, and green | Small, deep, and cuplike | Pearlescent round shells, smaller and shallower than Kumamotos | Larger, flatter, and rounder than all the others, with narrow ridges |
| FAMILIAR VARIETIES | Island Creek, Wellfleet, Blue Point, Beausoleil, Pemaquid | Hama Hama, Hog Island, Fanny Bay, Drakes Bay, Royal Miyagi, Kusshi | Humboldt, Shelton, and Royale Kumamotos | Totten Olympia | Belon, Glidden Flat, Damariscotta Flat |

# OYSTERS AT HOME

*Raise the shell to your mouth, throw back your head, scrape the creature from its lair with your teeth, taste its briny juice, and squelch it slightly against the palate before swallowing it alive.*

— Felipe Fernández-Armesto

Feasting on oysters at home is relatively easy and entirely pleasurable, particularly when you know your oysters and have a few basic tools on hand. If you've read this far, you can identify one oyster from another—East Coast or West, briny or sweet, kelpy, fruity, buttery, or brassy.

Shop for oysters at a busy, reputable fish market or an equally bustling fish counter at a specialty food store or supermarket. Get to know the fishmonger. Talk oysters and ask questions, especially if you're uncertain about anything.

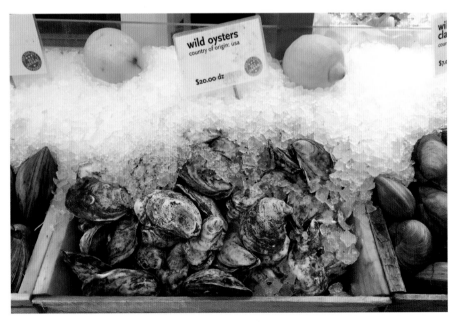

Wild oysters, Eli's Manhattan

Whether you find an assortment of oysters or simply one or two varieties, they must be fresh. Shells should be deeply cupped and closed tight. If they're open in the slightest, the oysters will be dead—and inedible.

Transportation, refrigeration, and technological advances have enabled us to enjoy fresh oysters from any of their North American habitats, though oysters that are cultivated closer to home are likely to be the freshest.

Oysters arrive at the market in tagged bags. The tags tell you where the oysters were raised, confirm that they were raised in certified—clean, safe, unpolluted—waters, and indicate who shipped them. Your fishmonger can show you the shellfish tags and certification, if you would like to see them.

You also can order oysters directly from leading growers on both coasts. If you don't have a reliable market and fishmonger, this may be the best way to feed your oyster habit. You'll receive your shellfish via FedEx, two or three days out of the water at most, and still very fresh. There is a list of wonderful growers who ship in the resources section of this book.

If you're not serving your oysters right away, they should be refrigerated. Store the oysters in a pan, cup side down, loosely covered with damp towels (cloth or paper) to keep them from drying out. If the fishmonger packed your oysters in ice for the

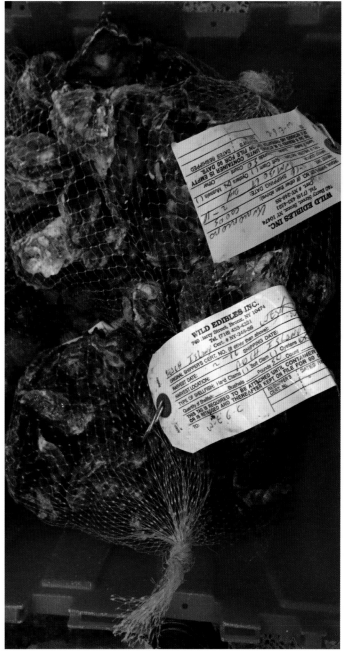

Fresh oysters, bagged and tagged

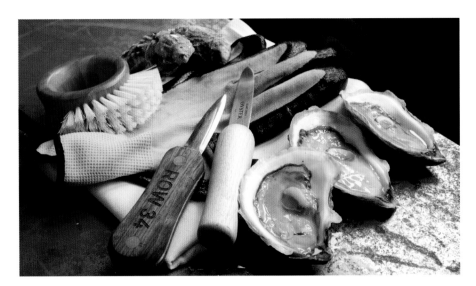

Oyster shucking tools

trip home, dump the ice before storing to prevent them from becoming too cold or wet.

Never store live oysters—and they are alive until you eat them—in bags or sealed containers. Oysters need oxygen to remain fresh. They don't do well lying around, so if you can, buy oysters the day you expect to eat them.

If you're planning an oyster feast at home, the whole oysters you buy must be alive, with the shells tightly closed. If an oyster appears to be open even a crack, give it a sharp tap with the back of a spoon or other sturdy object—a live oyster that is agitated like this will immediately seal itself. Should you have any doubts as to whether the oyster is alive, toss it in the trash.

That same sharp tap also will tell you if the oyster is full or flat. If you get a hollow sound from the tap, let that oyster go and move on to the next.

Meanwhile, get your tools ready. You will need a stiff bristle brush, a good oyster knife, a sturdy glove to protect your hand while shucking, and one or more dish towels or cloths. An apron is important too, as things can get messy. Depending on your counter surface, you might want a cutting board. Have a trash bag nearby to collect the top shells and other debris.

Next, clean off any sand or grit that may be stuck to your oysters' shells. Hold each oyster under cold running water, brush briskly, and rinse.

Right before you start shucking, prepare your serving platter with a generous layer of crushed ice. The platter should be big enough for all the oysters to be comfortably arranged. A platter with a raised edge is a particularly

Two beauties, Island Creek Oyster Bar, Boston

good choice, as it will protect your oysters from sliding off and prevent the ice from dripping on the table. Should you be fortunate enough to have individual oyster plates, all you'll need to do is rest one oyster in each of the perfectly formed hollows.

When its time to shuck, be mindful of how oysters are constructed.

Oysters have a cupped, rounded edge and a pointy hinge end, also known as an umbo, opposite. Despite appearances, the umbo is the sole place on the oyster where the shells are actually joined. In addition to the cupped, rounded edge, oysters also have a cupped, rounded side (the bottom) and a flat upper side (the top).

Before you begin to shuck, put on your glove. Whether you have inexpensive Kevlar, pricey stainless steel, or something in between, your glove will protect you should your oysters be particularly sharp around the edges, or your knife slip.

Even though you're wearing a glove, wrap the oyster in a towel as well. The towel will protect you should anything go awry. Hold the oyster with the cup side in the palm of your gloved hand and the hinge toward you. In this position the all-important adductor muscle that connects the top and bottom shells always will be on your right. If you don't want to hold the oyster while opening it, place it on a nonslip surface with the same positioning — steadied with your gloved hand and towel.

Now you're ready to shuck.

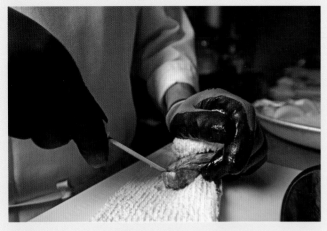

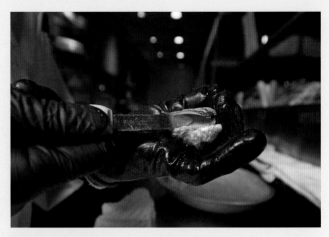

**1.** Insert your knife into the oyster's hinge about a quarter of an inch, or until it gets stuck. This maneuver requires mild pressure.

**2.** Gently twist the knife until the hinge pops and the oyster opens. Remove the knife from the oyster as gently as you inserted it. Wipe the knife clean of any oyster goo that may have stuck.

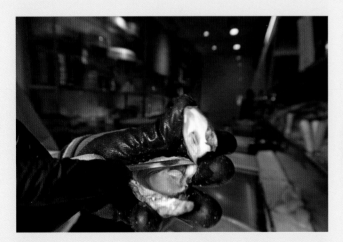

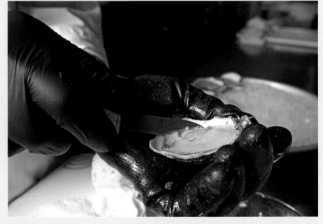

**3.** Hold the oyster in the same fashion as before. Carefully slide the knife inside the oyster and along the top shell to detach the adductor muscle. Remove the top shell and inspect your oyster for any bits of shell or debris. Carefully flick them away with the tip of the knife, taking care not to lose any of the precious oyster liquor.

**4.** Gently run the knife along the adductor muscle in the bottom shell to loosen the oyster from the shell. Check again for any errant bits or debris. Nestle the oyster on the ice. Repeat.

Aldemar Moreno shucking at Row 34 Restaurant

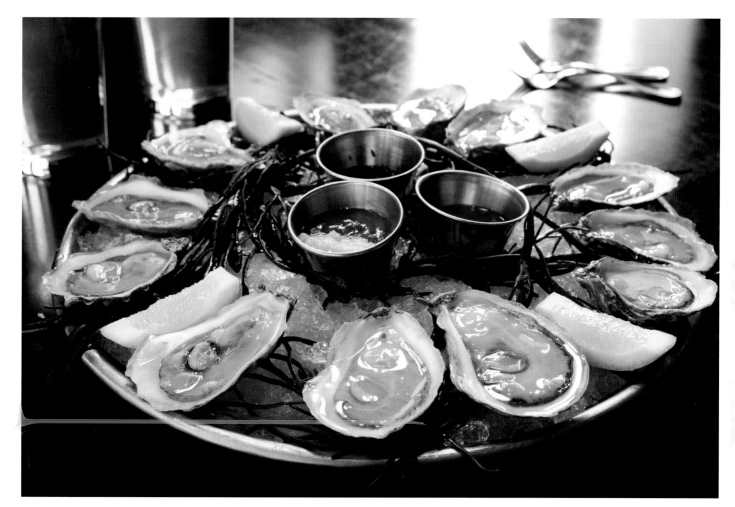

Shucked to perfection

A well-shucked oyster will be perfectly clean and unscarred. On the off chance you nicked your oyster while shucking, carefully flip it over — no one will be the wiser.

Arrange your beautifully shucked oysters on the platter and garnish with lemon wedges and, if your fishmonger has provided it, seaweed. Include any sauce on the side. Step back and enjoy your handiwork.

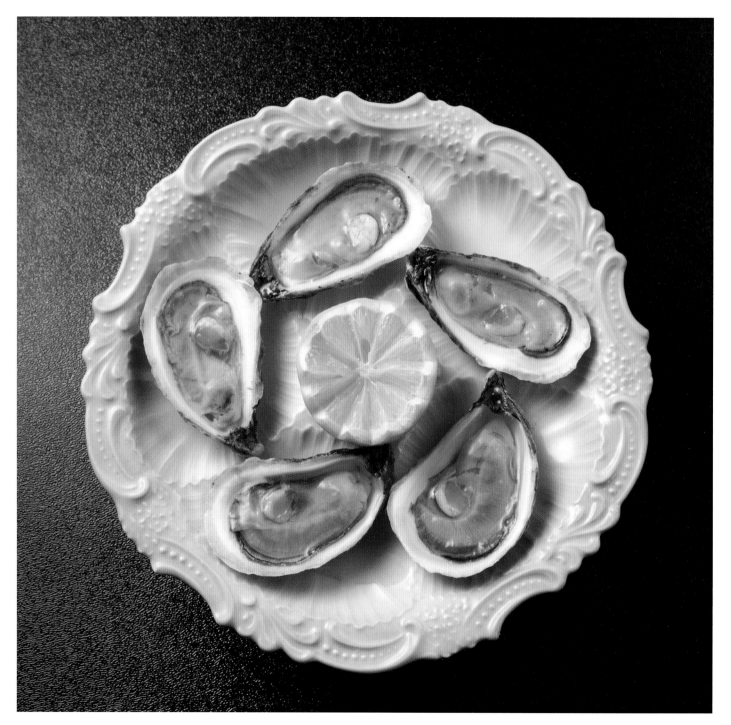

Vintage oyster plate, Germany 1920s

# NAKED OR DRESSED?

There is much debate around how to eat an oyster—naked or dressed, slurped from the shell or lifted with an oyster fork. The most devoted oyster lovers insist on purity, straight from the shell with, at most, a squeeze of fresh lemon. If sauce is a must, mignonette is the sauce of choice.

## JEREMY SEWALL'S CLASSIC MIGNONETTE SAUCE

$\frac{1}{2}$ cup champagne vinegar
$\frac{1}{2}$ cup white wine
$\frac{1}{4}$ cup minced shallot
1 teaspoon black pepper

In a bowl, mix together all of the ingredients. Cover the bowl with plastic wrap and chill the mignonette in the refrigerator until ready to serve, or for up to five days.

If you want a spicier version, you can add jalapeños and Sriracha as follows:

## JEREMY SEWALL'S SPICY MIGNONETTE SAUCE

2 large shallots, peeled and finely minced
$\frac{1}{4}$ cup white wine
$\frac{1}{4}$ cup white wine vinegar
1 small jalapeño pepper, seeded and minced
1 teaspoon freshly ground black pepper
1 teaspoon Sriracha hot sauce

In a bowl, mix together all of the ingredients. Cover the bowl with plastic wrap and chill the mignonette in the refrigerator until ready to serve, or for up to five days.

# HAND-FORGED, STRONG, AND NIMBLE

---

*I do not weep at the world—I am too busy sharpening my oyster knife.*
—Zora Neale Hurston

Oyster aficionados are as passionate about their tools—especially their knives—as they are about taste. Oyster knives can be merely functional or elaborate works of art—mass-produced for as little as $9.99 or custom-made with a hand-forged, personalized, etched blade for upward of $2,000. In between there are numerous choices.

We don't know the exact point along the oyster timeline when the first primitive implements appeared to pry open oysters. Whenever it was, and however primitive the implements, they were a marked improvement over the original smash-against-the-rocks and split routine—time-consuming and exhausting work for early hunter-gatherers.

In due course long, flat, narrow blades called stabbers evolved. Eventually the relatively generic stabber begat the Chesapeake, New York, Boston, Cape Cod, and other knives, all forged and deemed suitable for oysters native to their particular regions and named, like oysters, for those localities.

Some *ostreomanes* maintain that all you need to do the job is a clean, flat-head screwdriver or church key and precise wrist action. Though either tool will work, the novice shucker might find it challenging to improvise. The best bet is a good oyster knife specifically designed for the action at hand.

Shucking oysters takes dexterity and finesse, and knives are notably durable and nimble. Typically an oyster knife has a short, strong, stainless steel blade designed to perform two distinct functions—it will provide leverage so you can swiftly pop the oyster's hinge and then cleanly detach the muscle from the shell.

Choosing the right oyster knife makes it a lot easier to shuck. "Right" in this case means a knife that feels comfortable and secure in your hand, with a blade that is suitable to the size of the oyster—long enough to cross the oyster at the widest point and easily release the interior adductor muscle.

The shape of the knife's handle is more important than its material—wood, rubber, plastic, and composites all are used. The bulbous end of the handle

is meant to prevent the knife from slipping, which is especially important if you're new to shucking. Before you shuck, get to know your knife. Feel how the handle rests in your palm, turn it over in your hand, and make a few shucking movements so you'll be comfortable when you start. It's not unlike taking practice swings in golf or baseball.

Overall, blades are generally between two and four inches long. Some blades are pointier than others. Shorter blades with sharper points are best for delicate Kumamotos, Olympias, and other small oysters. Slightly longer, sturdier blades that taper to a point are more all-purpose, particularly suited to medium and medium-large oysters like Wellfleets. The longest blades are best reserved for the largest oysters, especially those from the Gulf. Experienced shuckers who handle lots of oysters have a variety of knives with blades of different sizes and tips. They can go from one to another without missing a beat.

Unless you're planning regular oyster feasts with a wide variety of oysters, most home shuckers will be fine with one knife, or possibly two, recommended for the oysters that are most readily available.

Whether you're using a cheapie bought nearby or a hand-forged beauty received as a gift, shuck with care to reveal each glistening oyster, free of grit, bits of shell, and, most importantly, bits of you.

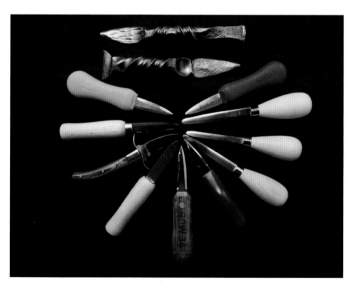

An assortment of shucking knives

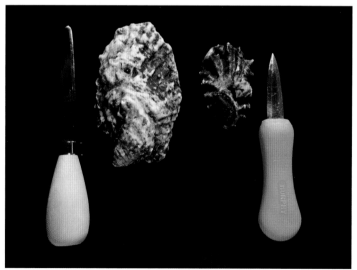

Large oyster, long blade. Small oyster, short blade.

# A DOZEN OYSTERS YOU SHOULD KNOW

 **AUNT DOTTY'S**
Plymouth, Massachusetts
Grower: Skip Bennett

 **BLUE POOL**
Hood Canal, Washington
Grower: Adam James

 **DIAMOND JIMS**
Norfolk, Long Island, New York
Grower: Ted Bucci

 **HALF MOON SELECTS**
Half Moon Bay, Georgia
Grower: John Pelli

 **HOG ISLAND SWEETWATERS**
Tomales Bay, California
Grower: John Finger

 **ISLAND CREEKS**
Duxbury, Massachusetts
Grower: Skip Bennett

 **JONATHAN ISLAND
PEARLY WHITES**
Narragansett, Rhode Island
Growers: Ben and Diane Franford

 **MOON SHOAL**
Barnstable, Massachusetts
Grower: John Finger

 **NORTHERN CROSS**
Fisherman's Island, Virginia
Grower: Tim Rapine

 **PEMAQUID**
Clarks Cove, Maine
Grower: Carter Newell

 **ROCKY NOOKS**
Kingston, Massachusetts
Growers: Greg Barker and
John Whebble

 **SHIGOKU**
Shelton, Washington
Grower: Bill Taylor

—Jeremy Sewall

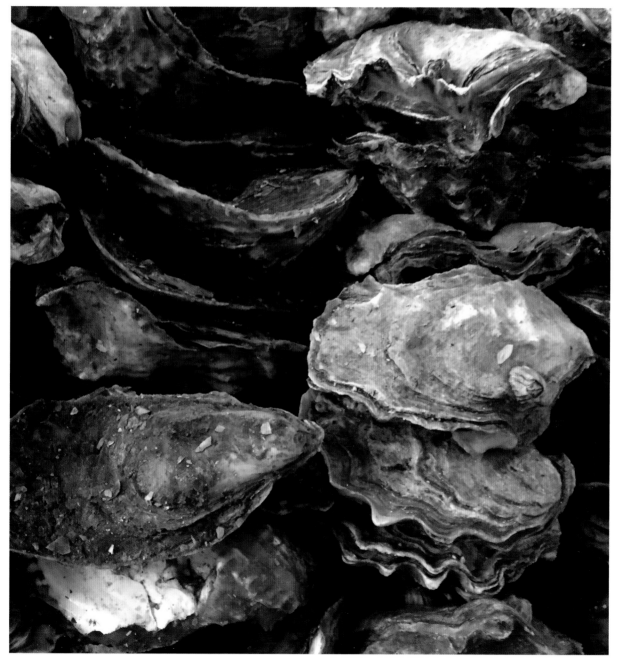

Oysters of the day, Aquagrill, New York City

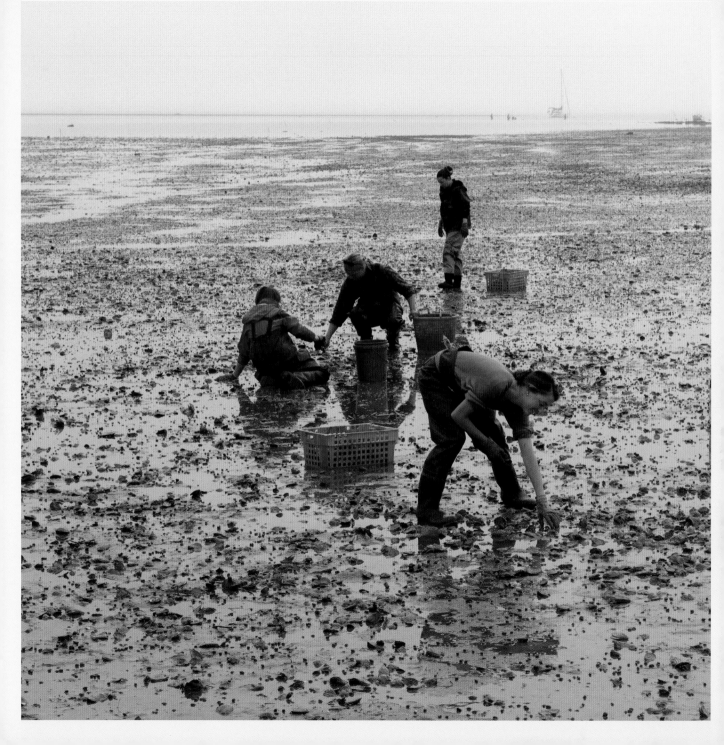

# OYSTERMEN

*I love oysters. It's like kissing the sea on the lips.*

— Léon-Paul Fargue

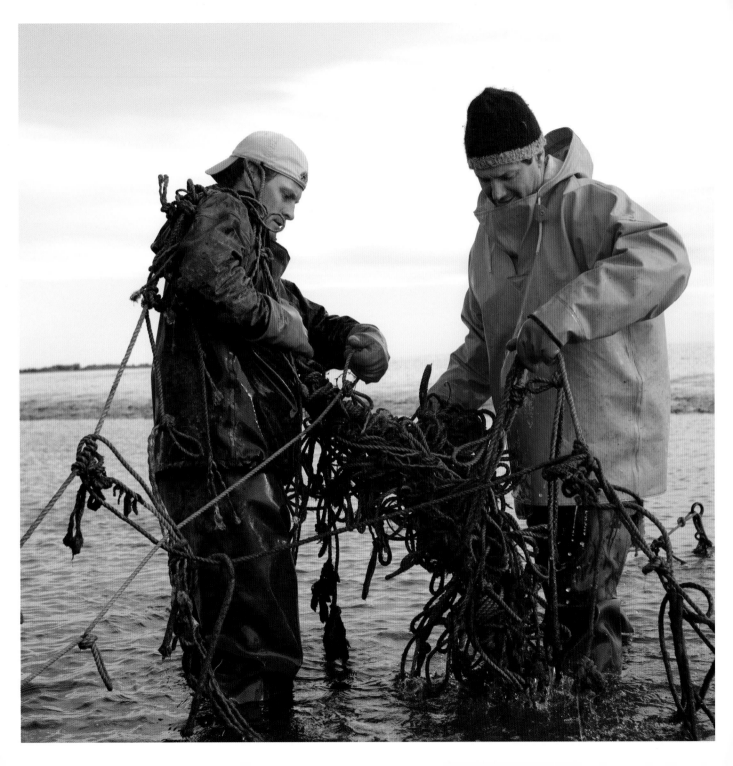

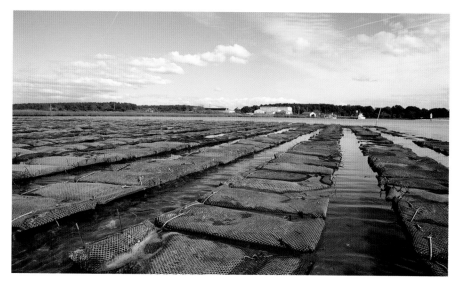

OPPOSITE: Workers at Island Creek Oysters, Duxbury, Massachusetts
ABOVE: Oyster bags at Ballard Fish & Oyster Company, Cheriton, Virginia

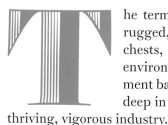

**T**he term "oystermen" traditionally conjures images of rugged, fifth generation baymen, in water up to their chests, sifting giant baskets of oysters. Today young environmentalists, marine scientists, local chefs, investment bankers, and others have joined their ranks, knee-deep in a new era of oysters. Together, they comprise a thriving, vigorous industry.

The men and women who farm oysters are uncompromising in their pursuits. Oyster farming is muddy and wet—tough, physical, and constant work. In the two years it takes for tiny seeds to mature into market-ready adult oysters a lot happens. On average, oysters—often hundreds of thousands or more in a single harvest—are touched by human hands upward of two dozen times before they are bagged, tagged, and on their way.

How oysters are farmed and handled—the grow-out method—is determined by climate, geography, and local regulations along with growers' individual preferences. Whether following in the footsteps of their forebears or responding to the lure of the water for the first time, adhering to tried-and-true methods or embracing state-of-the-art innovations, bringing in seed or growing oysters from scratch, oyster farmers across the board share an enduring passion for what they do.

Listen to oystermen speak. If you close your eyes, perhaps you'll even smell the sea.

Ballard Fish & Oyster Company, Cheriton, Virginia

*Shellfish is my life.*
 —Tim Rapine,
  Ballard Fish & Oyster Company,
  Cheriton, Virginia

Like every oyster, every oyster farm is unique and every oysterman has a story.

The story of Adam James and his sister Lissa James Monberg's Hama Hama Oysters begins in the late 1880s when their great-great-grandfather, Daniel Miller Robbins, traveled west from Minneapolis to the Olympic Peninsula. He set down roots in Lilliwaup, Washington, where he built a timber business. As in other newly settled coastal communities, oysters were gathered along the Lilliwaup shoreline, providing a steady source of readily available protein. Eventually, Robbins began selling oysters in bulk directly from his beachfront.

During and immediately after the Great Depression, Adam recounts, "people didn't need boards, they needed something to eat. That's when my grandfather, Bart Robbins, got really interested in oysters."

Bart Robbins, c. 1960, Hama Hama Oysters

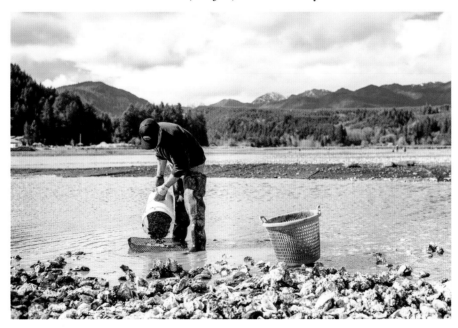

Harvesting at Hama Hama Oysters, Lilliwaup, Washington

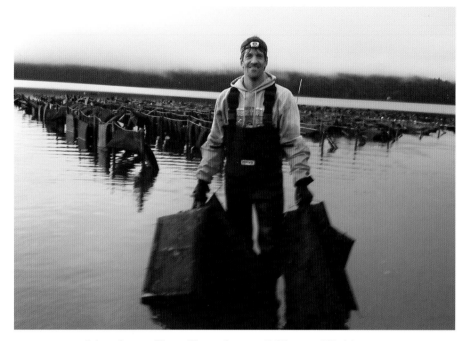

Adam James, Hama Hama Oysters, Lilliwaup, Washington

By the 1950s Robbins was shrimping and harvesting oysters for sale in nearby Seattle. Within three decades, the Robbins–James contingent was farming oysters full-time. Today they produce some of the most coveted West Coast oysters around.

Adam and Lissa were steeped in oysters from childhood, learning everything as they grew up. Or so they thought. When they took over managing the farm in 2007, Lissa admitted, "We didn't know nearly enough. To grow consistently great oysters, you have to know where they fatten best, how their flavor varies with growing location, and where they'll be most protected from floods and ravenous starfish. Considering that the farm is ten feet underwater half the time, learning the geography of our beach was—and continues to be—a challenge."

As they have been for generations, Hama Hama Oysters are gathered by hand at low tide. It is the rise and fall of the tides that keep this part of oyster farming from being 24/7 and utterly grueling. It also means that there is no such thing as a nine to five workday. In the winter, low tides are at night, forty-five minutes later each day. The day may start at

midnight and continue for hours in the darkness, amid bitter winds and driving rains. According to Adam, "The tides dictate our way of life. In the summer, it's a great day. In the winter, it can be rough." It's a life that is not for the faint of heart, or anyone who doesn't truly love oysters.

Love is a word Lane Zirlott often uses when he talks about his Alabama Murder Point Oysters. "Butter love," to be exact, reflecting how lovingly they are raised to be ultra-buttery and luscious.

Lane is relatively new to oyster farming, although his family has been commercially fishing the natural bounty of the Gulf of Mexico for five generations—beginning with oysters over a century ago.

Until recently oysters have been absent from Alabama's streams. The natural and man-made disasters that have ravaged the Gulf rendered the waters particularly inhospitable to oyster production. Under the auspices of the Auburn University Shellfish Laboratory, Alabama oysters are on the rebound.

Lane and his parents, veteran shrimpers Brent and Rosa Zirlott, joined the Auburn sea lab program and planted their first oysters in 2013. The three of them were smitten, and Lane, in particular, found his calling. Starting with twenty thousand tiny oysters, they produced five hundred thousand Murder Point Oysters the first year, eight hundred thousand the second, and soon their production will reach one million.

Historically, wild Gulf oysters have been big, piece-of-meat oysters, variable

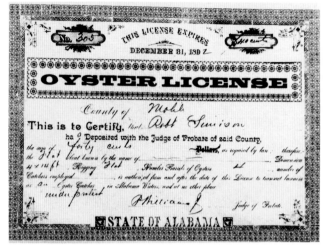

Original license to harvest oysters, 1892, Murder Point Oysters

Lane Zirlott, Murder Point Oysters, Irvington, Alabama

Tumbling drum, Murder Point Oysters, Irvington, Alabama

in size, taste, and texture. At four to five inches in length they are better suited for the deep fryer than served by the dozen with a squeeze of lemon.

From the outset Lane wanted to create a delicious half-shell, one-shot oyster for everybody. Between two and three inches long, deep cut, lovely to look at inside and out, perfectly balanced in flavor, buttery and creamy — the opposite of what people picture when they picture Gulf oysters.

"You eat with your eyes" is one of Lane's mantras. Producing an oyster that is beautiful to look at is as important to Lane as producing one that is tasty to eat. Grown in baskets above the water, constantly washed by the waves, turned and turned by hand, and then extensively tumbled in giant drums, Murder Points have smooth, shiny white shells with deep cups and clean edges.

Lane is concerned with every aspect of Murder Point and is with his oysters constantly. His unabashedly proud mother Rosa admits, "Lane talks to them every day to give them the butter love. He feels like these oysters are his babies."

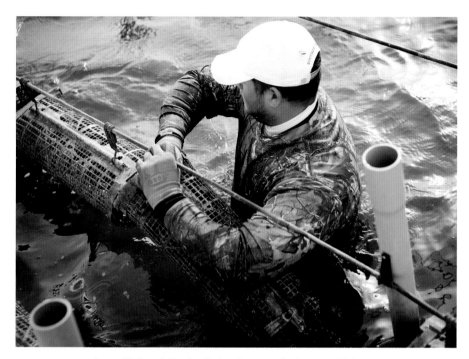

Lane Zirlott, Murder Point Oysters, Irvington, Alabama

"We pour our heart into it," boasts Lane, who tends his charges from first daylight to dark. "Whatever we do as Alabamians, we're passionate about it. Why not have the best oyster in the world from Alabama?"

Murder Points are aptly known as "Oysters Worth Killing For." According to legend, in the late 1920s two men came to blows over an oyster lease in Myrtle Point, near Gulf Shores, Alabama. When one of the men ended the dispute by killing the other, the name Murder Point quickly took hold. Considering the enormous passion that goes into every Murder Point oyster, turning local lore into a great tagline makes perfect sense. There is no better way to praise Murder Point oysters — they are that good.

*Shellfish is my life. Labor of love. Obsessed with producing the best.* This is how oyster farmers sum up their work. Tim Rapine, managing director of operations at the 120-year-old Ballard Fish & Oyster Company, equates oyster farming with parenthood. Tim's secret to producing the best possible oysters is "love and compassion." He explains, "The same love and compassion I show for my children, I show to these oysters."

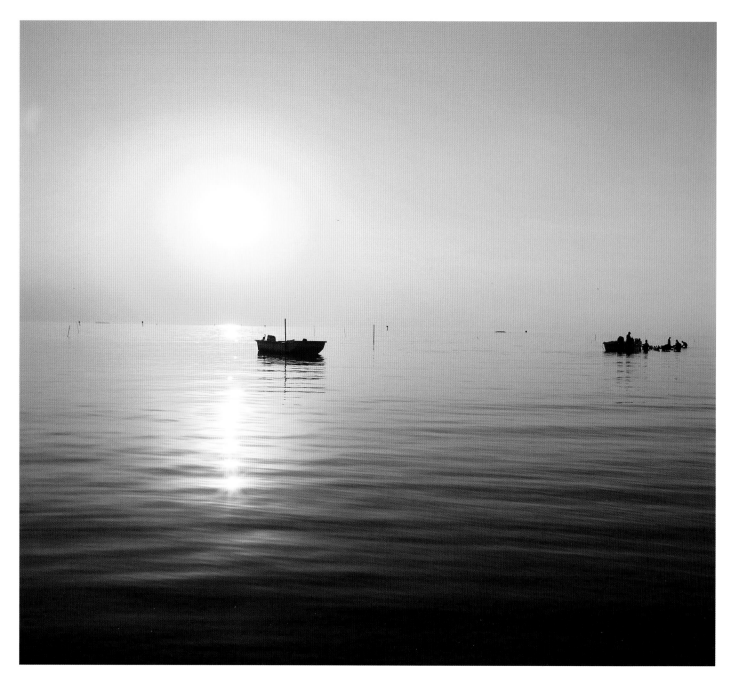

Ballard Fish & Oyster Company, Cheriton, Virginia

# THE LIFE CYCLE OF THE OYSTER

Oysters are broadcast spawners, which means that, in order to procreate, they release huge quantities of eggs and sperm into the water — five to eight million eggs at one time for adult females. Fertilized eggs become tiny larvae no bigger than the head of a pin. They swim around for a bit until they find a hard surface — ideally, an oyster shell — on which to grow. Within a few days of latching onto a growing surface they begin to form their own shells. Two to three weeks later, now known as spat or seed oysters, they reach the size of peas.

Despite their prolific egg production, oysters are highly discriminating about when and where they spawn. In particular, water temperatures must reach sixty-eight degrees or higher.[6] While ideal conditions may not always exist in nature, they can be created in oyster hatcheries. The water is warmed to perfection and the diet is rich algae — the perfect setting for oysters to produce the requisite sperm and eggs that become hatchery spat, which will attach themselves to hard surfaces and mature into succulent bivalves.

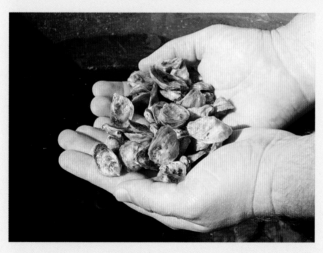

Baby oysters, Ballard Fish & Oyster Company

*The hand of the farmer is at the core of what we do.*
— Skip Bennett, Island Creek Oysters,
Duxbury, Massachusetts

*It's like a Rubik's Cube.*
— Stephen Wright, Chatham Shellfish
Company, Chatham, Massachusetts

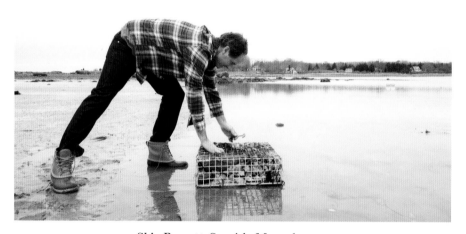

Skip Bennett, Saquish, Massachusetts

kip Bennett is from a family of lobstermen. He grew up in Duxbury, Massachusetts, started fishing for shellfish in high school, left Duxbury to attend college, returned in 1988 for one last summer, and ended up staying. By 1990 he was raising beautiful quahog and razor clams — a short-lived venture that was wiped out by a deadly parasite.

Local skeptics notwithstanding, Skip decided to raise oysters instead, even though they'd never grown in Duxbury Bay. He purchased oyster babies from a hatchery in Maine, each no bigger than a grain of sand, and by 1995 spread his first young oysters on the bottom of the bay to mature. Hoping simply for a good grow out, Skip stumbled onto one of the best ecosystems for oysters anywhere.

Duxbury Bay is rich in the plankton on which oysters feed. And it has a massive tidal flush that replaces up to 80 percent of the bay's water twice a day. Clean food and cool, nutrient-rich water are available throughout the year.

As generous as the natural world may be to Duxbury Bay, oyster farming there—as everywhere—is hard, hands-on work, often in harsh conditions. Moreover, Mother Nature's love is capricious. She can deliver a destructive nor'easter as easily as a gentle southeasterly breeze that blows away unwelcome warm surface water.

Skip calls oyster farming a reactive undertaking, as every season is different. Weather, water conditions, and food conditions can change at a moment's notice. Predators, like starfish, knobbed whelks, oyster drills, and green crabs, lurk. The otherwise dependable algae bloom that oysters enjoy may suddenly carry disease.

Above all, the proverbial book on growing oysters—the one with all the answers—has not been, and probably never will be, written. "It's really, really difficult to grow live animals," Skip says, but for him and his colleagues, "nothing is more creative than spawning oysters."

The pristine Duxbury Bay water, in which Island Creeks thrive, is too cold for them to reproduce. For many years, Island Creeks were spawned two hundred miles away at a hatchery in Maine. The babies, millions of them, were returned to Duxbury Bay and its aerated wells to mature. Today, spawning takes place at the new Duxbury hatchery as well. Gallons upon gallons of plankton are refined on-site to nourish the oyster babies.

As they multiply in size, the oysters are transferred to a system of cages in the middle of the bay. At around six months old and two inches long, they are spread on the bottom of the bay to fully mature. A year or so later, the oysters are harvested and culled for market.

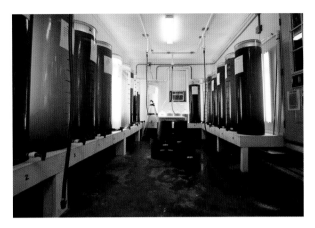

Plankton room, Island Creek Oysters, Duxbury, Massachusetts

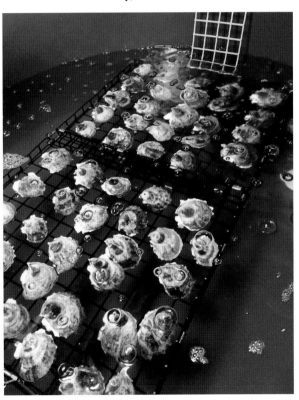

Oyster breeding stock, Island Creek Oysters, Duxbury, Massachusetts

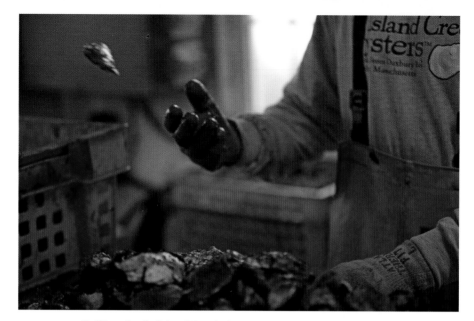

Culling shack, Island Creek Oysters, Duxbury, Massachusetts

As perfect as Island Creeks may be, they are not all perfect in the same way. Some chefs devoted to Island Creeks may want every oyster to be exactly the same size, so Skip's crew painstakingly hand selects and packages them accordingly. Oyster bars that offer greater variety are equally happy with unmatched mollusks. Their shipments are somewhat easier to assemble.

From hatchery to harvest to tagged mesh bags, for Skip and his colleagues at Island Creek Oysters, "the hand of the farmer is at the core of what we do."

The same can be said about oyster farmers everywhere.

For Steve Wright of nearby Chatham Shellfish Company, those hands "must make all the pieces fit" all the time, even when Mother Nature throws you a curveball—or worse. "It's a Rubik's Cube."

At Lane Zirlott's Murder Point Oysters things can turn on a dime. There have been occasions when the state of Alabama has ordered shellfish harvesting to stop for a period of weeks due to heavy rainfall and concerns about runoff pollution. When that happens, Lane and his crew must drop everything else. In short order, they haul as many oysters as they can from the water so as few as possible are lost. And then they must wait until the coast is clear.

Wild weather notwithstanding, when oysters are your world, the world, indeed, is your oyster.

Skip Bennett and Scott Snider, Saquish, Massachusetts

*We are farming on the edge of planet Earth.*
— Lissa James Monberg,
Hama Hama Oysters, Lilliwaup, Washington

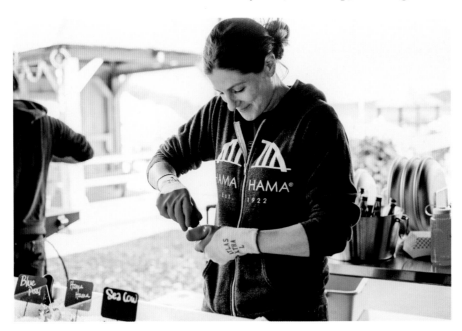

Lissa James Monberg, Hama Hama Oysters

 nvironmental stewardship is a natural extension of the oyster grower's life. No matter how varied their stories, the narrative arc for oyster farmers is familiar—"from resource extraction, to resource sustainability, to restorative stewardship," as Lissa James Monberg describes it.

As metaphorical descendants of the original hunter-gatherers, oyster farmers have a deep and instinctive relationship with the earth and the water. In many ways, they are historic preservationists, using sustainable aquaculture to restore the semblance and natural beauty of our coastlines.

From the majestic vistas of the Pacific Northwest to the meandering estuaries of the Chesapeake Bay to the tidal flats of the Gulf, the sheer physical beauty that surrounds oyster farmers on a daily basis is inescapable. It is no wonder that oyster farmers are self-declared stewards of the natural world. Oysters themselves are natural environmentalists—a keystone species that

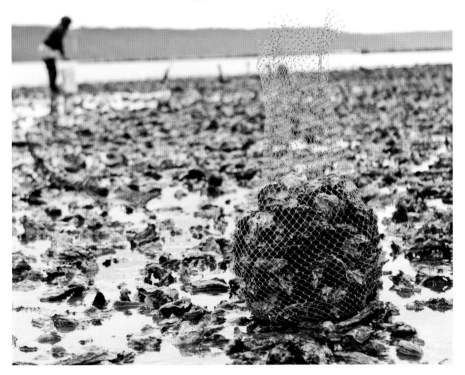

The shoreline at Hama Hama Oysters, Lilliwaup, Washington

facilitates a more complete and healthy ecosystem. As filter feeders, oysters are at one with their habitat. Thriving on plankton and algae, oysters get rid of nitrogen and other excess nutrients, clean and clarify the water, and provide an outstanding home for sea grasses and their aquatic neighbors.

And, they are utterly organic. Clean water and oyster seed are the sole prerequisites for growing oysters. No manufactured food, pesticides, or other man-made components are needed for oysters to survive and spawn.

Steve Wright of Chatham Oysters values the perfect ecosystem of the Oyster Pond estuary where the Atlantic Ocean meets Nantucket Sound, "the best water in the world," where his oyster story came to life.

As a boy in Connecticut, Steve was fascinated by the oyster boats that traveled up and down the Norwalk River. At Bridgeport Aquaculture School he homed in on oysters as a sustainable, domestic food source, pursued his interest in aquaculture and engineering at the University of Maine, and shortly thereafter took a job at Chatham Oysters. Today he runs the company with

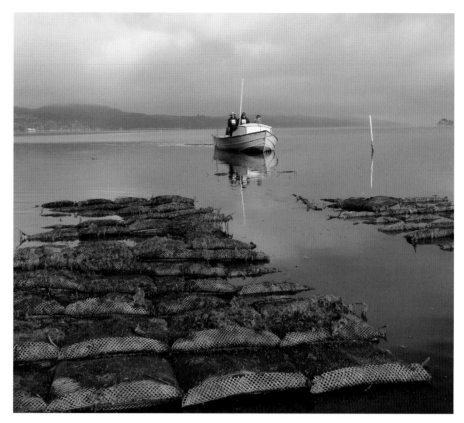

Floating bags of Hog Island oysters, Tomales Bay, California

an enduring appreciation for oysters as, "sustainable, economic multipliers. Good for the environment. Good for all."

In 1983 John Finger, marine biologist, oyster entrepreneur, and co-founder of Hog Island Oysters in Tomales Bay, California, set out to raise superior shellfish in a beautiful location. "Good things grow slowly" is a Hog Island motto that reflects thirty-plus years of experience developing sustainable aquaculture techniques and producing exceptional, nationally sought-after oysters. Slow means flavors will develop more fully and evenly and shells will grow thicker and shapelier.

Unlike most oysters that are named for where they are grown, Hog Islands are named for a state of mind — the passionate devotion to stewardship of the land and water. "Phenomenal" is the word John uses to describe the world in which he works. "It is all about what nature has provided"—beautiful bays that change with the season, a fully functioning ecosystem, biodiversity, and sustainability.

Tomales Bay, California

It is a singular alchemy that makes great oyster farmers and their shellfish undeniably spectacular. Pristine water and plentiful plankton are crucial, though neither can be taken for granted. Ample knowledge of *merroir*, the market, and everything in between is key. So are good instincts and common sense, accommodating taste buds, rapid response times, and the patience of saints. Respect for the natural world and unconditional love for what you do are perhaps the most important of all.

After all, John Finger admits, "Oysters are a celebration of nature."

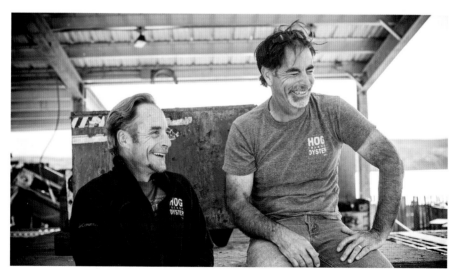

Terry Sawyer (left) and John Finger, Hog Island Oysters, Tomales Bay, California

# BOTTOM OR OFF-BOTTOM?

The particular way in which oysters are set out to mature is up to the grower. The spat may be distributed directly onto the ocean floor over existing oyster beds, similar to the way oysters grow in the wild. This is called bottom culturing, and growers who practice it use traditional rakes, tongs, and dredgers to gather the oysters.

Alternatively, oysters can be put in bags, racks, or cages that are suspended above the seafloor (off-bottom culturing) depending on how the oyster beds are situated and what the grower elects.

Off-bottom culturing can be executed in a variety of ways. For example, mesh grow-out bags of spat are often placed in cages to keep the burgeoning bivalves from floating away. If tidal conditions permit, the same grow-out bags of spat can instead be tied to steel bars and suspended in the water (rack and bag method). When space is an issue, stacks of grow-out trays may be used instead of bags.

Surface or floating cultivation uses diverse systems to allow oysters to float on the surface of the water, thus benefiting from the natural tumbling caused by the waves. Suspended cultures hang oysters from buoys, which also enables them to flip, rise, and fall with the tides. Bottom and off-bottom are not mutually exclusive

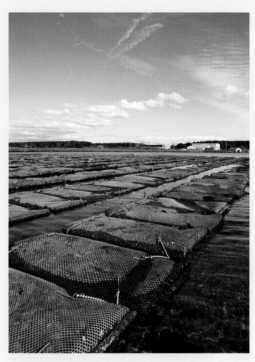

Ballard Fish & Oyster Company,
Cheriton, Virginia

methods, and many growers utilize both with a variety of configurations.

Whichever methods the farmer selects, it takes eighteen months to two years for oysters to grow to market size—approximately three inches long. Soon afterward, the fully grown mollusks can find their way to your table.

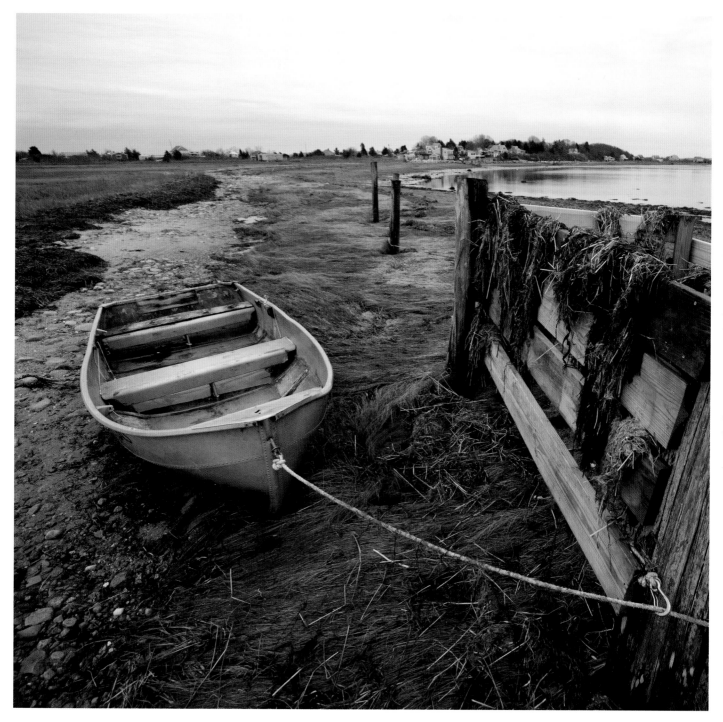

Saquish, Massachusetts, home of Aunt Dotty's oysters

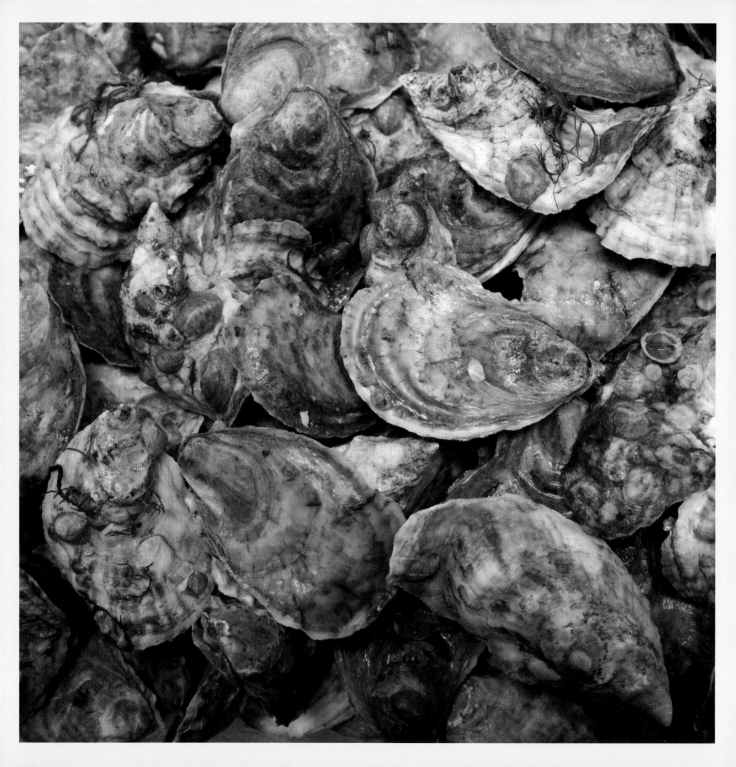

# SIMPLY OYSTERS

Deeply ridged, dramatically fluted, or fairly smooth; roundish, oval, or teardrop-shaped; flecked with gold, purple, or blue; or tinged with orange or green—an oyster is a thing of pure natural beauty. Look at an oyster and you will see its story—where it grew, what it ate, how the water flowed around it, how it was farmed, and what to anticipate when it meets your lips.[7]

# CONWAY ROYAL
## Prince Edward Island, Canada

Grower: Troy Jeffery

Conway Royals are grown on the western shore of Malpeque Bay and are similar in flavor to popular Malpeques. They have a more uniform shape and thicker shell with a mild salt flavor and mossy finish.

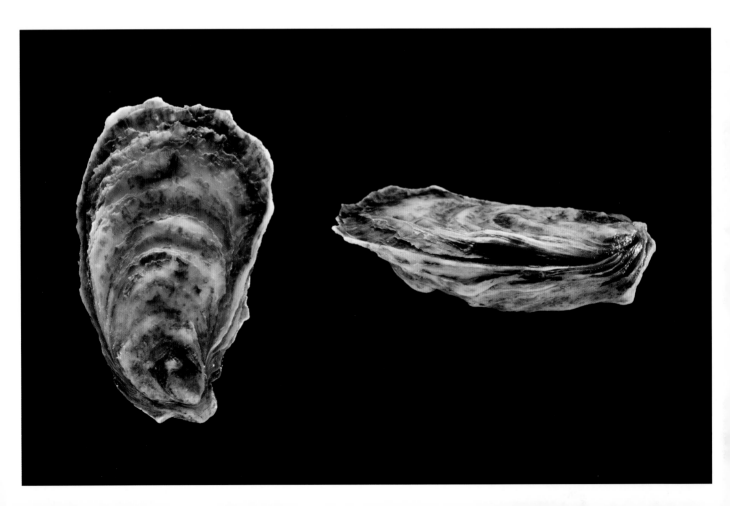

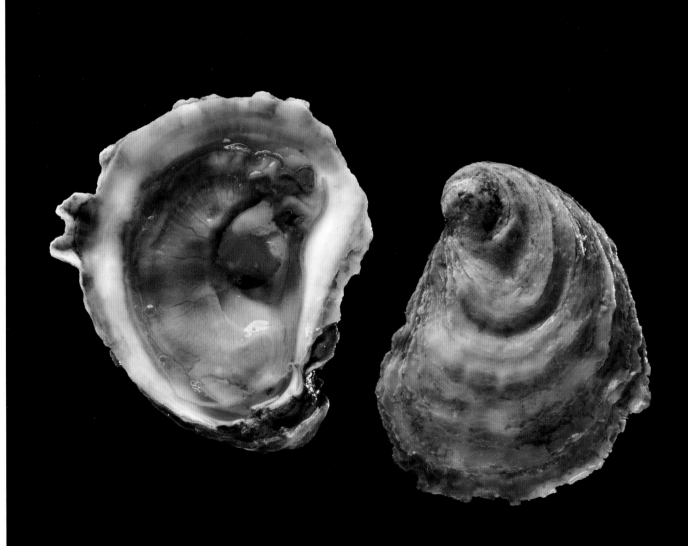

# FIN DE LA BAIE
## New Brunswick, Canada

Growers: Barry Kratchman and Mitchell Feigenbaun

With a name meaning "end of the bay," these pretty oysters are grown in Bouctouche, New Brunswick. They are top-cultured oysters that are sweet, salty, and have very silky meat.

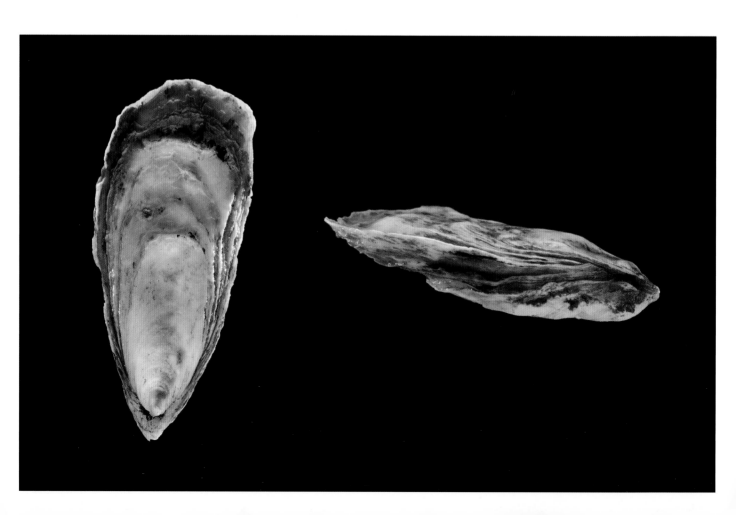

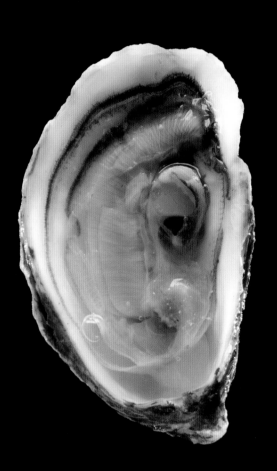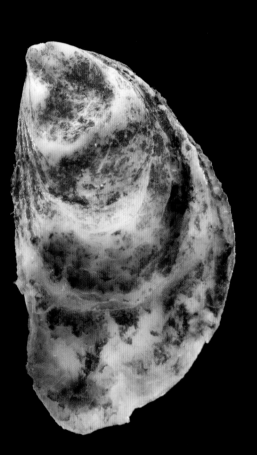

# IRISH POINT

Rustico Harbour,
Prince Edward Island, Canada

Growers: Scott and Margie Linkletter

Irish Points are raised in floating trays. They have small, thin, green-hued shells. Irish Points have high salinity and a touch of sweetness, with a texture that is not too meaty.

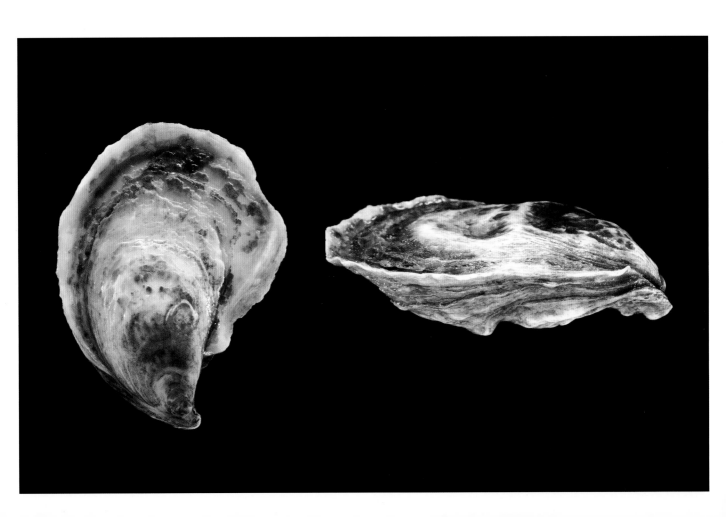

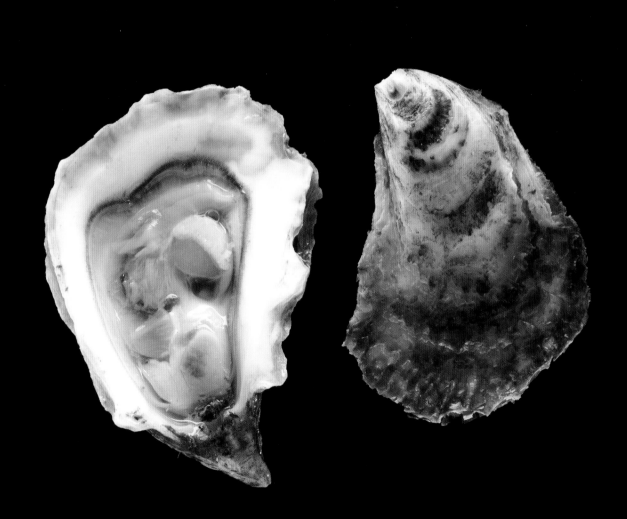

# MALPEQUE

## Prince Edward Island, Canada

Grower: Troy Jeffery

One of the best-known varieties of oyster ever to come out of Canada, Malpeques rival U.S. Blue Points in recognition. Bottom cultured in Malpeque Bay, they are tender oysters that balance sweet and briny flavors.

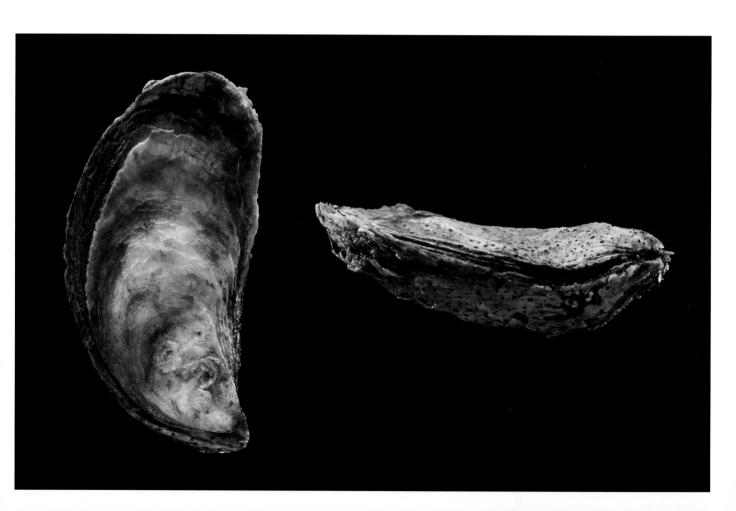

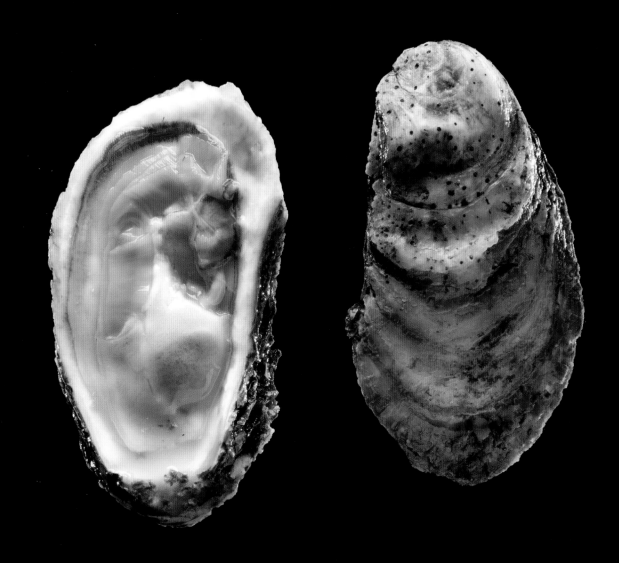

# SUMMERSIDE
## Northern Prince Edward Island, Canada

Grower: Troy Jeffery

Summersides are bottom cultured and grow to be medium or large in size, with a relatively deep cup. They are plump with a medium brine and a bright finish.

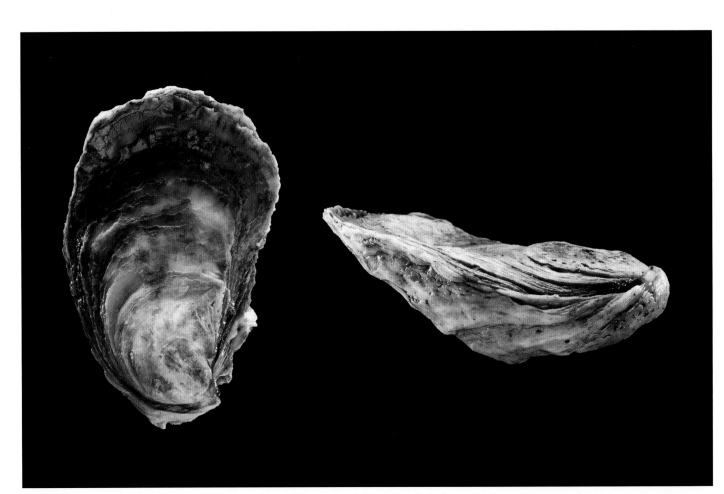

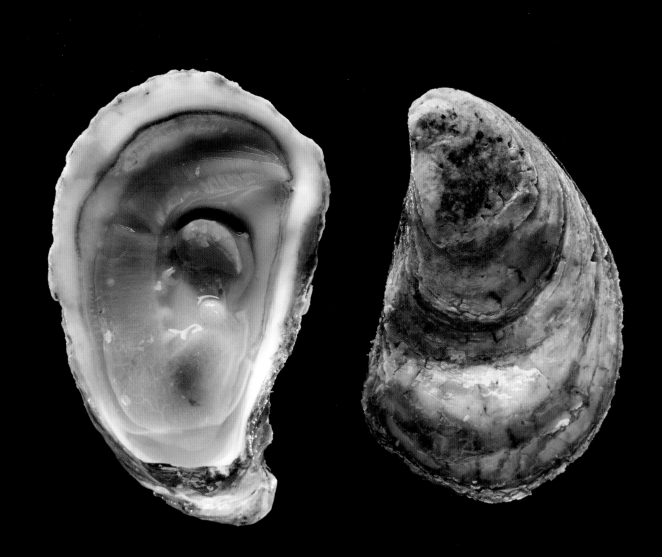

# **BELON** or **EUROPEAN FLAT**
## Mid-coast Maine

Grower: Wild, hand harvested

Belons grow wild in the Casco Bay area of Maine, in spots with about ten to twenty feet of water. They are hand harvested by fishers who dive down to retrieve them. Belons have a unique taste, starting with very salty flavors and ending with a strong copper finish, like sucking on a penny.

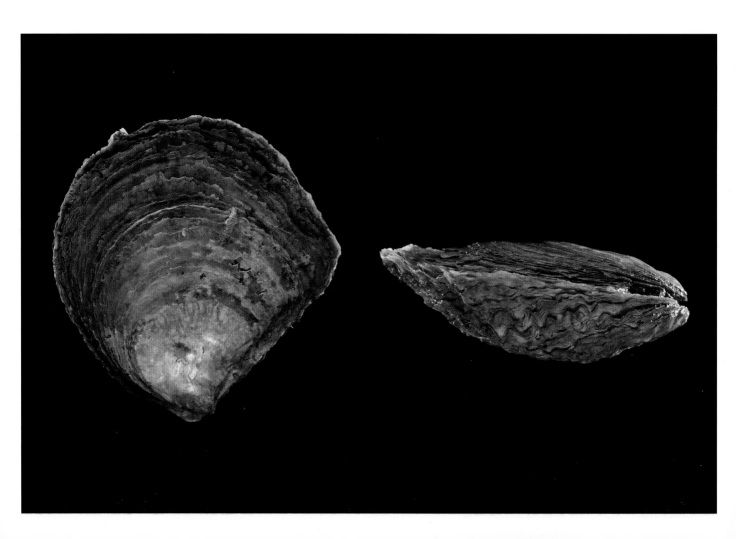

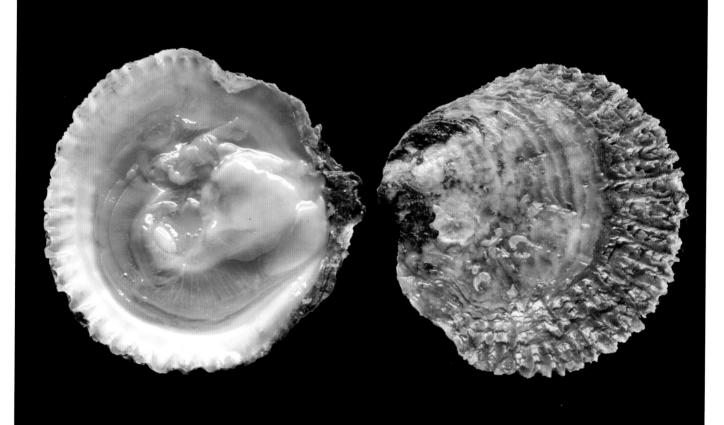

# PEMAQUID

## Clarks Cove, Maine

Grower: Carter Newell

These Maine oysters are bottom planted and then harvested in floating baskets. The baskets are moved to the mouth of the Damariscotta River to finish growing in lots of salt water. Pemaquids are plump, crisp, and salty with a slightly earthy finish from being bottom planted.

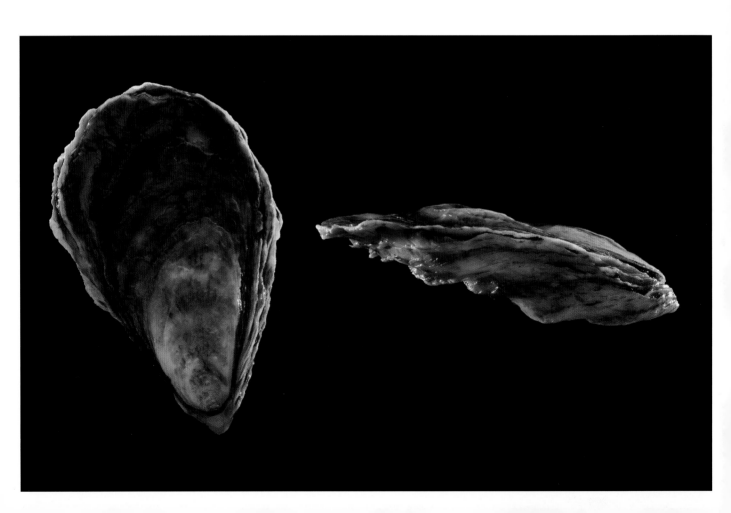

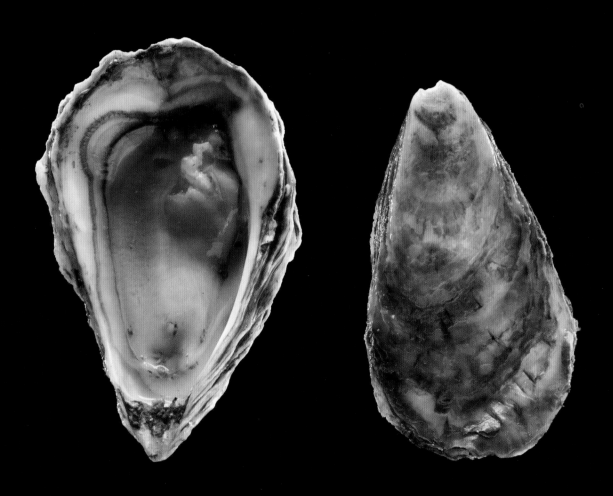

# FAT DOG

## Great Bay, New Hampshire

Grower: Jay Baker

Fat Dogs are completely cage-grown a few inches off the floor of Little Bay, a part of the Great Bay system that is fed by the Piscataqua River. The Piscataqua has some of the strongest currents on the East Coast, which bring salt water in from the Atlantic twice a day. Fat Dogs have a strong shell with a deep cup that comes from being tumbled in their cages by the rolling tides. A well-grown and well-cared-for oyster, the Fat Dog has a mossy sweet flavor with a salty finish.

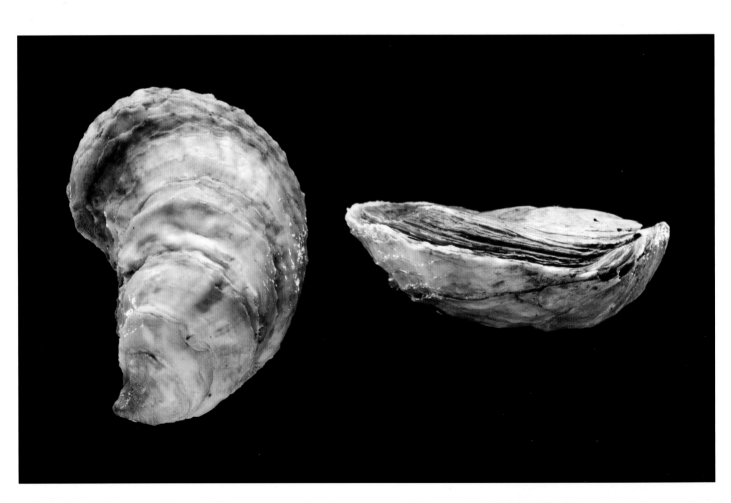

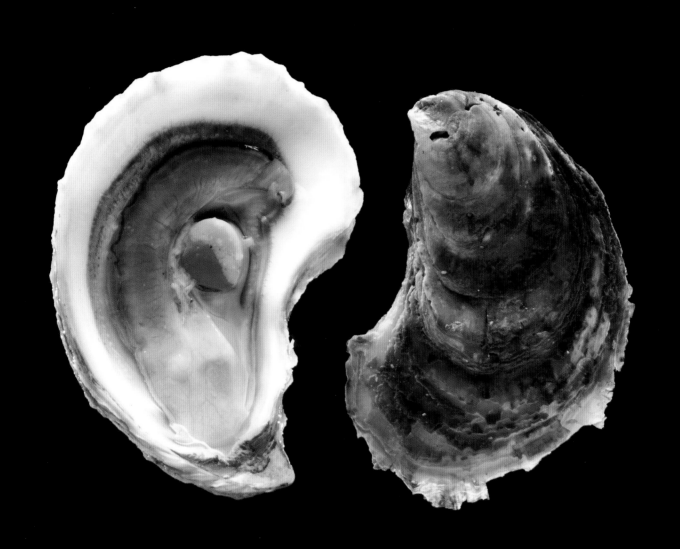

# LITTLE GRIZZLIES
## Great Bay, New Hampshire

Grower: Ray Grizzle

Grown in the Little Bay section of the Great Bay system, Little Grizzlies are becoming one of the most popular varieties of New Hampshire oyster. They have a teardrop-shaped, delicate shell and a soft flavor, with a mild melon finish.

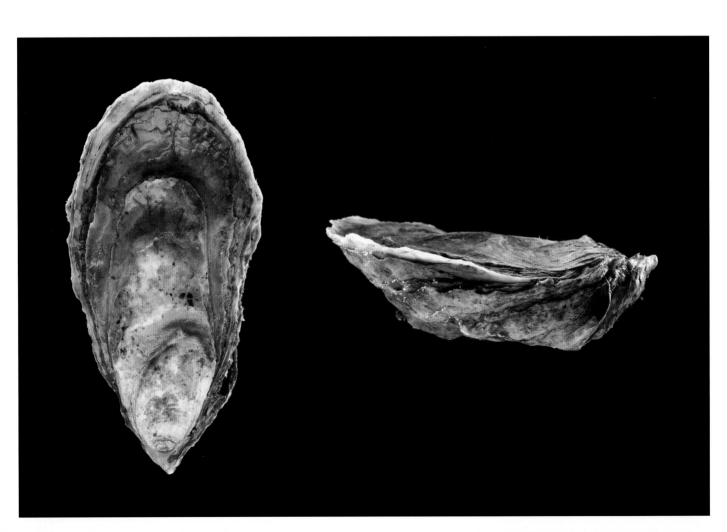

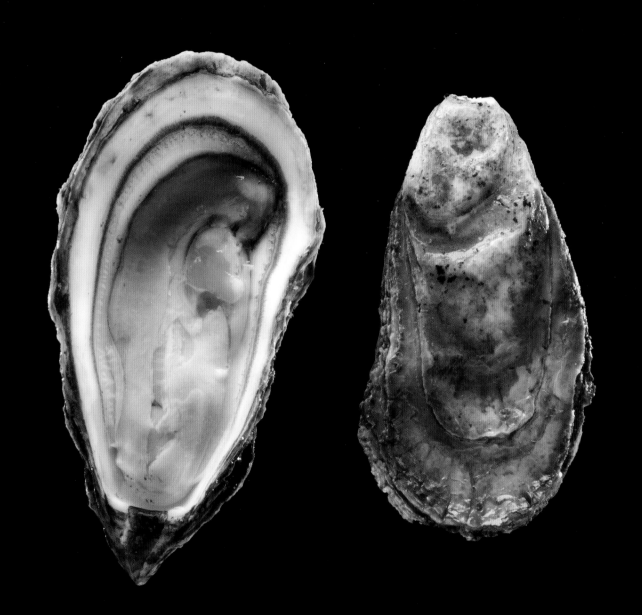

# AUNT DOTTY'S
## Plymouth, Massachusetts

Grower: Skip Bennett

Aunt Dotty's go from upweller, to floating bags, to trays placed on the tidal flats of Saquish, an area at the entrance to Massachusetts' Plymouth Bay. These boutique oysters take about three years to grow and spend their winters in Skip Bennett's cellar so as not to freeze. They are returned to the flats every April to continue growing. The oysters are named after Skip's Aunt Dotty, who was the last member of his family to live at their secluded Saquish property. Aunt Dotty's have a light brine and a great sweetness to them—a rich oyster with a mineral finish.

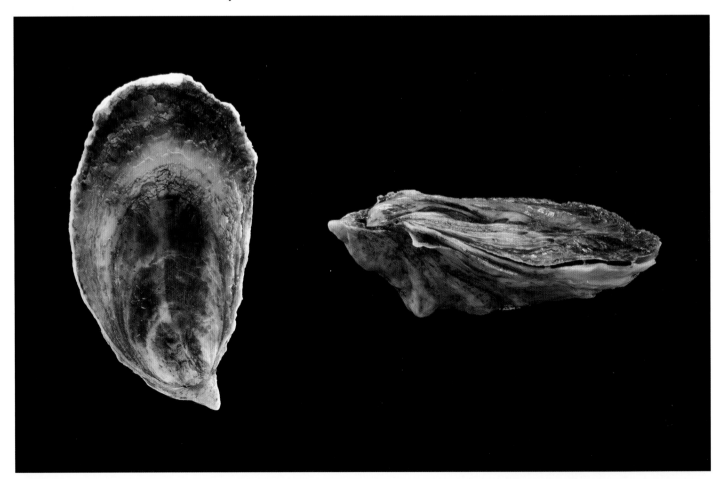

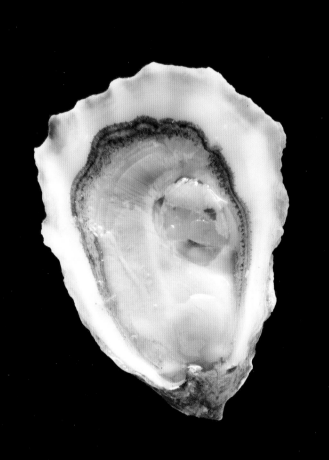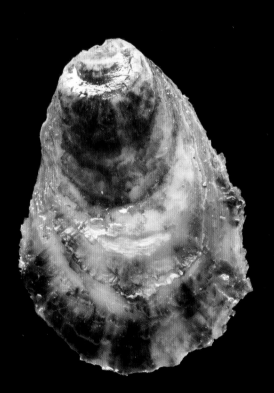

# CHATHAM

## Chatham, Massachusetts

Grower: Steve Wright

Chatham is on the elbow of Cape Cod, where they have been farming oysters on the same lease since 1976. Most Chathams are grown in the traditional rack and bag system on the Oyster Pond River. Others are bottom planted and harvested in the winter, so they can be available year-round. Chathams have a deep cup and a beautiful gray and green shell. They taste like a mouthful of ocean water to start and then turn slightly mossy.

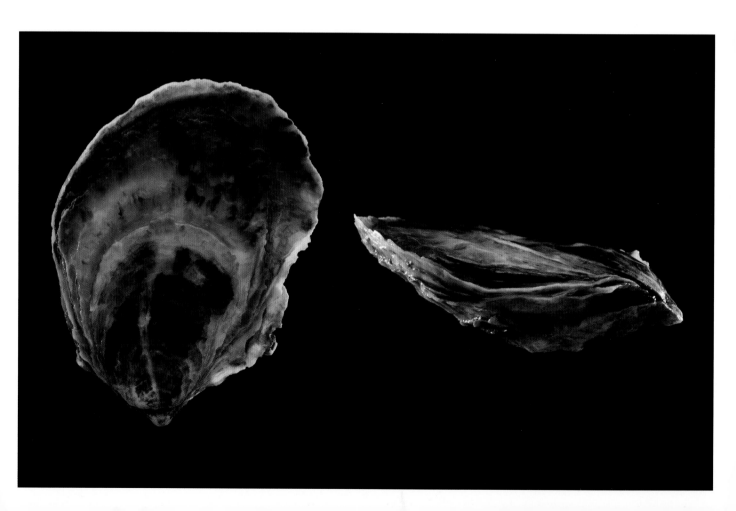

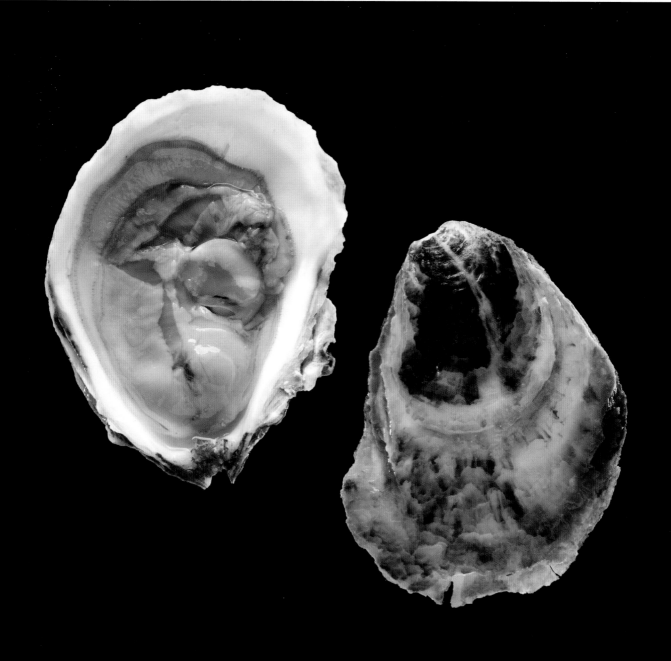

# CHILMARK

## Martha's Vineyard, Massachusetts

Grower: Broderick Family

The Brodericks have fished on Martha's Vineyard for several generations and raise Chilmarks in off-bottom cages on the west side of the island in Menemsha Pond. Production of Chilmarks is limited and most of these popular oysters stay on the island. Chilmarks have a thick shell that is full of meat—a perfect balance of seawater taste and succulent texture. By the end of the summer, they take on a more vegetal flavor.

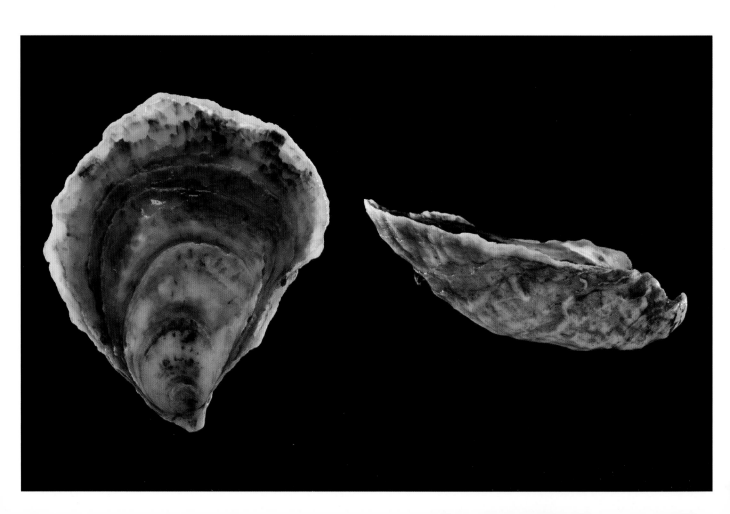

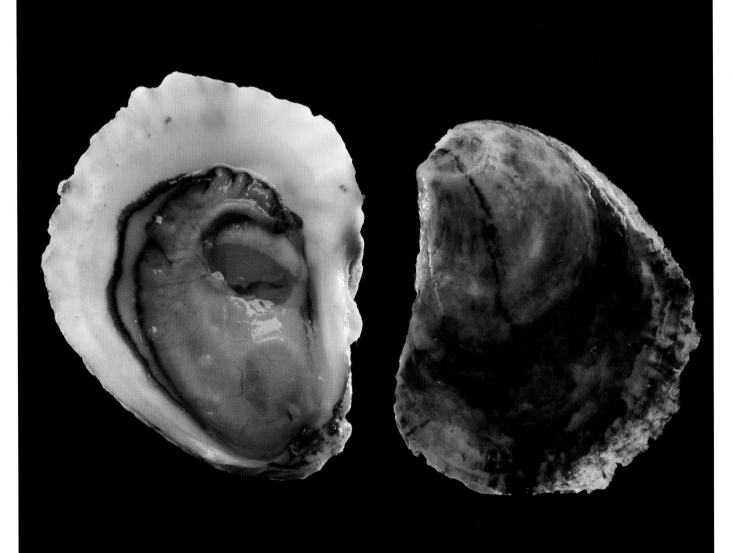

# FIRST ENCOUNTERS

## Eastham, Massachusetts

Growers: Bill Van Norman, Peter Burns,
and John Newman

Named after the local First Encounter Beach, these beauties have been cultivated since around 2010. First Encounters are grown in a traditional rack and bag method in an area that gets lots of wind and tide, which contributes to their tumbled look. The flavor of these oysters starts with a briny seaweed taste and resolves in a dry wine finish.

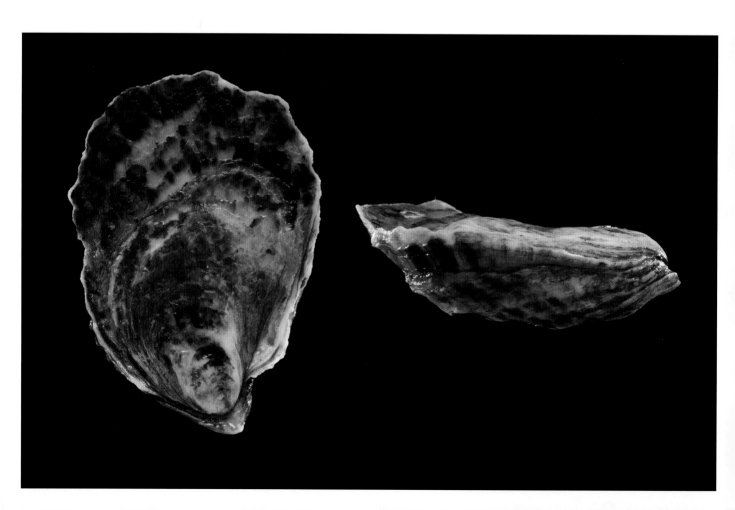

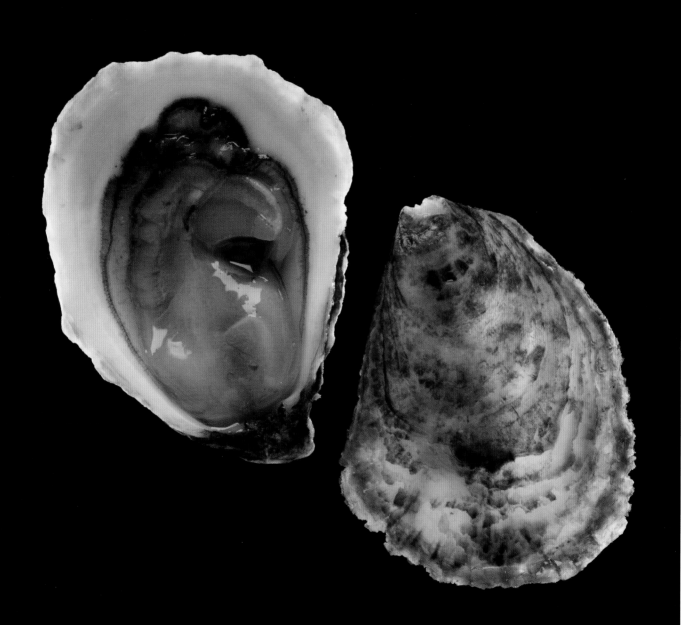

# FIRST LIGHT

## Mashpee, Massachusetts

Grower: Kris Clark, Mashpee Wampanoag Tribe

First Lights are grown in the Popponesset Bay on the south side of Cape Cod by members of the Wampanoag tribe, which has been a part of Mashpee, Massachusetts, before it was even called Mashpee. The bay is protected by a barrier beach and has little wind, but big tides. The First Light is a mild oyster with a creamy flavor. After the first taste, First Lights have a vegetal—almost celery—finish.

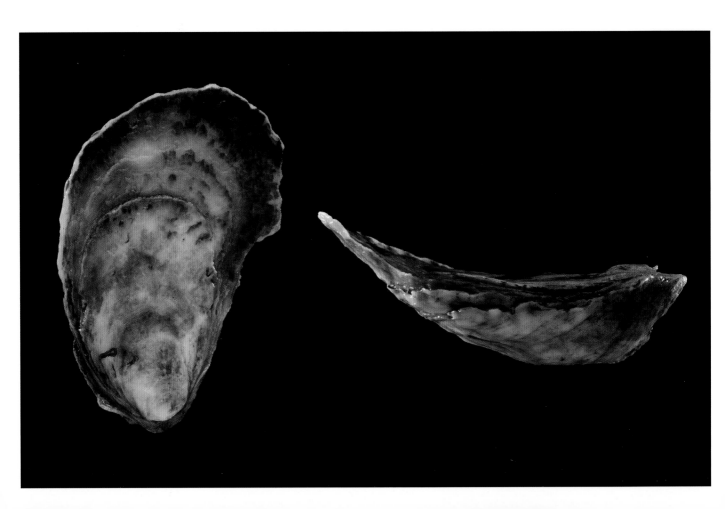

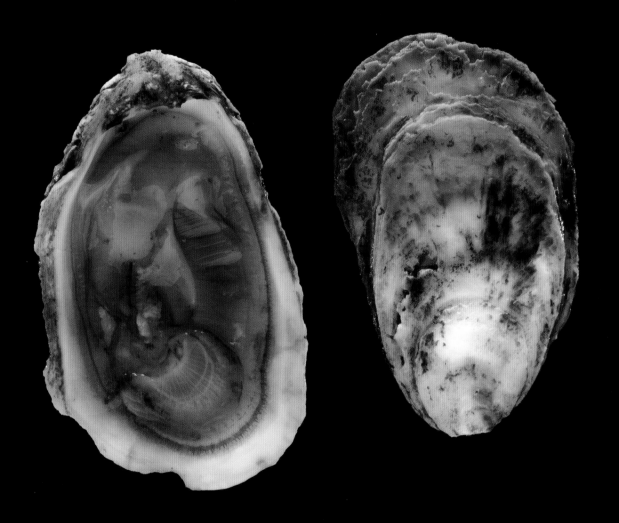

# HOWLAND'S LANDINGS

## Kingston Bay, Duxbury, Massachusetts

Grower: Bill Driver

Howland's Landings are small production oysters that are started in a rack and bag method and, after about a year, finished on a sandy bottom. All of these oysters are hand harvested by Bill himself. A very savory oyster to start, Howland's Landings become lightly briny, with a great mild, sweet finish.

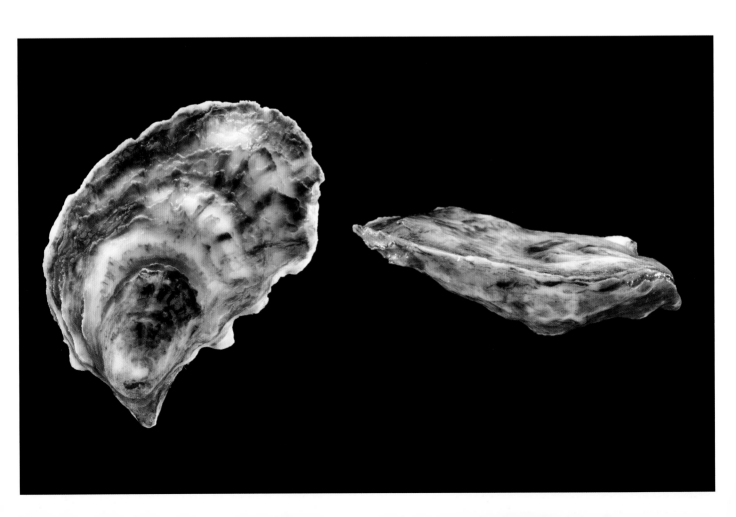

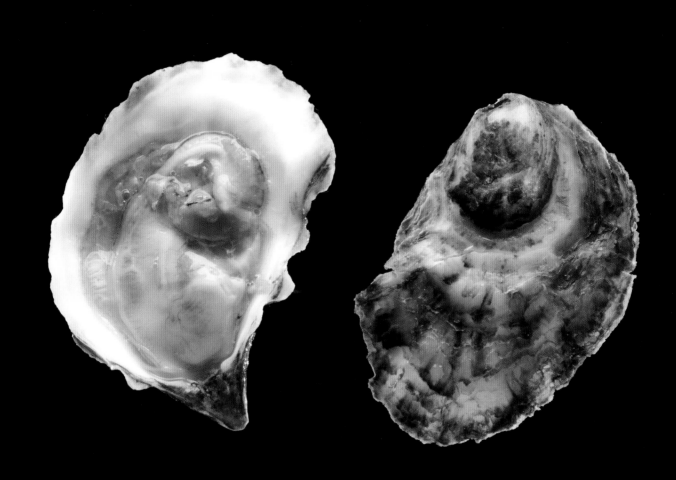

# ICHABOD FLATS
## Plymouth, Massachusetts

Growers: Don Wilkinson and Sean Withington

Ichabod Flats begin growing in mesh bags. When they are large enough, they are placed on the bottom of the Plymouth mudflats to finish their grow out. Each oyster is harvested by hand and beautifully shaped. Their taste is buttery and meaty, with a touch of seaweed flavor at the end.

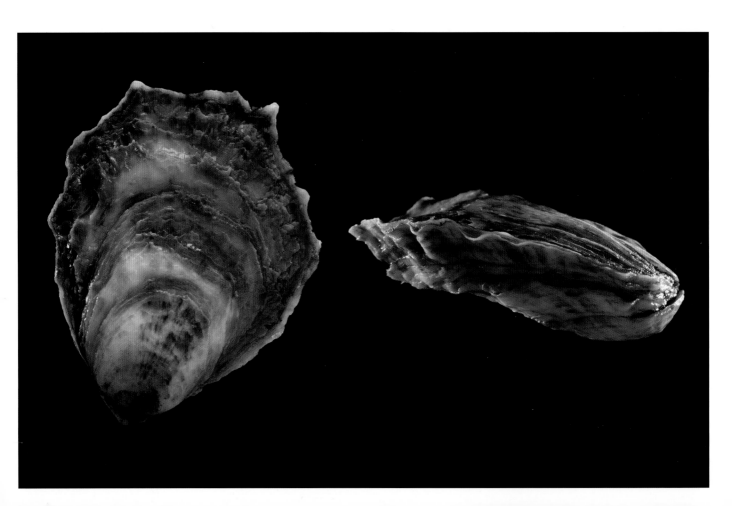

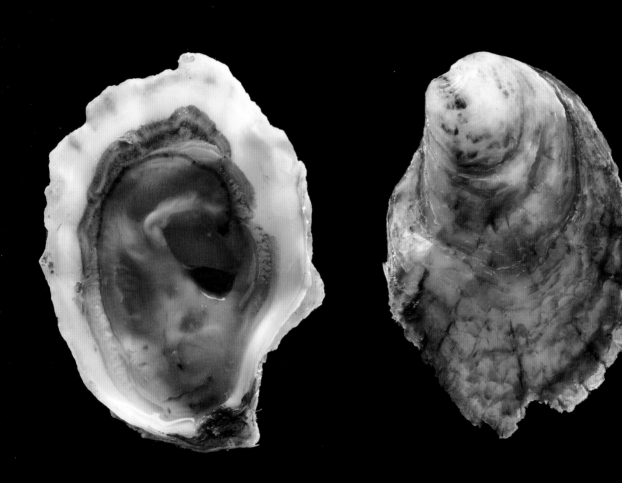

# ISLAND CREEKS
## Duxbury, Massachusetts

Grower: Skip Bennett

Island Creeks are Duxbury born and grown, beginning with Skip Bennett's hatchery in Duxbury. They spend three to four months in a floating upweller and then are bottom planted in Duxbury Bay where they grow for approximately eighteen months more. The Bay has huge tides and ideal water temperatures (rarely above seventy degrees) — perfect for growing oysters. Island Creeks have a unique flavor profile that ranges from briny to sweet. They start with a briny pop and move into vegetal notes in the middle.

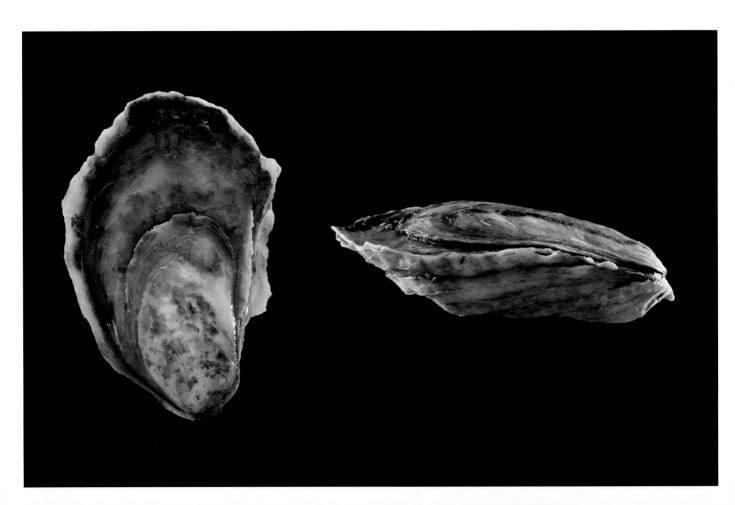

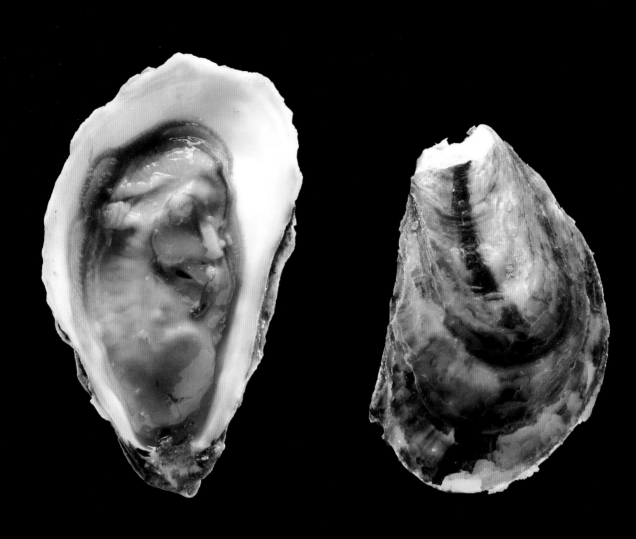

# MOON SHOAL

## Barnstable, Massachusetts

Grower: Jon Martin

These oysters are rack and bag grown until they are about two inches in length, and are then finished in large open trays that sit on the sandy bottom of Barnstable Harbor. A near perfect Cape Cod oyster, the Moon Shoal has a salty and buttery flavor.

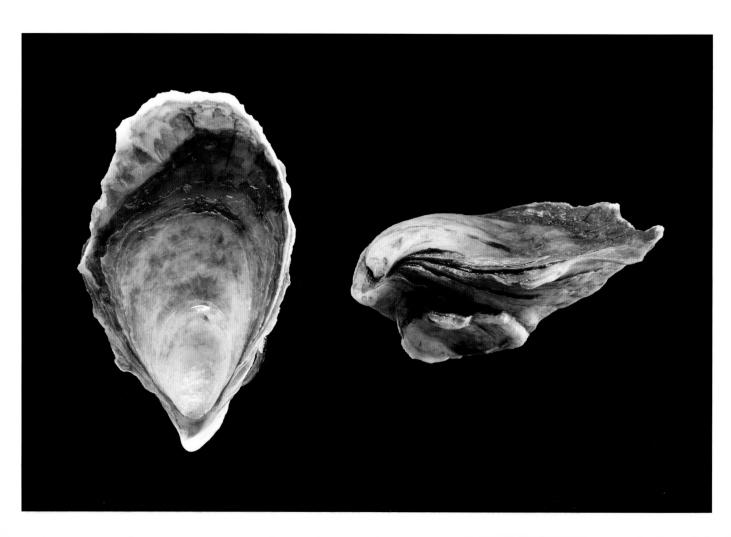

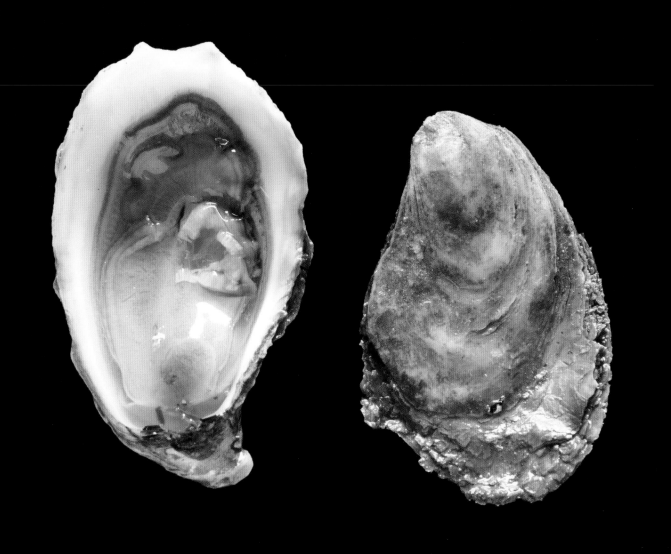

# NANTUCKET HARBOR
## Nantucket Island, Massachusetts

Grower: Simon Edwards

This island oyster takes between eighteen and thirty months to grow and is only available for about half of the year. Very few Nantucket Harbors leave New England. With a thick shell and plump meat, this oyster has a medium salt content and a sweet finish.

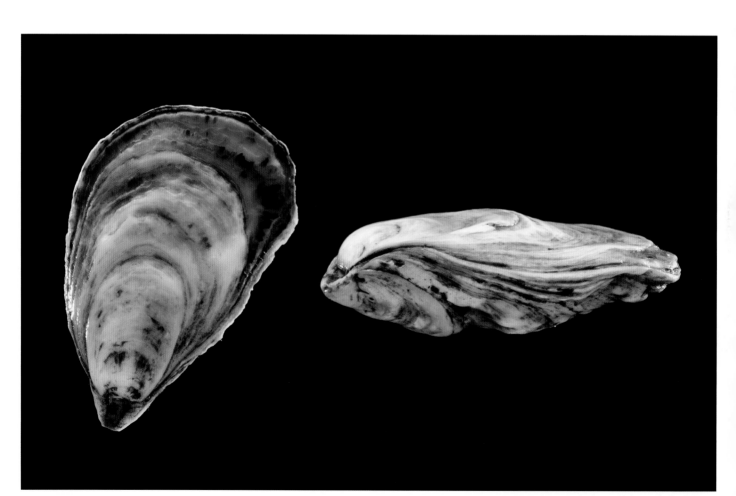

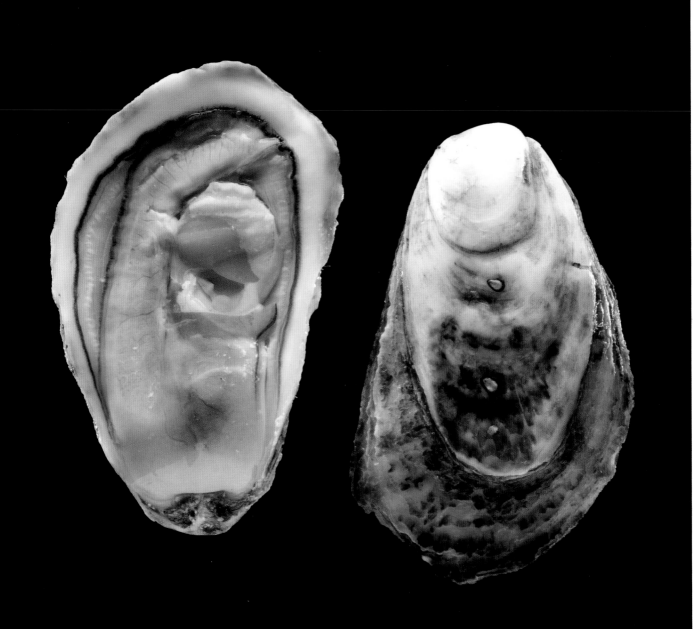

EAST COAST

# ONSETS

Wareham, Massachusetts

Growers: J. R. Nelson and G. M. Besse

Plump and juicy Onsets are rack and bag grown in Buzzards Bay, north of the Cape Cod Canal. They have a great shot of brine up front, with a well-balanced mineral finish.

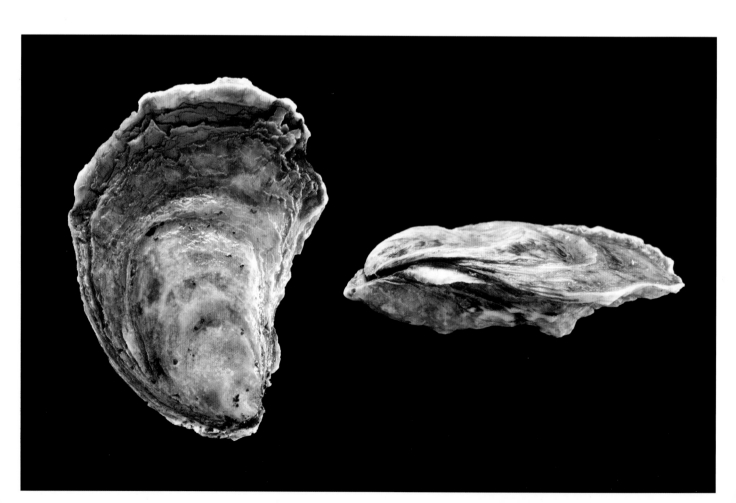

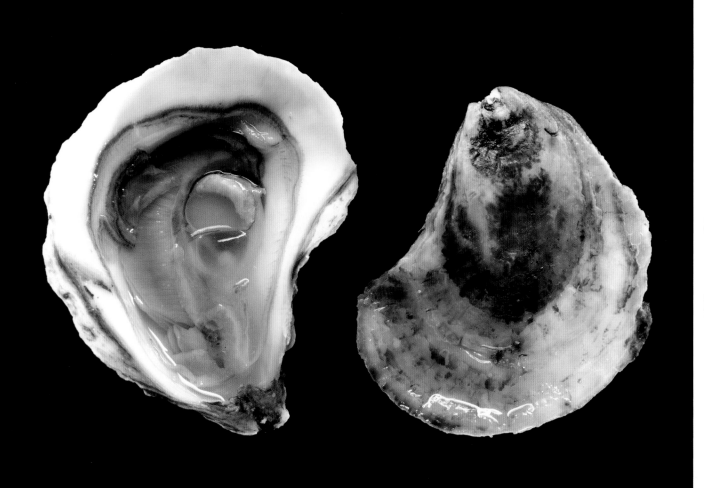

# PADANARAM

## South Dartmouth, Massachusetts

Grower: Steve Caravana

Steve Caravana, a longtime fisherman and lobsterman, is now growing the first oysters in Apponagansett Bay. Raised in floating cages near the surface of the nutrient-rich water, Padanarams are very fruit forward, with a mineral and salt finish.

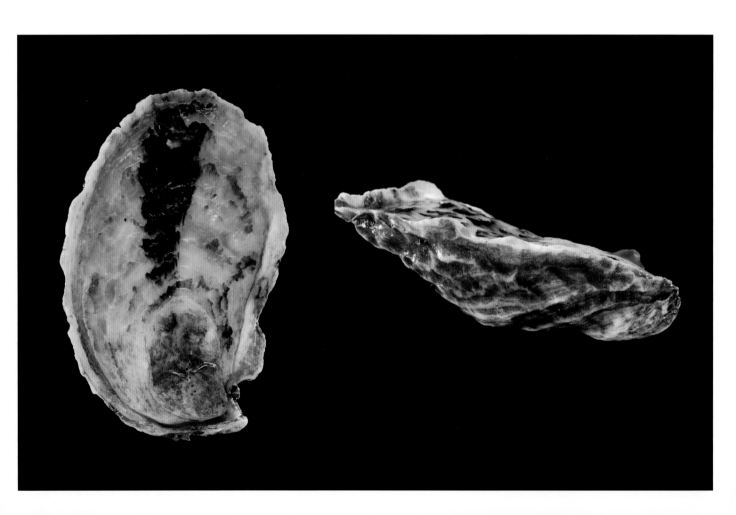

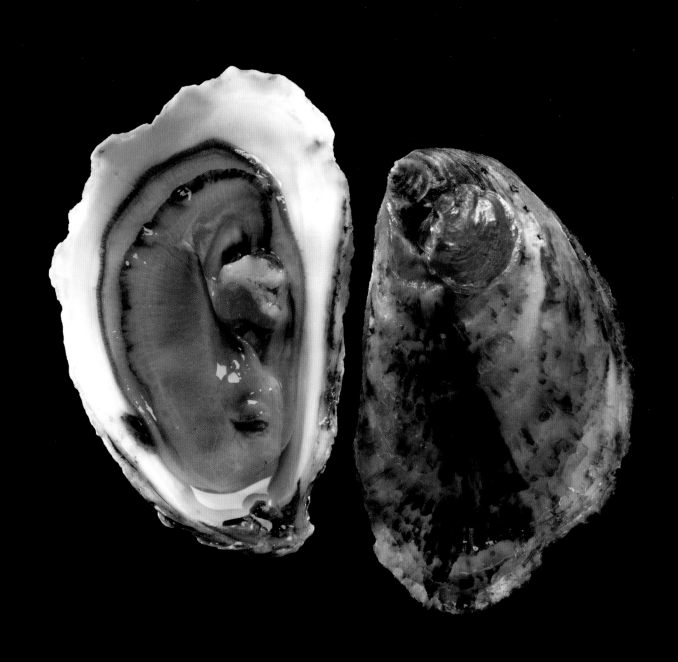

# PETER'S POINTS

## Onset, Massachusetts

Growers: Dennis Pittsley and Robert Tourigny

These green babies are bags to bottom planted in Fisherman's Cove, Massachusetts. Peter's Points are always under water from the Cape Cod Canal—never exposed to low tide—and harvested with a rake. Their beautiful green color comes from the heavy algae in the water where they are grown. Peter's Points have a nice briny flavor with a strong grassy finish.

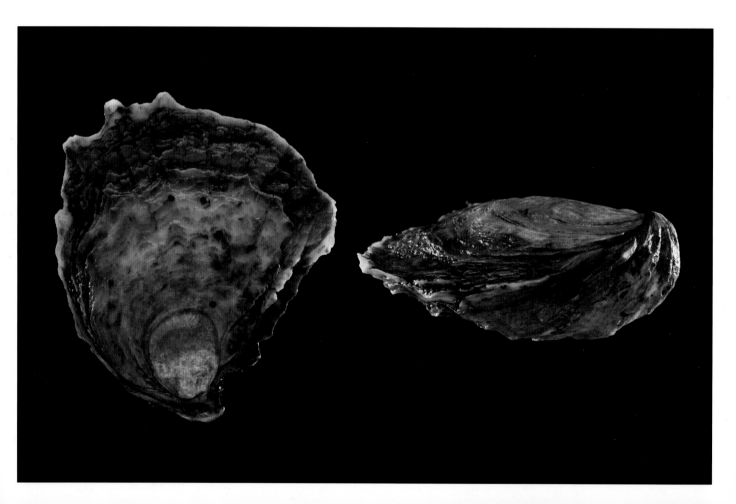

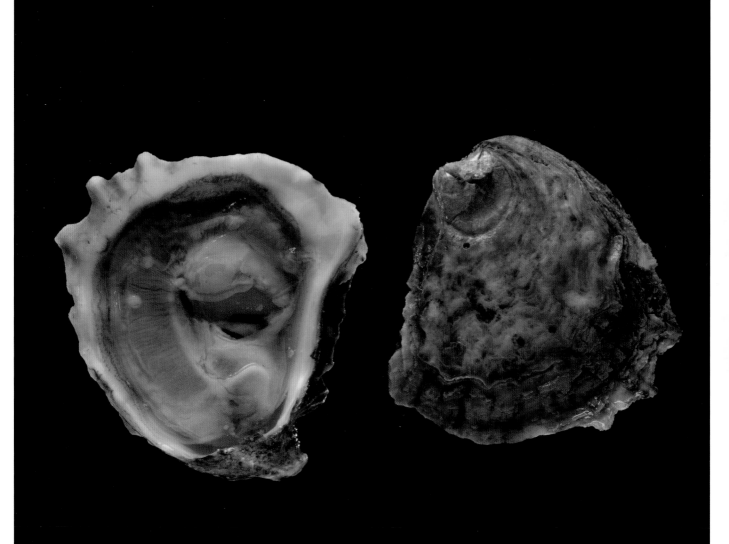

# PLEASANT BAY

## Orleans, Massachusetts

Grower: Peter and Jeff Orcutt

Pleasant Bays are grown on the outer part of Cape Cod, with heavy exposure to the Atlantic Ocean. They are grown with the rack and bag method, which produces a plump oyster with a heavy Atlantic salt flavor and a buttery finish.

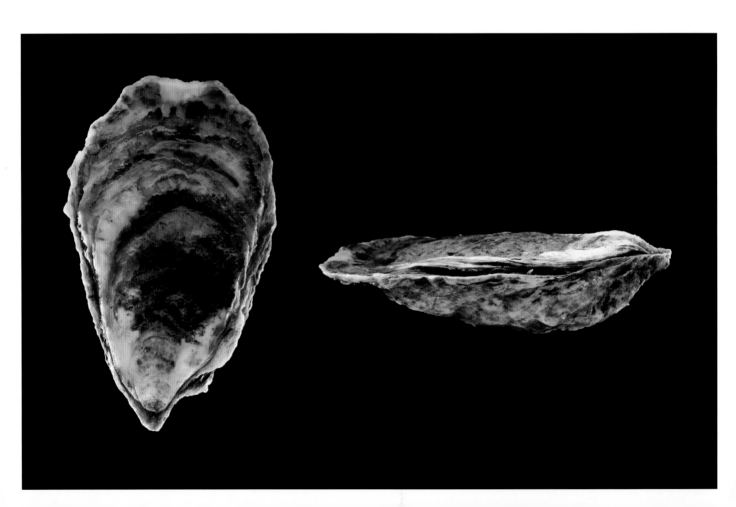

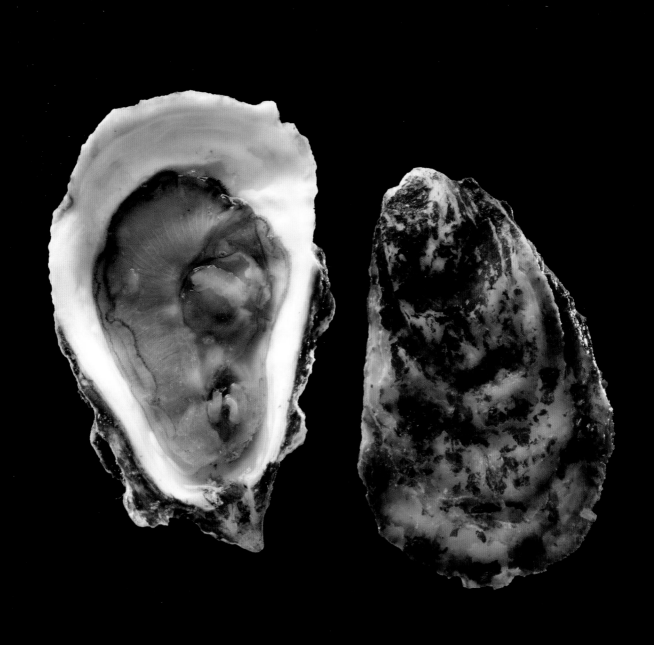

# ROCKY NOOKS
## Kingston, Massachusetts

Growers: Greg Barker and John Whebble

Rocky's are grown right next to Duxbury in Kingston Bay, which shares the great water temperature and big tides of its neighbor. The first crop of Rocky Nooks was planted in 2009 with seed from neighboring farmer Skip Bennett. Rocky Nooks are hand harvested and consistent in size and shape, with the shells full of meat. They have a briny and sweet start but end with a strong, earthy finish.

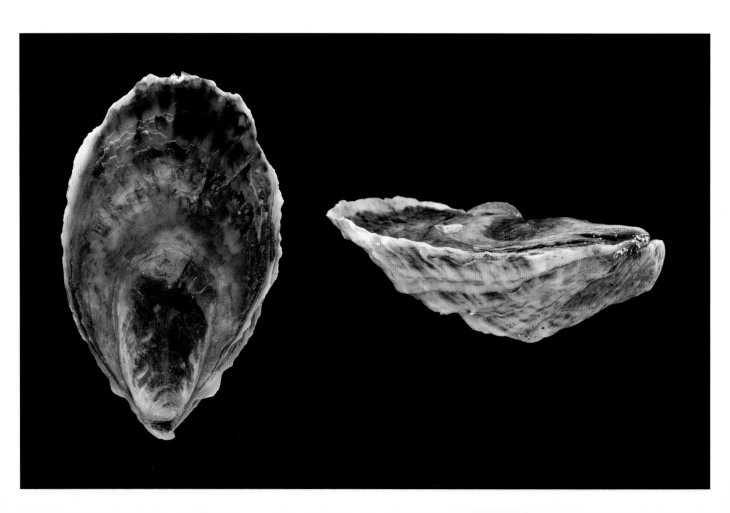

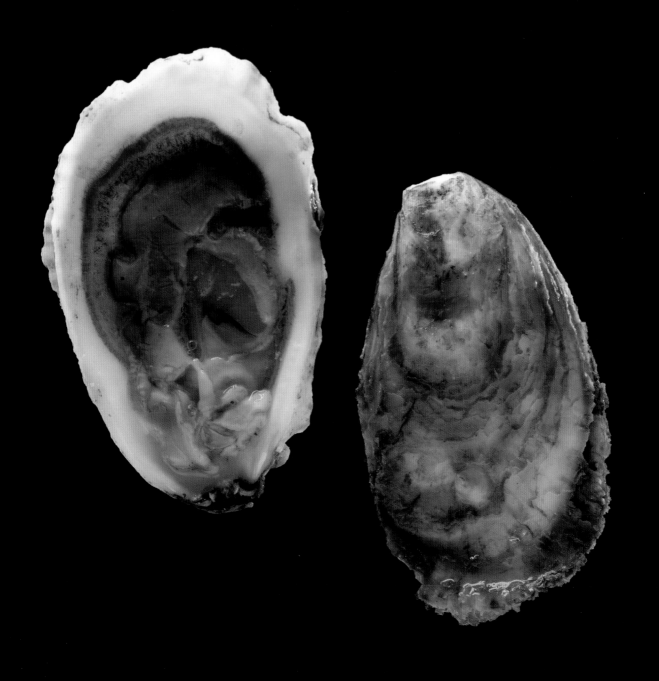

# ROW 34
## Duxbury, Massachusetts

Grower: Skip Bennett

Grown from Skip Bennett's own seed, Row 34s spend three to four months in an upweller before being placed in floating bags in the back river in Duxbury. They finish growing in trays that are stacked in threes in the area of Skip's farm that is closest to the mouth of the bay. Row 34s are rotated three times a week, to promote even growth. A very special oyster, the Row 34 is meaty with an earthy brine flavor—think mushrooms and chicken.

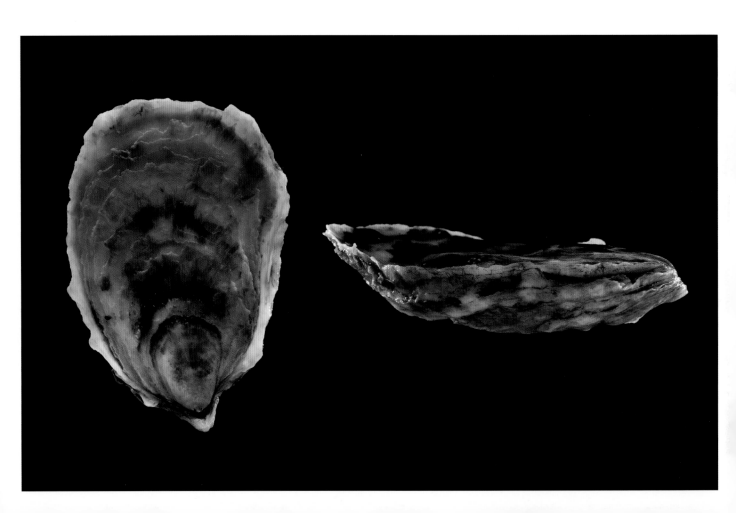

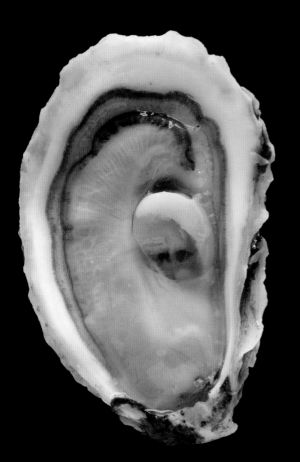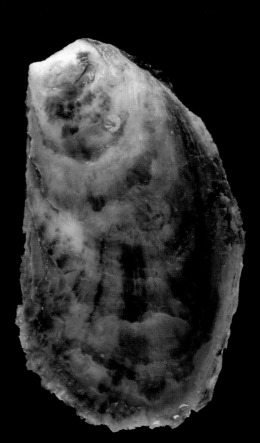

# SPRING CREEK

## Barnstable, Massachusetts

Growers: Scott and Tina Laurie

Spring Creeks are started two different ways—in wooden racks and in floating bags. Once Spring Creeks have grown large enough, they are transferred to trays above the mud on the bay's floor. The oysters have a deep, thick cup and a beautiful round shape from all the tumbling they experience. Their flavor is delicate and mild with a balanced sweetness.

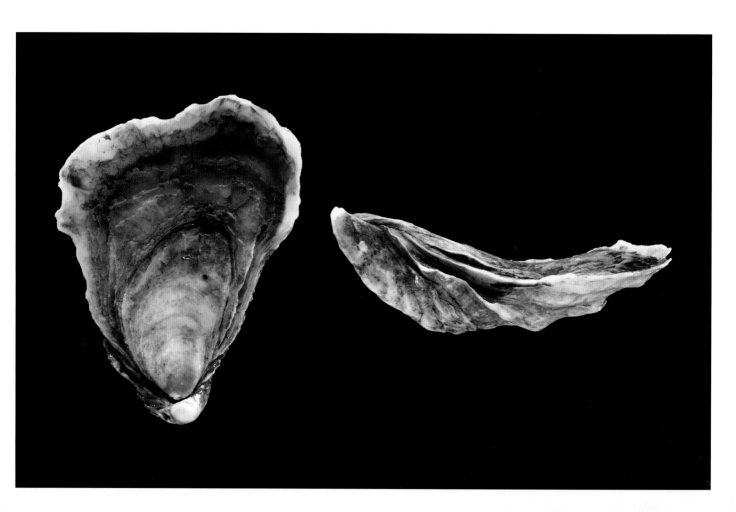

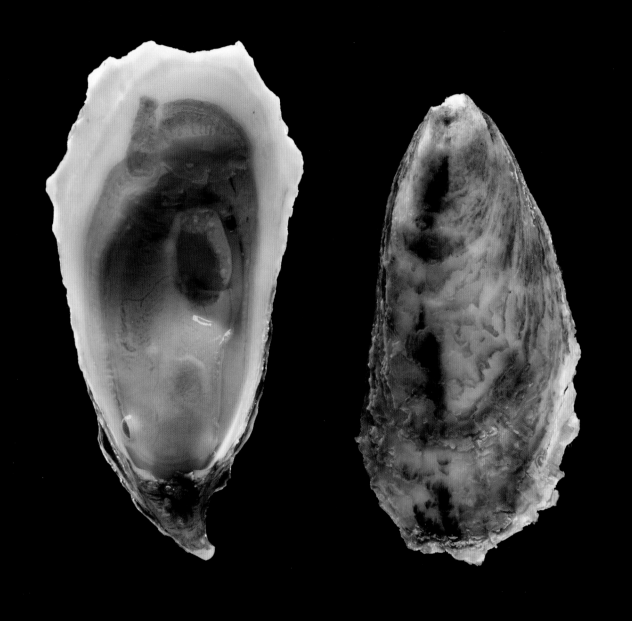

# SUNKEN MEADOW

## Eastham, Massachusetts

Growers: Russ Sandblom and daughter Mary Kate Paravisini

Eastham is just south of Wellfleet, Massachusetts. Sunken Meadows are grown in a shallow, pristine area near the waters of the Massachusetts Audubon's Wildlife Sanctuary. Cultivated in bags off the bottom, these oysters get lots of wave action and frequent tumbling that result in a smooth shell. The flavor of Sunken Meadows is straight-up meaty—strong, with a salty chicken broth taste up front and a lingering umami note toward the end.

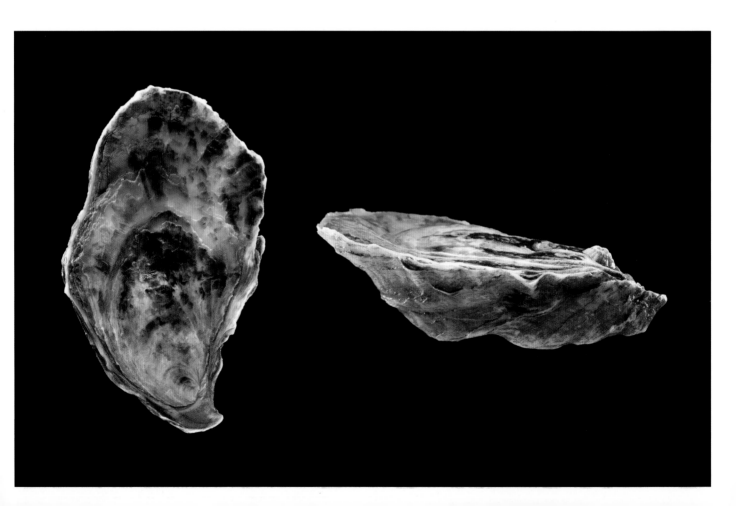

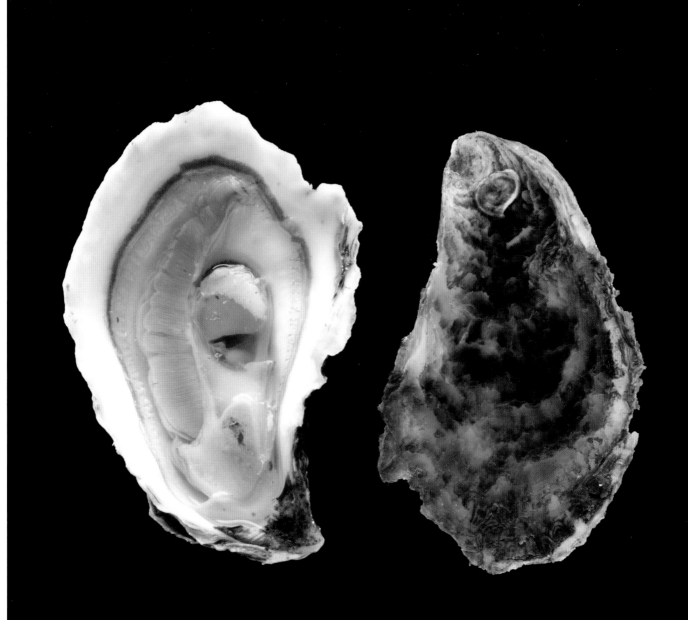

# THATCH ISLAND

## Barnstable, Massachusetts

Grower: Chuck Westfall

Thatch Islands are rack and bag grown, which results in a great cup shape. They start with a mildly briny flavor and end with a touch of bitter sweetness, similar to mustard greens.

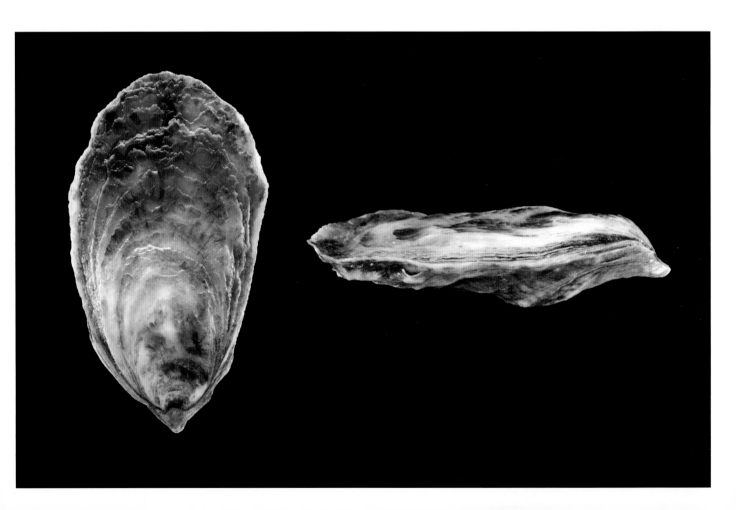

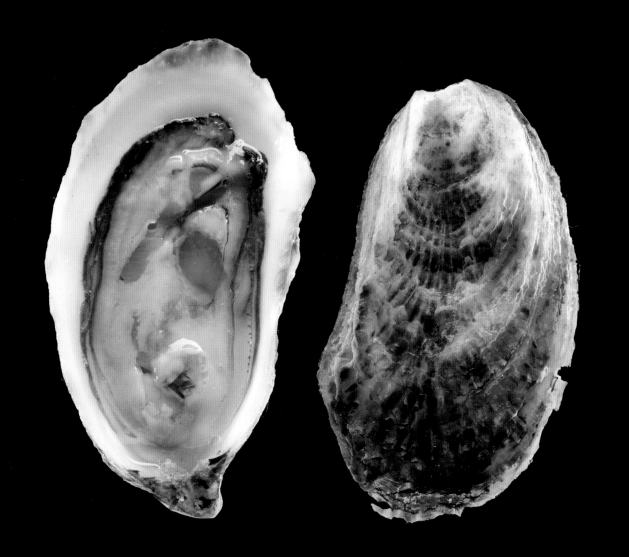

# WELLFLEET

## Wellfleet, Massachusetts

Grower: William "Chopper" Young

Wellfleet is as famous for its oysters as anywhere in the world. The harbor is composed of almost two hundred acres of oyster beds where farmed and wild oysters grow. The warm summer weather and big tides help create the wild population, which has been collected by locals for decades. Wellfleets are famous for their salty flavor, but this salinity gives way to a minerally, clean finish. The plump, firm meat and great taste easily make Wellfleets one of the best-known oysters on the planet.

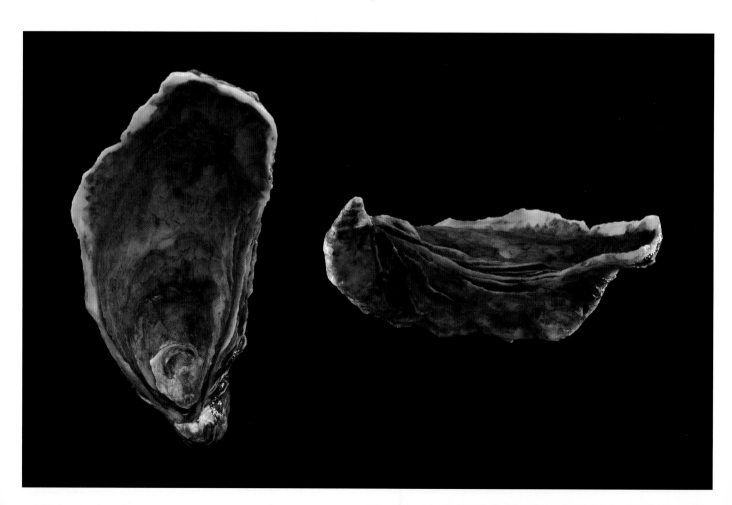

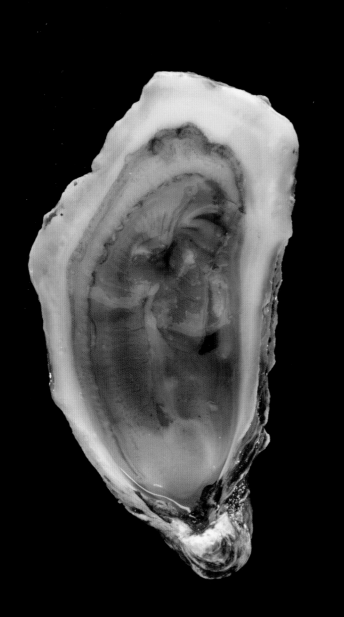
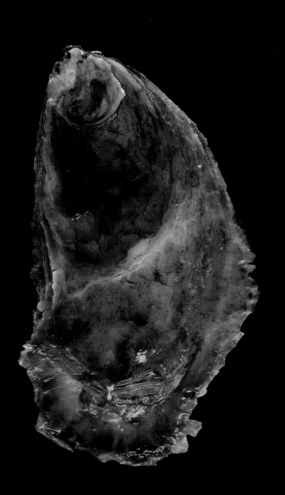

# JONATHAN ISLAND PEARLY WHITES

## Narragansett, Rhode Island

Growers: Ben and Diane Franford

Jonathan Island Pearly Whites are grown in floating bags. The shells of these oysters are entirely full of liquor and meat. Their flavor is high in salt and minerality, with spinach notes.

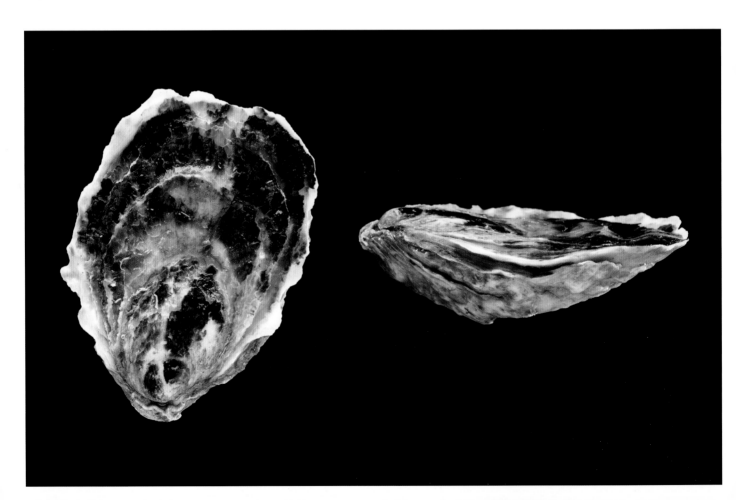

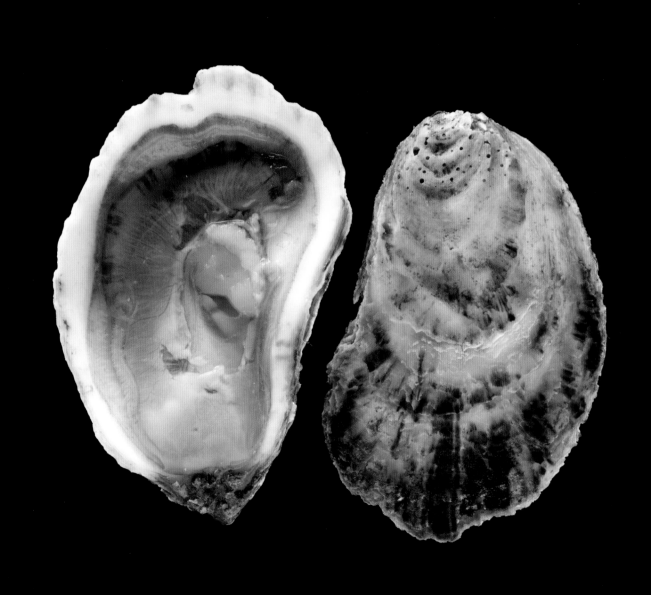

EAST COAST

# MOONSTONES
## Point Judith Pond, Rhode Island

Growers: John and Cindy West

Moonstones are rack and bag grown in Point Judith Pond near Narragansett Bay, Rhode Island. They have a beautiful striped shell and are moderately briny with a great mineral taste—a little like ocean stone flavor.

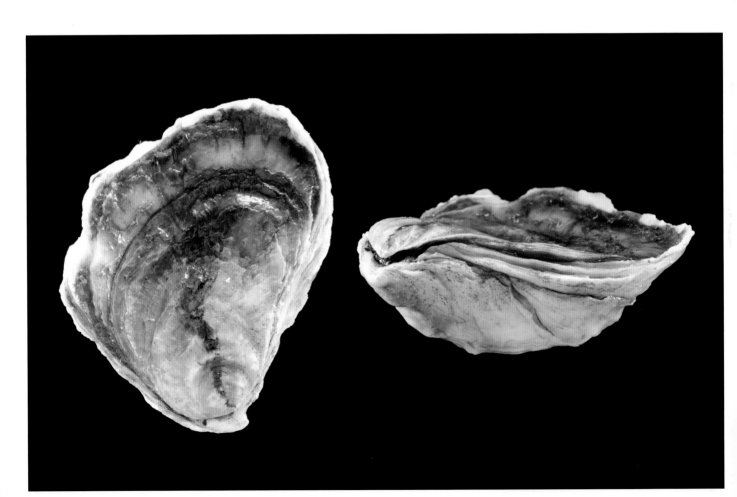

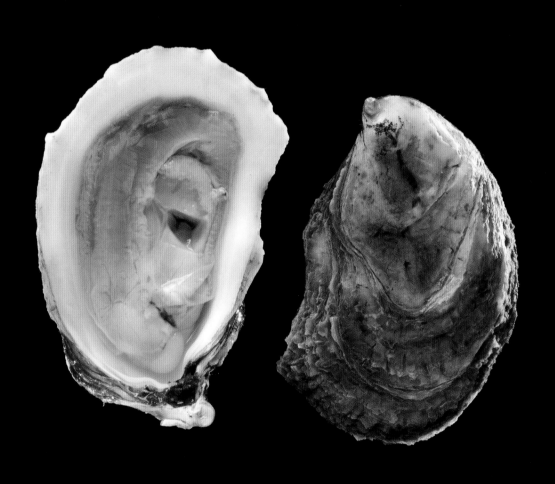

# QUONNIE ROCK
## Charlestown, Rhode Island

Grower: Jim Arnoux

Quonnies are started in a floating cage nursery, then moved to trays, and finished on the bottom of Quonochontaug Pond. They have a typical Rhode Island salt pond oyster flavor, starting creamy and ending with a salty finish.

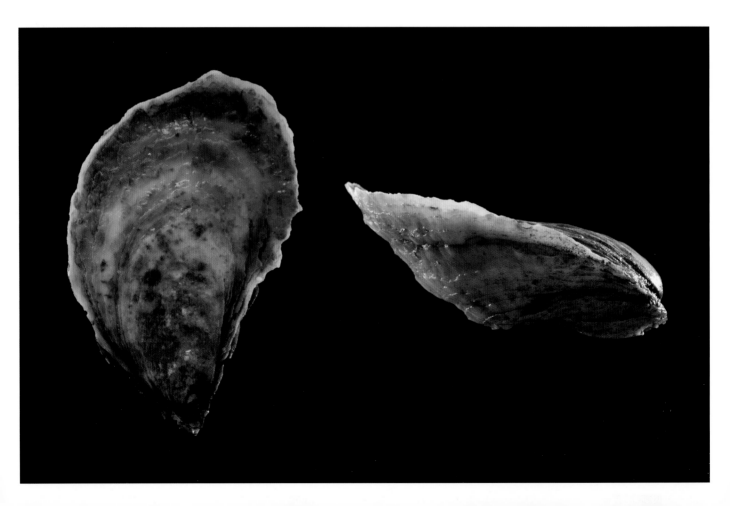

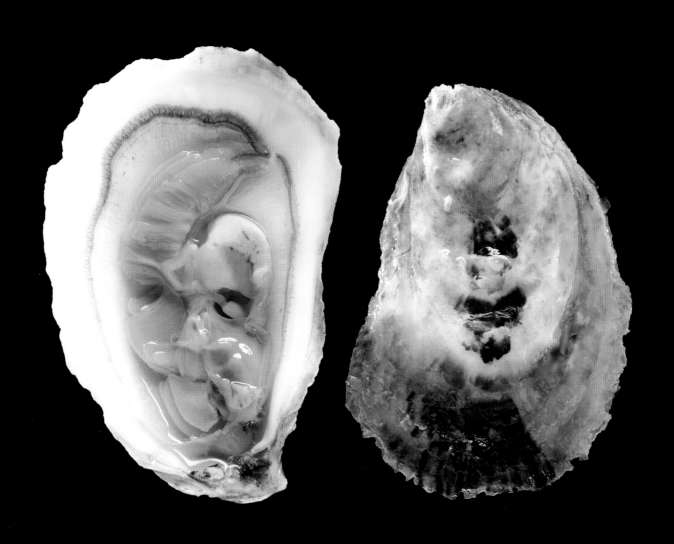

# CONNECTICUT BLUE POINTS

## Long Island Sound and Connecticut

Grower: Wild oysters, cultivated by Norm Bloom

After spawning, Connecticut Blue Points are distributed in a well-groomed oyster nursery bed, where they remain for ten months. When they are the size of a dime, they are transferred to either the shallows off coastal Connecticut or the deep recesses of Long Island Sound. The oysters are rotated between the two locations until they are three and a half inches in size. Connecticut Blue Points are round and meaty with mild salinity—a straightforward oyster without much complexity.

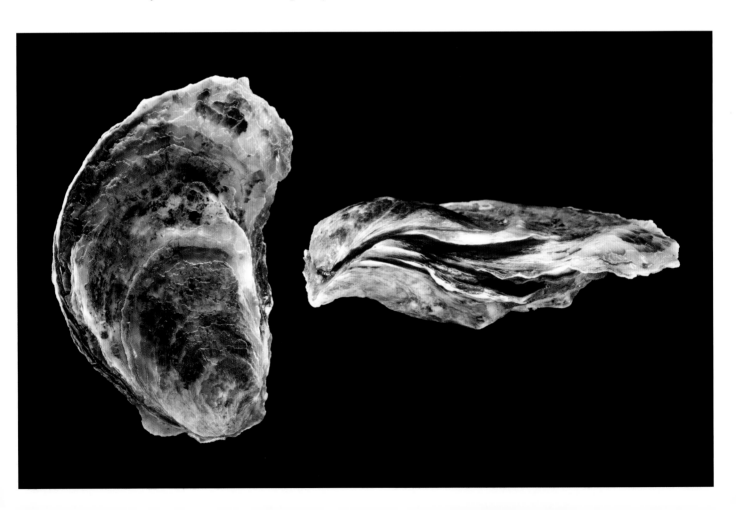

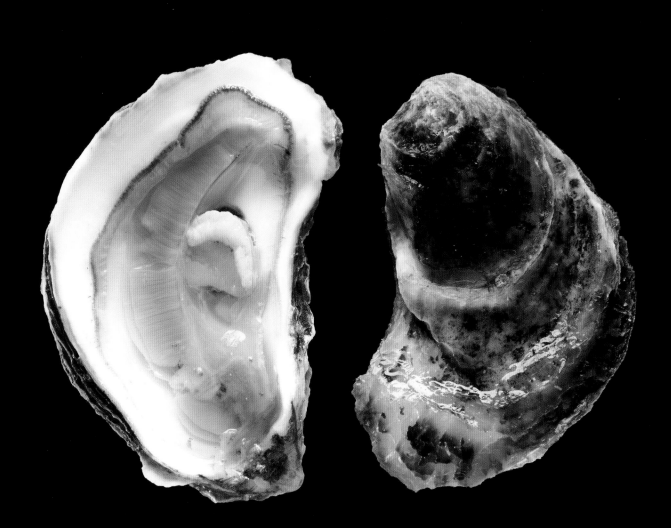

# COPPS ISLAND
## Norwalk, Connecticut

Grower: Norm Bloom and Family

The Bloom family has been harvesting oysters and other sea life in the same area since the 1940s. Copps Islands are grown from wild seed that is captured on empty oyster shells in the Long Island Sound. They are harvested with a dredge on a large boat, then transferred to a smaller boat and brought into a chilled room, where they are cleaned and sorted. Copps Islands have low salinity and are rich with mineral notes. They are flavorful with a great firm texture.

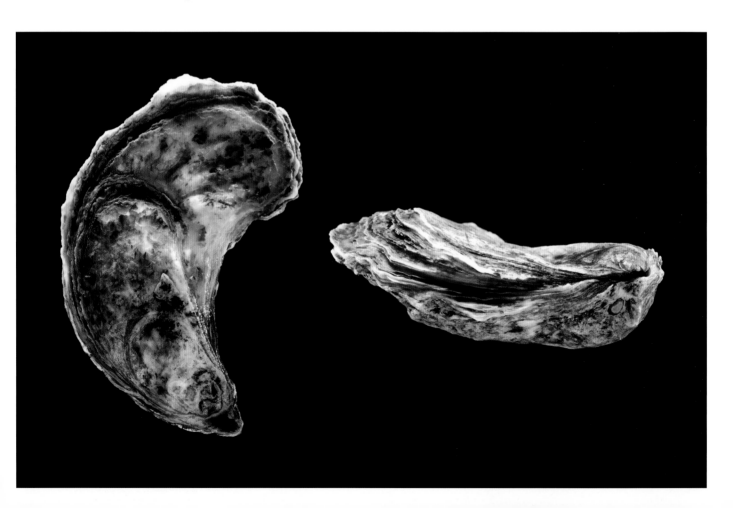

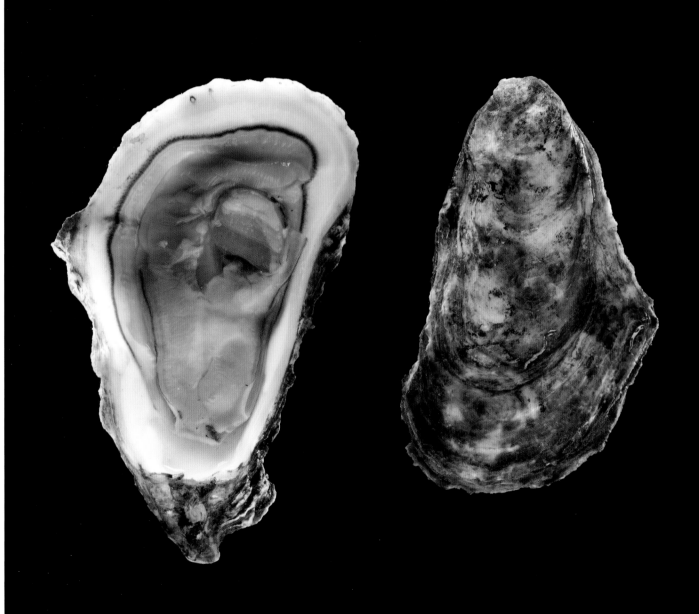

# DIAMOND JIMS

## North Fork, Long Island, New York

Grower: Ted Bucci

Diamond Jims are grown in upwellers and hanging cages, where they experience the benefit of having water constantly pumped around them. Raised in Southold Bay on the east end of Long Island, Diamond Jims have a three-year grow out, are thick shelled, and have a big salt blast up front, with a chicken broth flavor that lingers. They are named after wealthy businessman and legendary oyster lover Diamond Jim Brady.

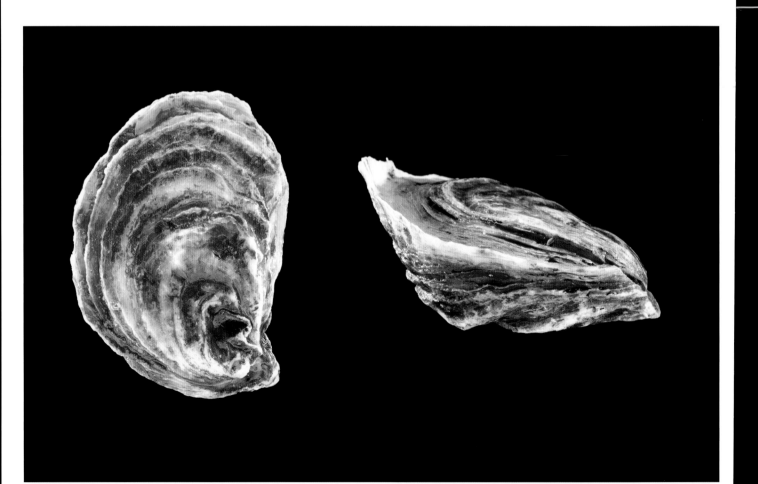

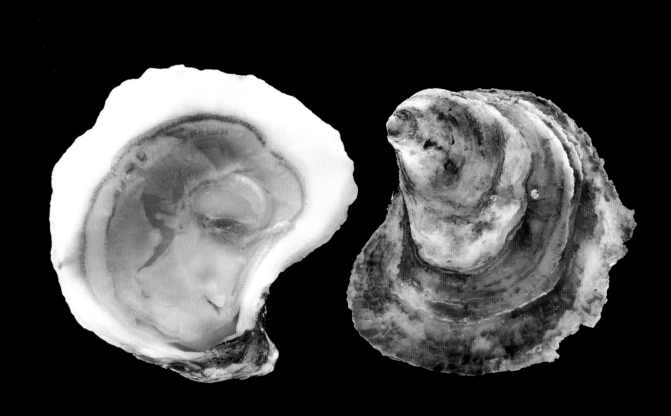

## PECONIC GOLDS
Peconic Bay, Long Island, New York

Grower: Matt Ketcham

Peconic Golds are cage grown underwater, even at low tide. Their beautiful gold shells come from all the algae and minerals in the water of the Long Island Sound's Peconic Bay. They have a salty seaweed flavor with a lingering hint of mineral.

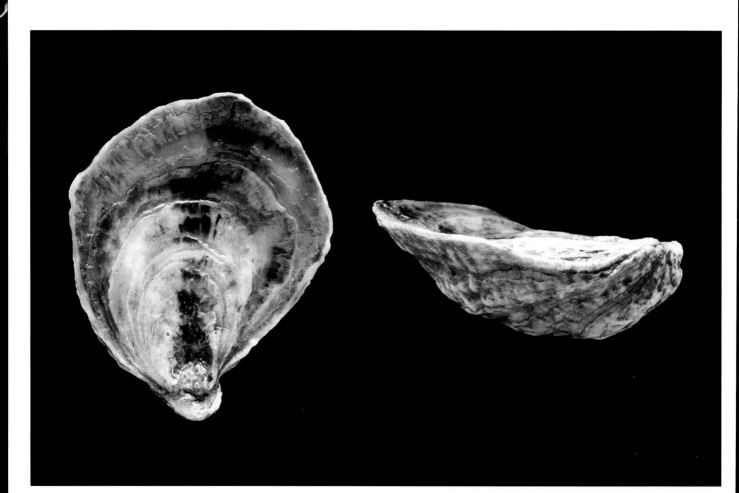

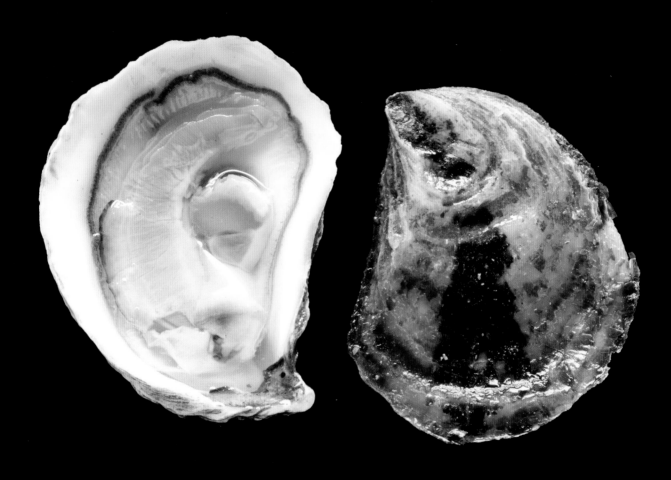

# CHINCOTEAGUE

## Chincoteague, Virginia

Grower: Mike McGee

Chincoteagues are grown near the Assateague National Park in the Chesapeake, where they have exposure to freshwater. They are a skinny, long oyster that tastes like a sip of seawater—big salt with a quick finish.

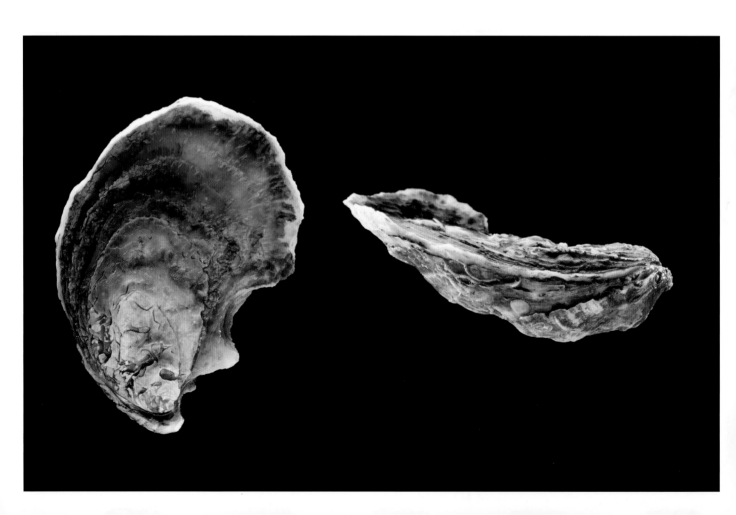

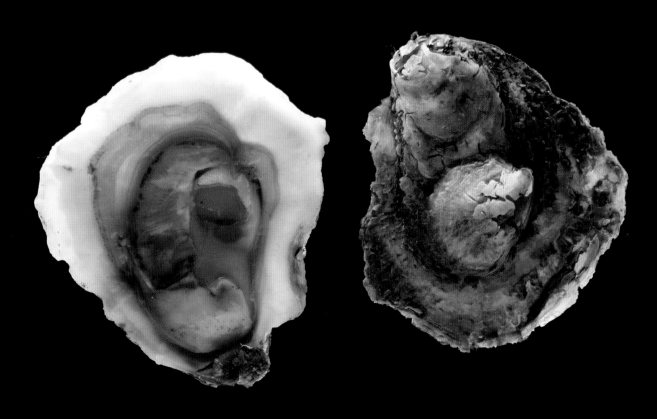

# MISTY POINT
## Smith Island, Virginia

Grower: Chad Ballard

Misty Points are grown in trays on the bottom of Virginia's Pope's Bay and tumbled to give them a good cup. This variety of Virginia oyster has a great salt blast with a celery and grassy finish.

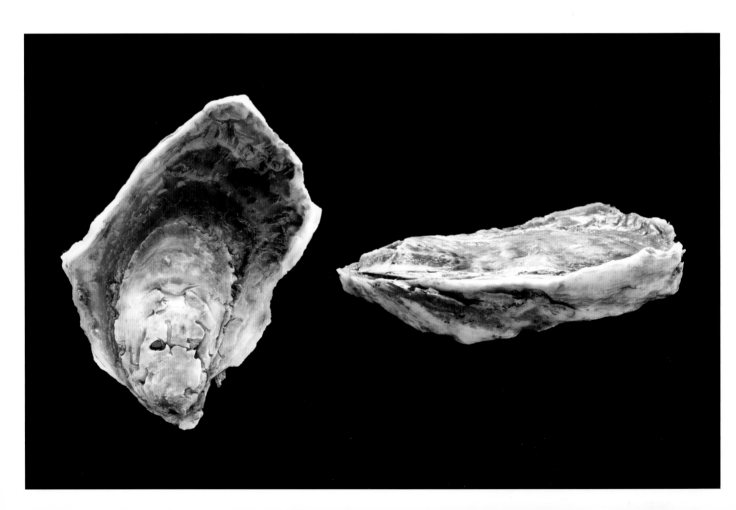

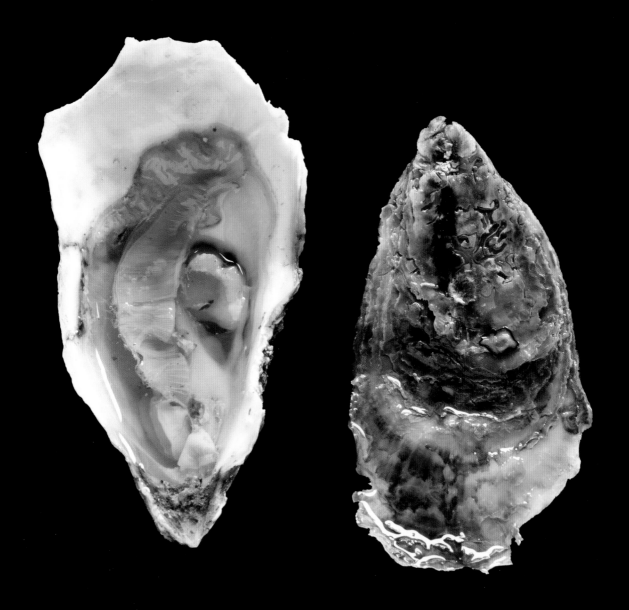

# NORTHERN CROSS

Fisherman's Island, Virginia

Grower: Tim Rapine

Northern Crosses—bred from Island Creek and Virginia oysters—are a project of Island Creek and Chincoteague Oysters and truly unique. They start growing with a rack and bag method and then are bottom planted. When they reach maturity, the oysters are moved to the shore of the Virginia National Wildlife Refuge and finished in the cold, salty water. Northern Crosses have a strong vegetal flavor up front—almost like spinach—and then a great bread-like quality with strong salt on the finish, not typical for a Virginia oyster.

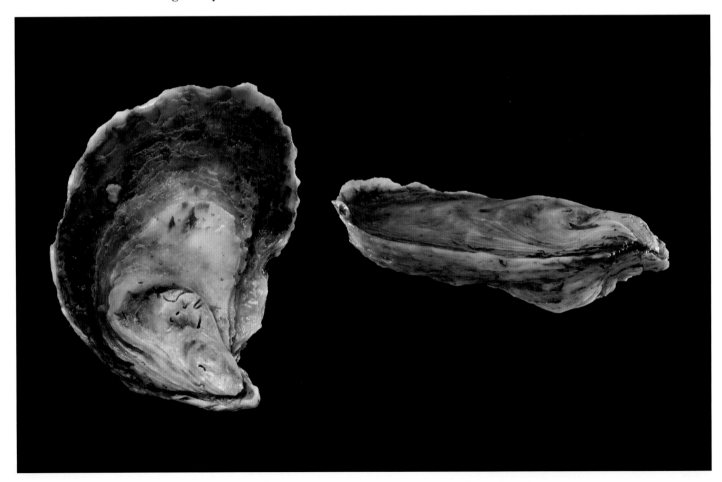

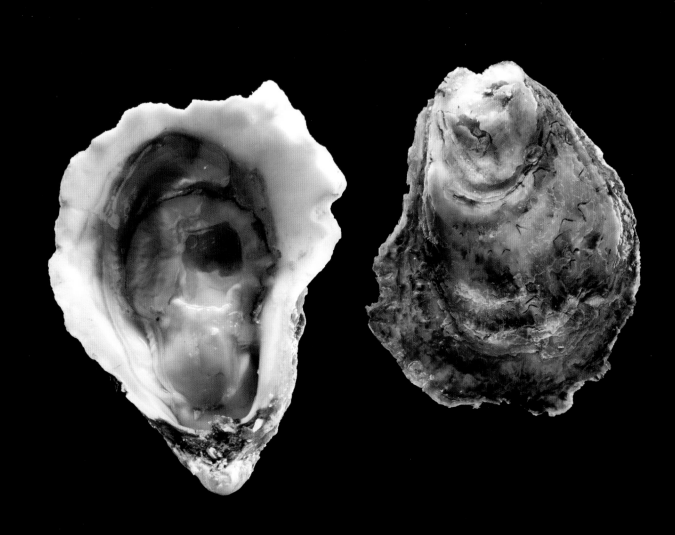

# HALF MOON SELECTS
## Half Moon Bay, Georgia

Grower: John Pelli

Half Moon Selects are small, beautifully grown Georgia oysters that have big flavor. The well-cupped shell is full of meat, and the oyster tastes like a flash of seawater with a vegetal finish.

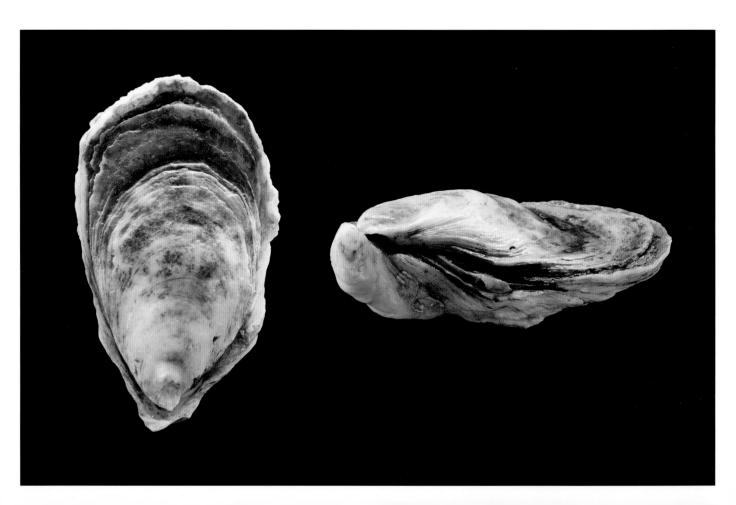

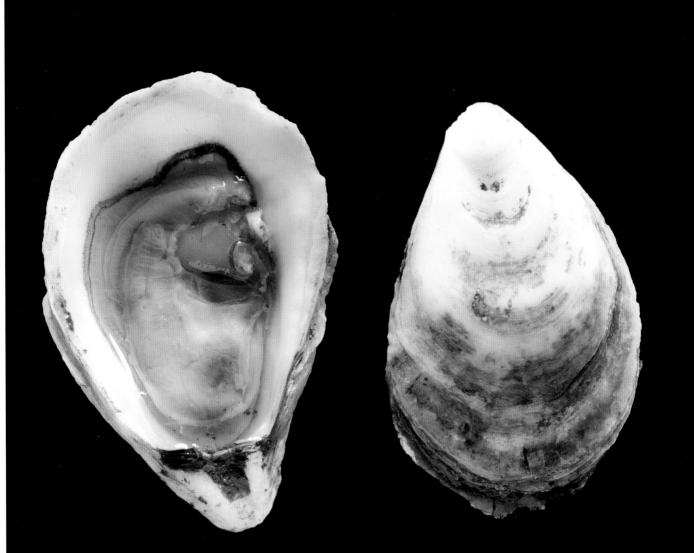

GULF COAST

# PELICAN REEF
## Cedar Key, Florida

Grower: Davis Family

Pelican Reefs are tray raised on the Gulf side of Florida. They are similar in appearance to Cape oysters—plump and full shelled. Their salinity is modest and the finish is sweet.

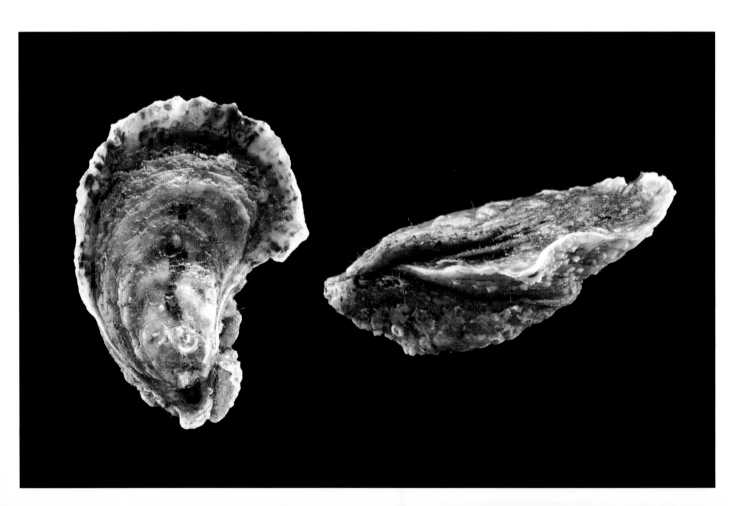

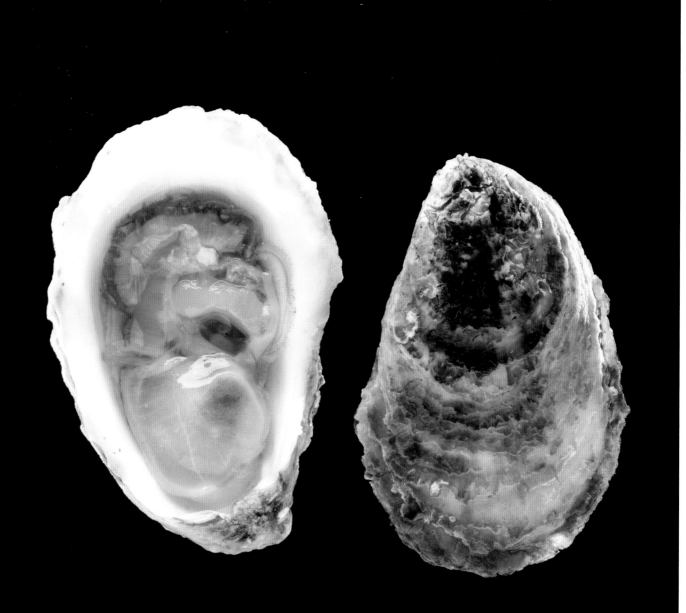

# MASSACRE ISLAND
## Dauphin Island, Alabama

Grower: Myers Family

Massacres are grown in cages off of the bottom on the west end of Dauphin Island, in the waters of the Mississippi Sound. They are a beautifully shaped, medium-sized oyster that has a sweet and briny flavor that is easy to like. Massacre Islands are a well-rounded, approachable Gulf oyster.

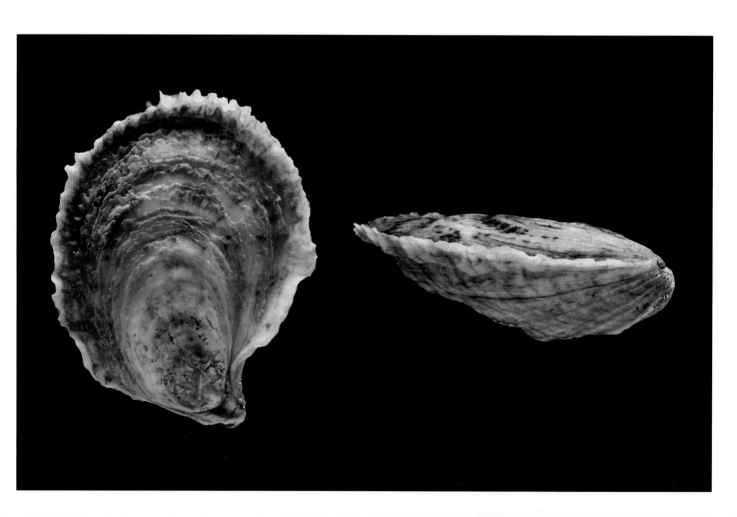

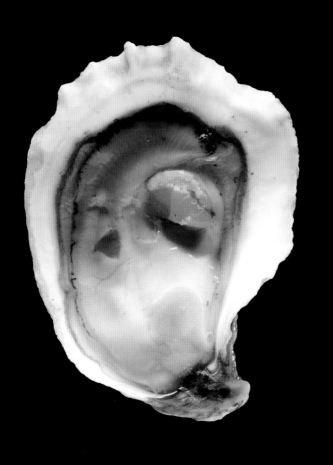
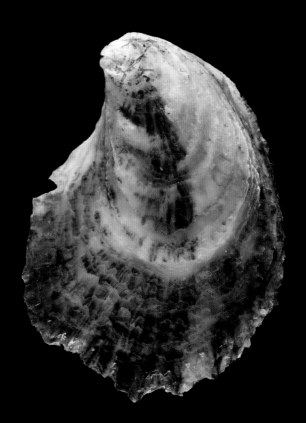

# MURDER POINT OYSTERS

## Bayou La Batre, Alabama

Grower: Zirlott Family

Murder Point is a family-run farm that has been catching shrimp and fish in the area for generations. Their Murder Points are grown in the Gulf of Mexico from *virginica* seed using the long line farming method. Murder Points have a thick shell and plump meat; they provide a rich metallic taste with a buttery finish.

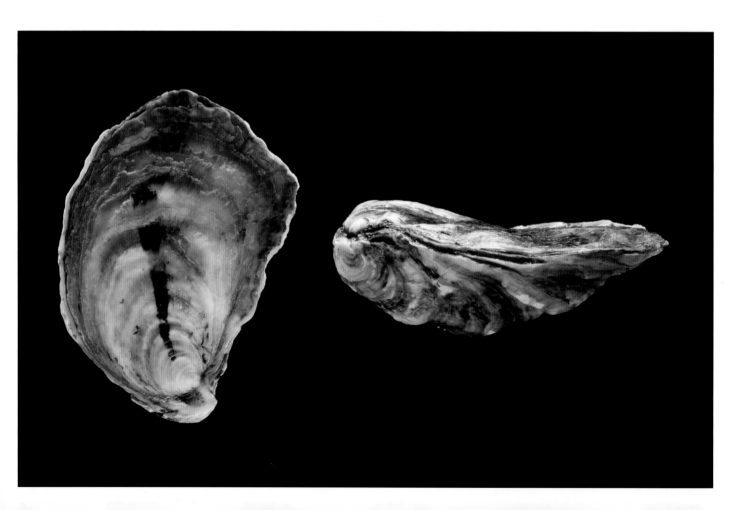

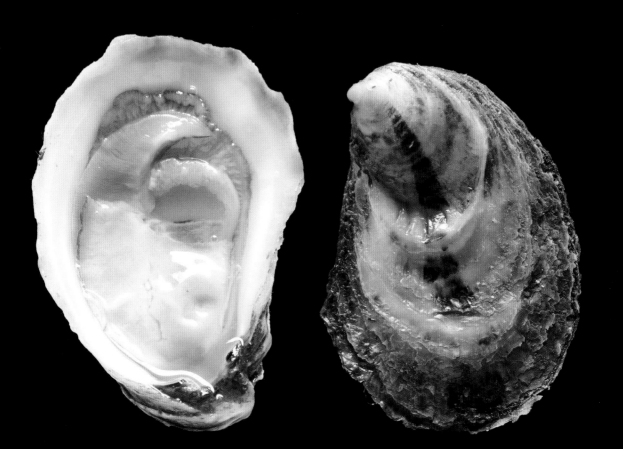

# GIGAMOTO

## British Columbia, Canada

Grower: Cat Haddon

Gigamotos are smaller Pacific oysters that are beach grown. They are frequently tumbled, resulting in a nice cup, and each oyster is hand harvested. Gigamotos have a moderate briny flavor and a sweet seaweed finish.

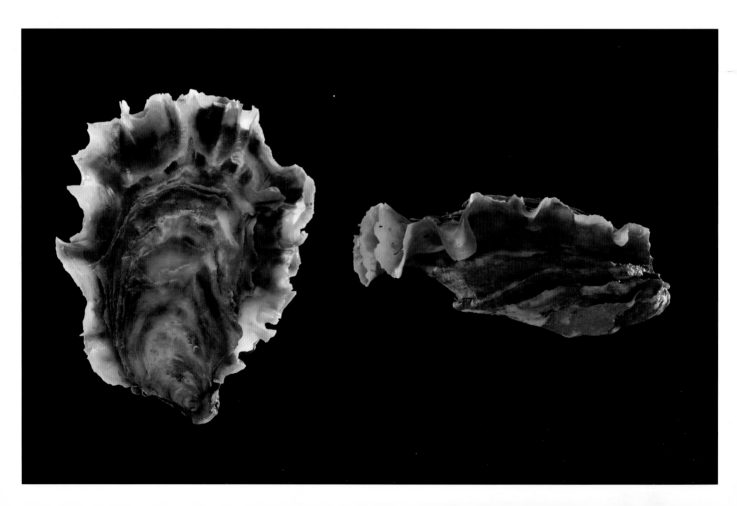

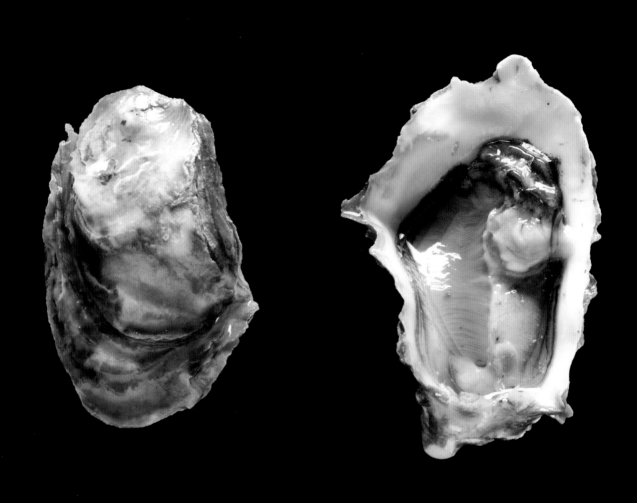

WEST COAST

# KUSSHI

## Vancouver Island, British Columbia

Grower: Keith Reid

*Kusshi* is the Japanese word for "precious grown." Kusshi oysters are grown in floating trays in Deep Bay, British Columbia. The oysters are also tumbled, resulting in very deep cups and beautifully colored shells that are full of meat. Kusshis are one of the most attractive oysters for presentation, and they are delicious to eat—mildly briny, like lightly salted melon.

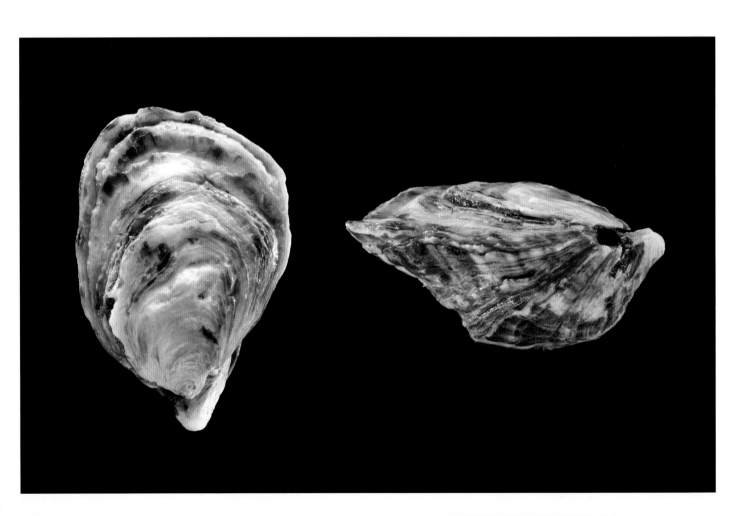

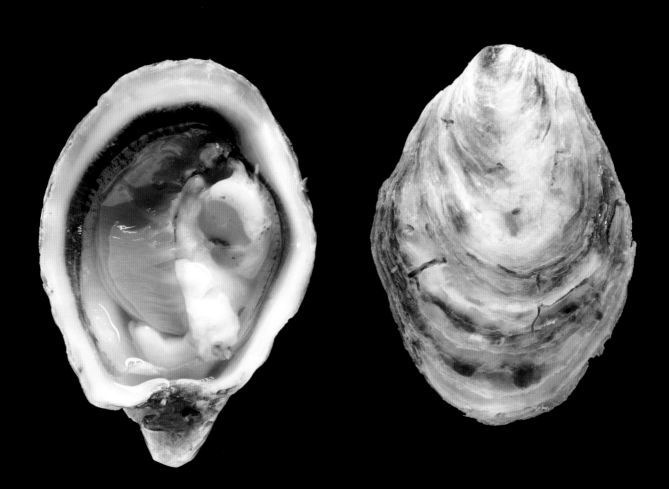

WEST COAST

# BLUE POOL
## Hood Canal, Washington

Grower: Adam James

Blue Pools are named after a favorite swimming hole of the Robbins family, where the water *really* is blue. They are tumbled, with a deep cup and smooth shell. The oyster is very meaty and has a crisp, earthy sweet flavor, with a vegetable finish.

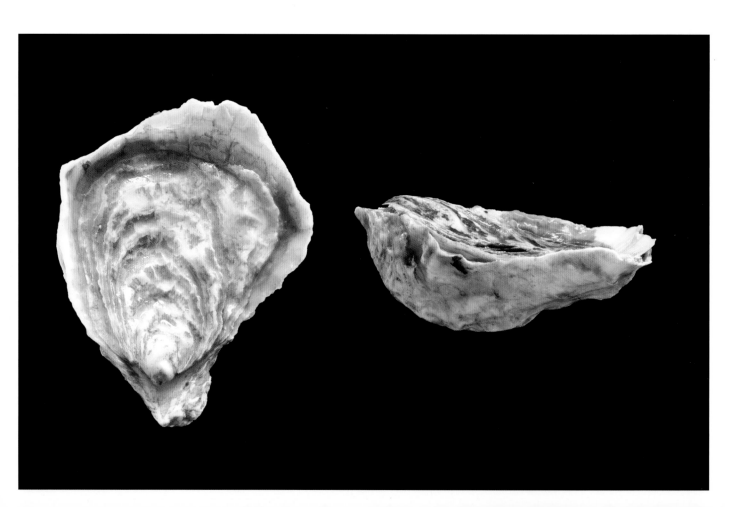

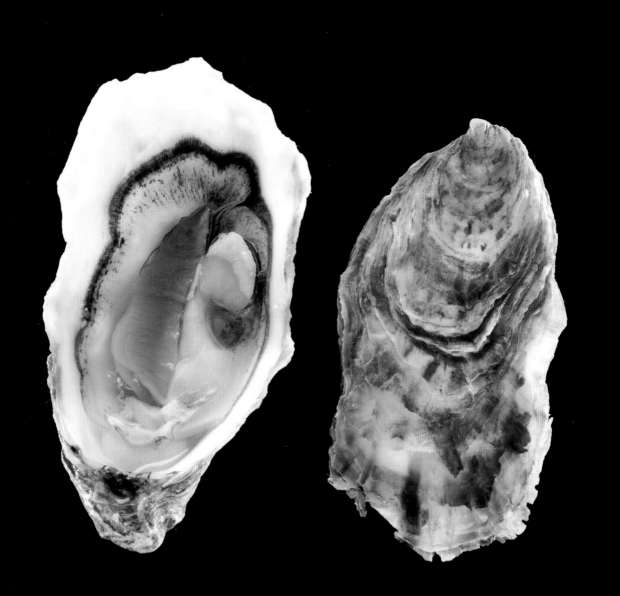

WEST COAST

# CHELSEA GEMS

Eld Inlet, Washington

Growers: Shina Wysocki and G. M. Besse

Chelsea Gems are rack and bag grown off the bottom in the Puget Sound's Eld Inlet. These oysters are tide tumbled, which creates a beautifully shaped cup. They have a mild brine flavor, with a finish of cucumber and moss.

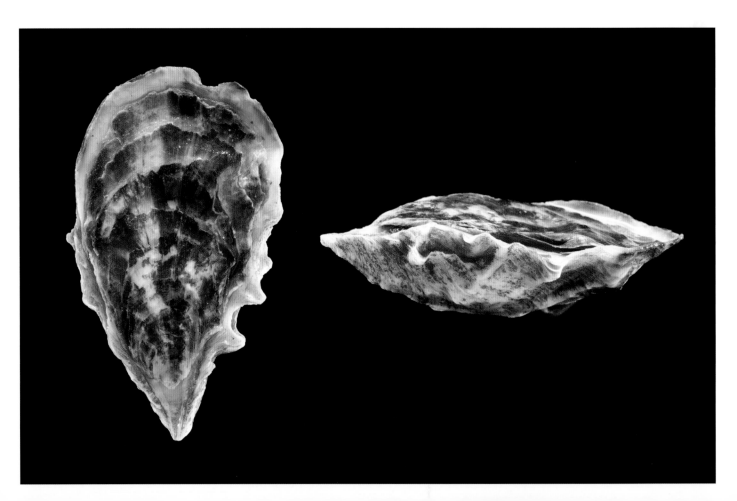

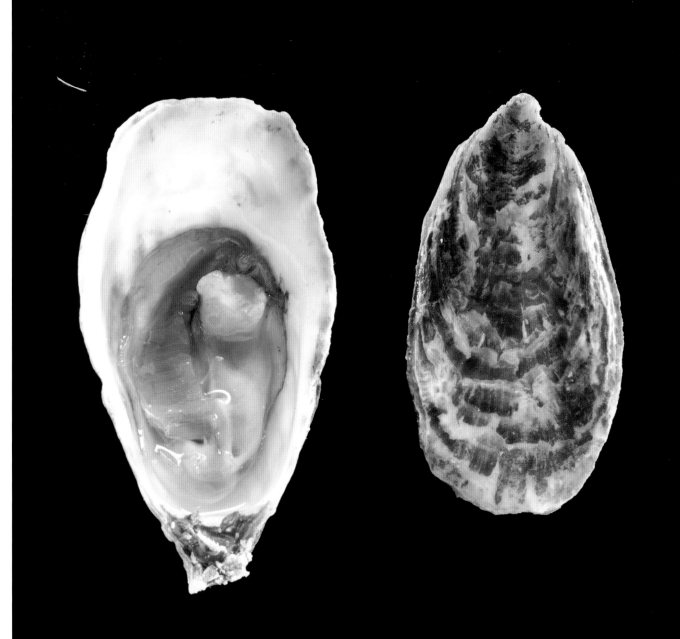

# DABOB BAY
## Hood Canal, Washington

Growers: Annie Fitzgerald and Katie King

Dabob Bays are a slow-growing oyster, raised in the deep clean waters of the Hood Canal. There is not much algae in these cold waters, and the oysters mature slowly, ending up beautifully crisp with a light salty flavor.

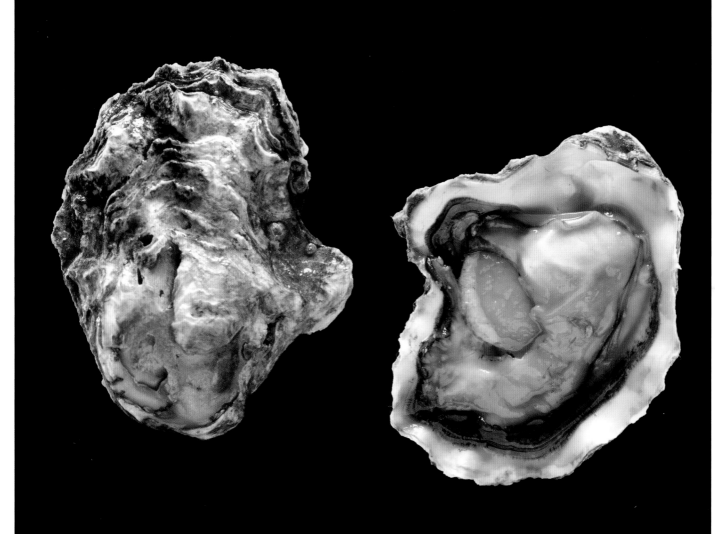

# HAMA HAMA
## Hood Canal, Washington

Grower: Adam James

Grown in one of the most beautiful areas in the country, Hama Hamas are started on the gravel beaches of the Hamma Hamma River. After getting big enough, they are hand harvested into floating crates to finish growing. Hama Hamas are a slow-growing oyster that has two unique flavor profiles. In the spring they tend to be sweeter; in the winter, brinier. In both seasons the oysters have a light cucumber/melon finish.

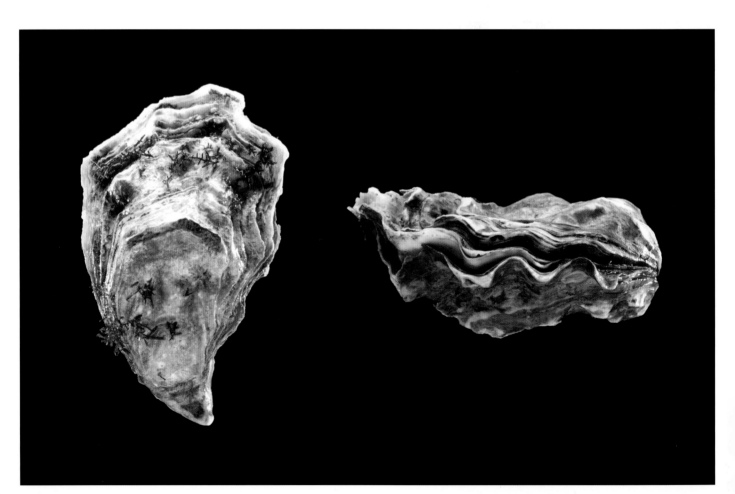

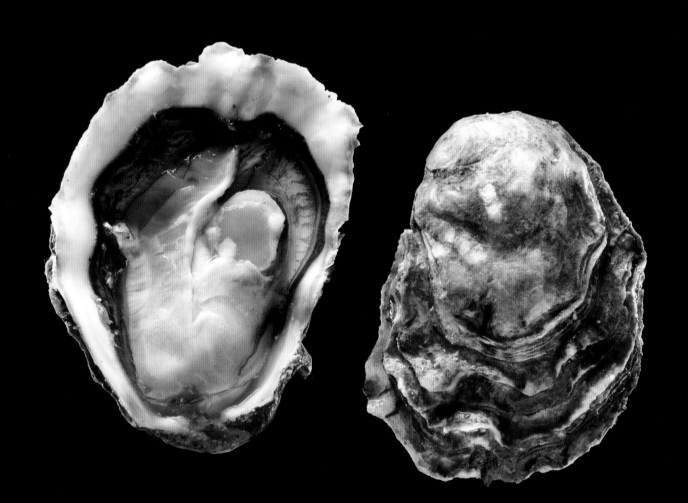

# KUMAMOTO

## Shelton, Washington

Grower: Bill Taylor

Kumamotos are a particularly slow-growing species of oyster originally brought over from Japan and now cultivated in Washington's Puget Sound, California's Humboldt Bay, and Baja, Mexico. For many years they were not available in Japan, but they have recently been brought back. Kumamotos are small but very flavorful, fruity at first with an almost wine-like quality and a ripe melon finish.

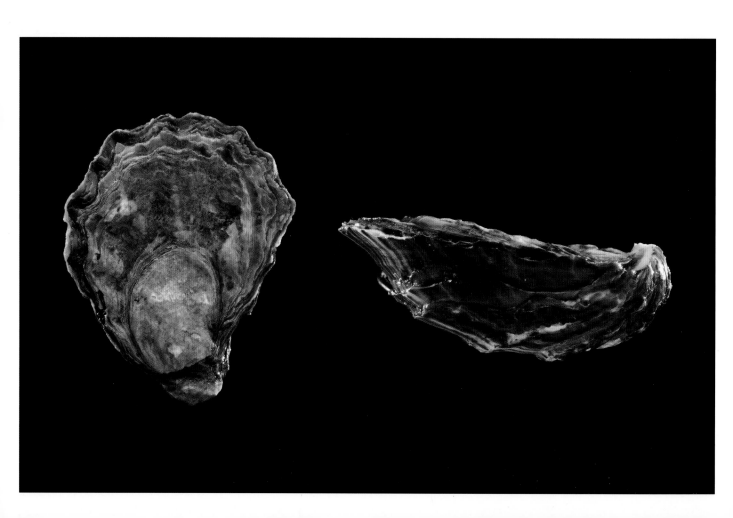

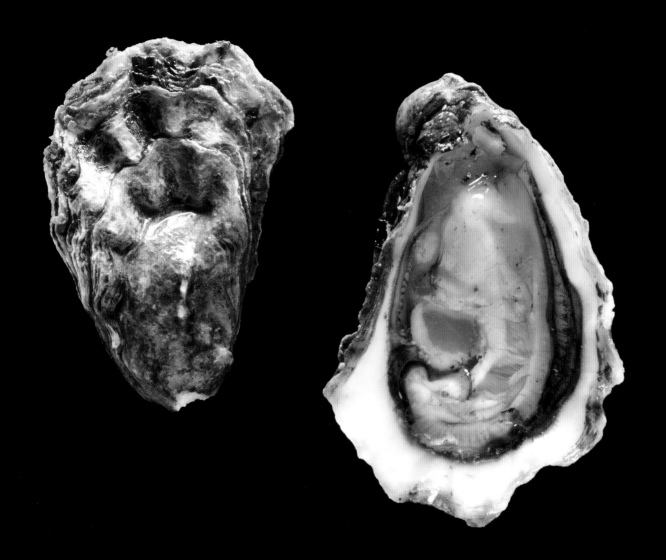

# MIYAGI

## Puget Sound, Washington

Grower: Penn Cove Shellfish

Originally from Japan, this Pacific oyster grows at the foot of Olympia Mountain in the southern part of the Puget Sound. Miyagis are heavily fluted with a deep cup—they are a full-shelled and plump variety of oyster, with a seaweedy, briny flavor.

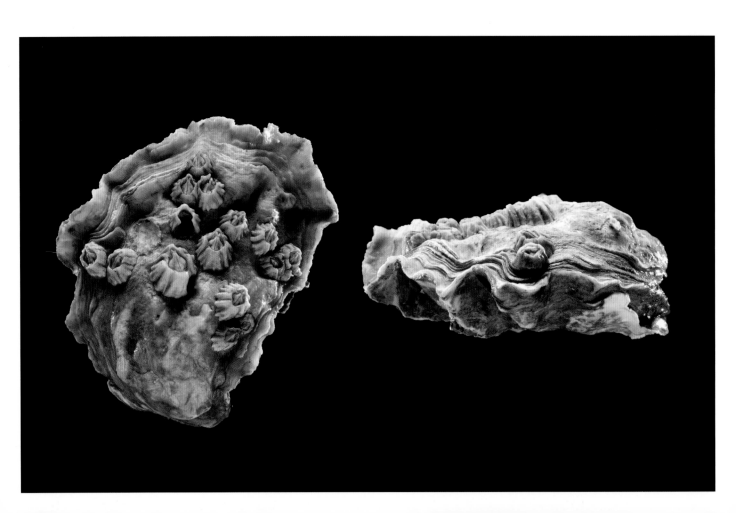

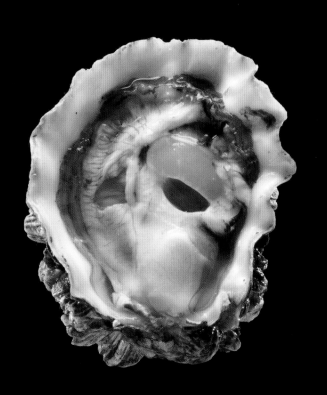
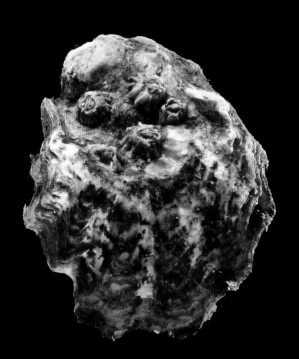

WEST COAST

# OLYMPIA

## Shelton, Washington

Grower: Bill Taylor

Olympias are a distinct species, and the only oyster that is native to the Pacific Northwest. These little gems grow to about the size of a quarter but have big flavor—coppery and smoky, with just a little sweetness to finish.

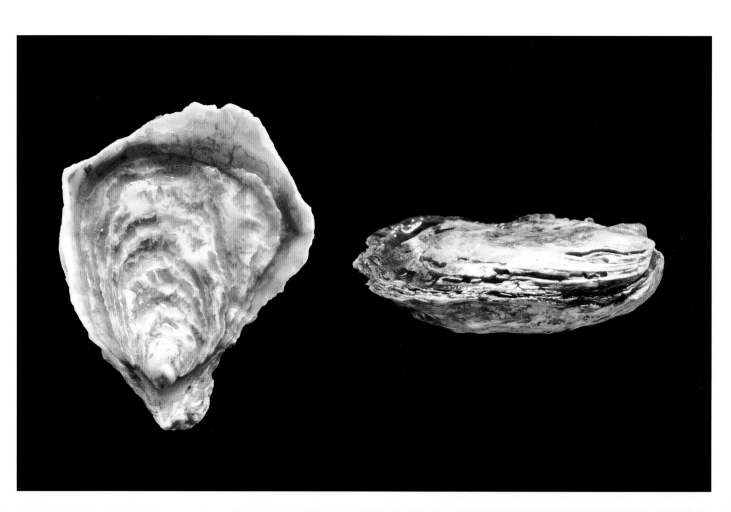

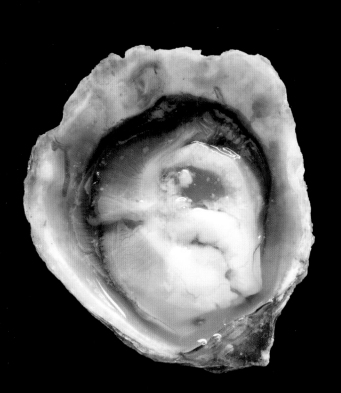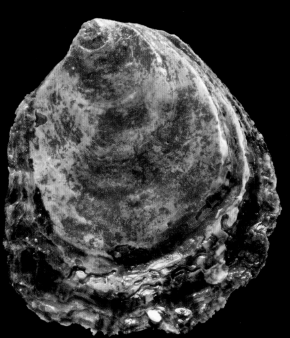

# SEA COW

## Hammersley Inlet, Washington

Growers: Hansen and Kadoun Families

These handsome oysters are grown in a floating farm in the South Puget Sound. Sea Cows are constantly turned by the sound's swift currents, which gives them a beautiful shape. They taste like a sweet melon that has been sprinkled with salt.

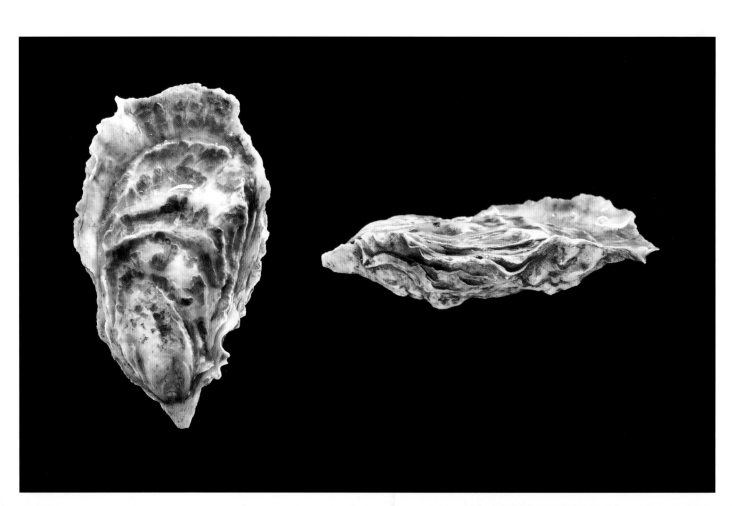

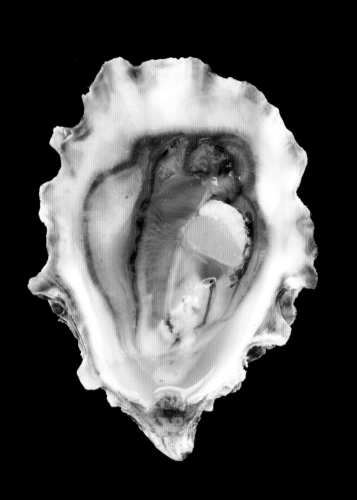
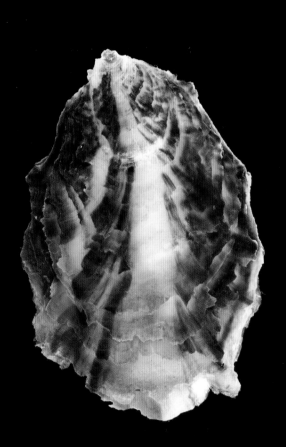

# HOG ISLAND SWEETWATERS

## Tomales Bay, California

Grower: John Finger

Hog Island Sweetwaters are started in a nursery and tumbled daily to help develop a deep cup. From there they are moved to a traditional French-style rack and bag method to finish the grow out. They are a little sweet, as the name would suggest, but have a great mineral finish.

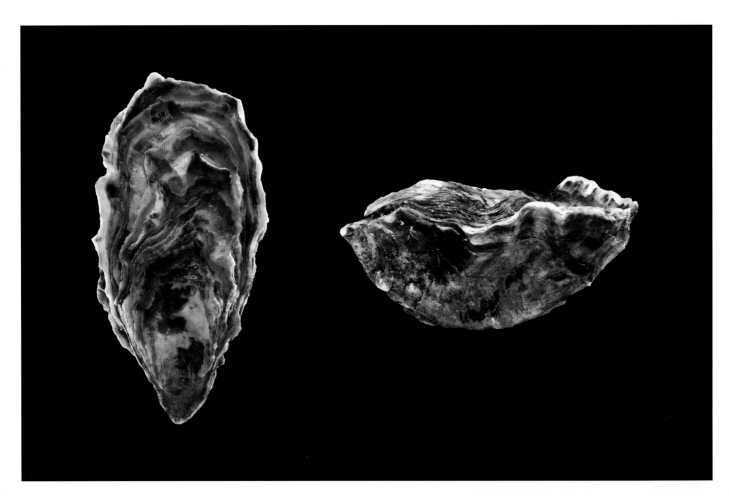

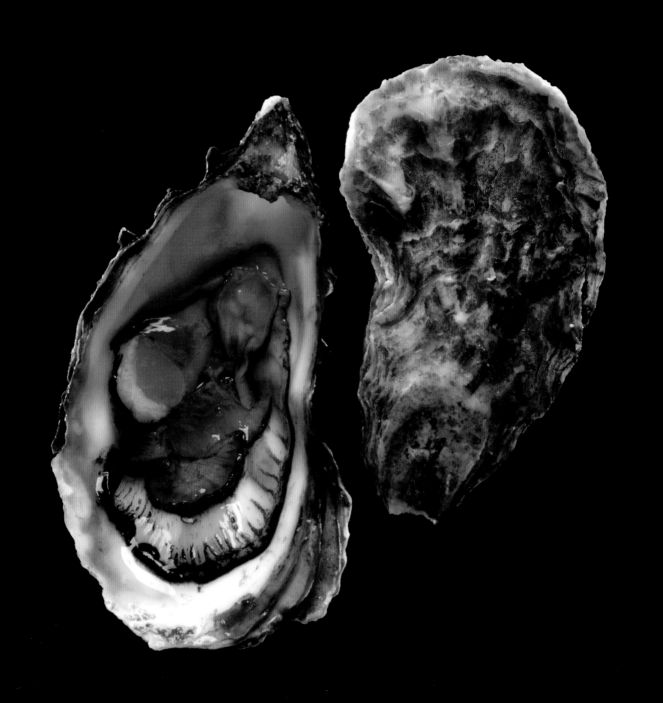

Mr. Lemon—"Can I do anything for you Miss Shell?"
Miss Shell—"No thank you I can get along without Lemon-aide."

TAUNTON IRON WORKS CO.

TAUNTON, MASS.

Salesroom, 87 & 89 Blackstone St.,

BOSTON, MASS.

Copyright 1888 by The Buffords Sons Lith. Co.

# OYSTER STORIES

*One of the supreme delights that nature has bestowed on man. . . .*
*Oysters lead to discussion, to contemplation, and to sensual delight.*
*There is nothing quite like them.*

— James Beard

**W**hether or not oysters have touched your lips, you've no doubt encountered them. Even beyond the oyster bar, oysters are everywhere, personifying luxury and sex, mystery and opportunity.

For centuries oysters have inspired writers, musicians, and artists, lowly street vendors and four-star chefs, and everyone in between. They are adored and reviled at the same table; no one is neutral about oysters. As a point of reference, however, few argue about their meaning.

Perhaps the most famous of all oyster references comes from Shakespeare's *Merry Wives of Windsor*, "Why, then the world's mine oyster, Which I with sword will open." Enthusiastic parents and energetic commencement speakers alike encourage the eager and admonish the lazy with variations on those famed words. The world is your oyster. All things are possible. Go for the gold.

From Shakespeare to Sherlock Holmes, *Moby-Dick* to *Alice in Wonderland*, oyster metaphors resonate and myths flourish. Iconic paintings celebrate the oyster's sensuality and beauty. The very history of oysters is as rich and varied as oysters themselves.

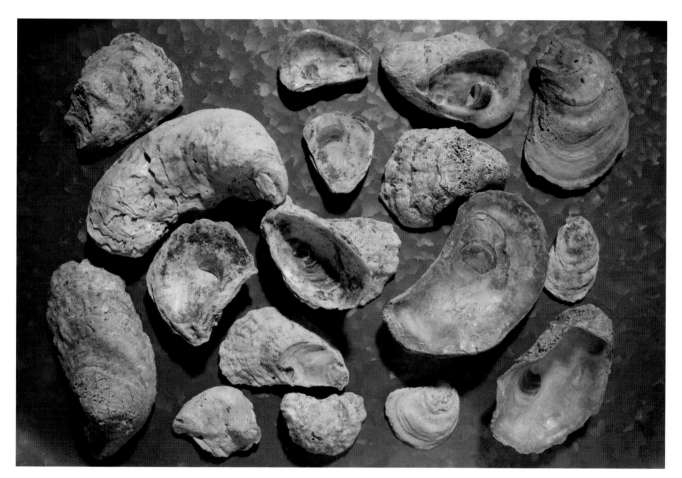

100-year-old oyster shells

# STOPS ALONG
# THE OYSTER TIMELINE

*It is the food that unites us with our ancestors — the
dish you consume in what is recognizably the way
people have encountered their nourishment since the
first emergence of the species.*

— Felipe Fernández-Armesto

ysters are almost as old as time itself. Their shells,
all but indestructible, accumulate on the seafloor in
mounds called middens and lay uninterrupted for mil-
lennia. There are prehistoric middens scattered along
North African, eastern American, and European shores,
as well as along the Pacific coast from northern Canada
to Chile and around Australia, Tasmania, and New Zealand.[8] Archeologists
believe that Manhattan's middens may date back as far as 6950 BC.

Though there is no documented evidence as to exactly who began eating
oysters and when, historians suggest that the abundant wild protein sus-
tained the earliest humans and has fed their progeny ever since.

Oysters appear in recorded history at least as far back as Aristotle. In
his *Historia Animalium* (320 BC), Aristotle tackled — albeit mistakenly — the
genesis of oysters, purporting that they generated spontaneously from mud
and slime. Despite their supposed mucky origins, the Greeks loved their
oysters. They indulged in great oyster feasts, washing down platter after
platter with copious amounts of wine. The Greeks were so enamored of oys-
ters they portrayed Aphrodite, the goddess of beauty and love, emerging
from the sea in an oyster shell. Henceforth, oysters as aphrodisiacs.

Although coastal North American Indians were harvesting wild oysters
long before *Historia Animalium*, Greek aqua farmers were among the ear-
liest to cultivate oysters. One account of these practices begins in Rhodes,
around the time Aristotle was writing. Fishermen saw that miniscule oysters
attached themselves to fragments of broken pottery at the bottom of the sea
and proliferated among the shards. Season after season they added to the
pottery dunes, stimulating oyster growth and reproduction.

Oyster trade card, late 19th century

Another legend credits the fishermen of Lesvos with first cultivating oysters. They detected that while large numbers of mollusks easily grew in many places along the coast, oysters required specific water currents, tidal conditions, and temperatures in order to reproduce. As a result they adapted their oyster pursuits and honed their expectations accordingly. These millennia-old observations remain fundamental for today's oyster farmers all over the world.

Three centuries after Aristotle, Pliny the Elder (AD 23–79), an author, naturalist, and military commander of the early Roman Empire, wrote effusively and at length about oysters, "that for this long time past the palm has been awarded to them at our tables as a most exquisite dish." His *Natural History* is one of the largest extant single works from the time and thought to cover all ancient knowledge. In a chapter called "The Various Kinds of Oysters: Fifty-Eight Remedies and Observations, Purples: Nine Remedies," Pliny chronicled their many properties.

Fellow writer and statesman Gaius Licinius Mucianus further described oysters[9]:

> *The oysters of Cyzicus are larger than those of Lake Lucrinus, fresher than those of the British coasts, sweeter than those of Medulæ, more tasty than those of Ephesus, more plump than those of Lucus, less slimy than those of Coryphas, more delicate than those of Istria, and whiter than those of Circeii.*

Looking at today's map, we see that oysters arrived in Rome by wagon, horseback, and foot from England in the north; Croatia, Greece, and Turkey to the east; and remote locations within the empire itself.

Not surprisingly, some oysters were fresher than others. British oysters traveled over land for more than one thousand miles. They were brined in some fashion, likely salt water, and tightly secured in barrels or earthenware vessels for safekeeping along the treacherous journey.

Romans devoured oysters in vast quantities. Like the Greeks they believed oysters to be far more than an epicurean pleasure. Oysters were thought to improve male sexual prowess, were considered an aphrodisiac for both sexes, and acted as a source of medical remedies for all. Conspicuously consuming piles of oysters confirmed for your fellow citizens that you were, indeed, rich.

The demand for oysters was so great, and the profits so lucrative, that around 92 BC an enterprising Roman named Sergius Orata concocted the first artificial oyster beds.[10] From that point on he was able to supply his voracious customers, irrespective of unfavorable tidal conditions and other interruptions that limited the wild oyster supply.

Modern food histories note that "in all centuries there are records of the excessive fondness of great men for oysters." Cervantes, Louis XI, Diderot, Robespierre, and Danton, along with their British and Scottish contemporaries, were among the many connoisseurs.[11] Voltaire and Rousseau, notably, ate oysters for inspiration. For Napoleon, a meal of oysters was essential before going into battle. Henry VIII was known to have raucous oyster orgies.

By the mid-eighteenth century working-class and poor individuals had joined the ranks of oyster eaters. Oysters were on offer at neighborhood saloons and hawked from pushcarts in even the dodgiest of areas. Fanciful notions about sex, inspiration, and riches were not part of the oyster equation for these consumers. For less-great men, oysters were exactly what they craved — cheap, plentiful, and readily available nourishment.

OYSTER STALLS AND LUNCH ROOMS AT FULTON MARKET, FULTON STREET, N. Y.— SEE PAGE 137.

Oyster stalls and lunchroom, Fulton Market, 1867

Oysters had long been a staple of coastal American Indians. When the first European explorers arrived, they were amazed by the sheer profusion of oysters and awestruck by some that were a foot long. Approximately 350 miles of oyster beds bordered New York alone. The island boasted a deep, sheltered harbor where multiple rivers met and tidal conditions were perfect for oysters to breed and reproduce—in extraordinary numbers. According to local lore, when the settlers arrived, they were able to walk across the Hudson at low tide, from Lower Manhattan to New Jersey, on a solid path of oyster shells.

As in Europe, from the late eighteenth century onward oysters were everywhere in the New World. The oyster is unique in food history as nourishment enjoyed in the same way by rich and poor alike—raw and ice-cold. Shacks along New York's East River enabled people to slurp oysters for a penny apiece. While some simply enjoyed a bite on the run, others were

knocking back the day's sustenance. Downtown oyster parlors offered all-you-can-eat oyster feasts for a few cents. Fancy restaurants farther north nestled oysters by the dozens on shaved ice-laden silver platters. Tiny oyster forks were provided for more delicate eaters.

By the end of the nineteenth century, before industrial pollution took its toll, New York waters produced seven hundred million oysters a year.[12]

Boston was another oyster-obsessed city. Long before the famed Union Oyster House opened in 1826, the Charles and Mystic Rivers were dense with oyster reefs — so dense that a 1634 account stated that oysters thwarted large ships trying to navigate the harbor.

Antique oyster forks

Geo. Koehler's Ladies' Oyster & Lunch Room, trade card, late 19th century

The four-hundred-year-old Cambridge Cemetery sits atop middens dating back to the earliest American Indian settlements. Similarly, oyster shells provided the solid ground for Boston's first streets. Those same workhorse shells were so prolific and durable the locals deployed them as projectile weapons against the British during the Boston Massacre of 1770.[13]

Ninety years later it was the oysters themselves that fueled soldiers. During the Civil War, when most food supplies were severely limited, oysters were plentiful. At the start of the war Sergeant Allen M. Geer of the Twentieth Illinois Volunteers, stationed near Savannah, wrote, "Had a morning lunch of three dozen roast oysters only three dollars per bushel. Some German people here make money cooking oysters for soldiers and in taking them from the shell."[14]

Before and after the Civil War cities and towns across the nation boasted every manner of oyster establishment. Oysters were presented raw and naked and sauced to a fare-thee-well. They filled savory pies, were stuffed into the cavities of fish and fowl, and were rolled in various cuts of meat. Equally popular at home, oysters were sautéed, creamed, fricasseed, scalloped, and fried. The first pigs in blankets were made with oysters, bacon, and toast, and the dish was one of several oyster recipes described in *Mrs. Lincoln's Boston Cook Book: What to Do and What Not to Do in Cooking* published in 1884.[15]

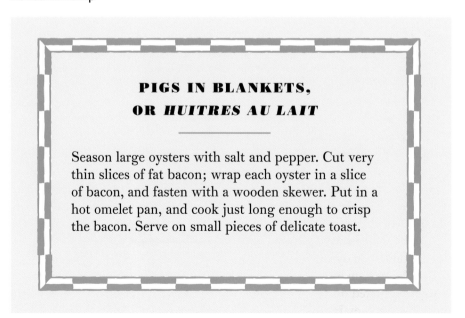

**PIGS IN BLANKETS,
OR *HUITRES AU LAIT***

Season large oysters with salt and pepper. Cut very thin slices of fat bacon; wrap each oyster in a slice of bacon, and fasten with a wooden skewer. Put in a hot omelet pan, and cook just long enough to crisp the bacon. Serve on small pieces of delicate toast.

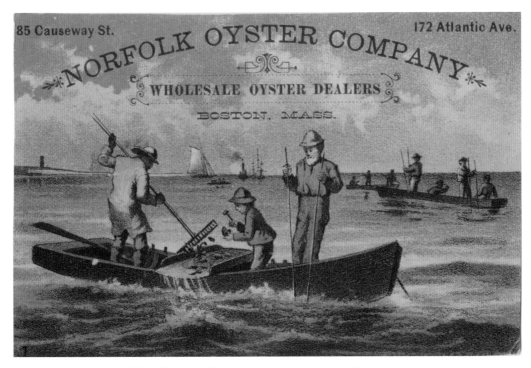

Norfolk Oyster Company, trade card, late 19th century

In 1881 a government-sponsored fisheries study listed 379 oyster "houses" in Philadelphia alone, not including hotel dining rooms, saloons, and cellars. The oyster business also was booming in Chicago, Cincinnati, Louisville, St. Louis, Denver, and elsewhere. Business was so good that intrepid stagecoach drivers on the legendary Oyster Line regularly carried the precious cargo a thousand miles or more from Baltimore, across the steep and dangerous Allegheny Mountains, to Ohio. Oysters were then canned and pickled for safekeeping on the journey farther westward, to St. Louis and beyond.

Most of these traveling crates of oysters came from the Chesapeake Bay where, by the late nineteenth century, supplies were precipitously dwindling. Overharvesting was a big problem for oysters, but it wasn't the only one. Oyster beds were rapidly being privatized, limiting access for many long-established oystermen.

Local government officials in Virginia got involved with the oyster problems with mixed outcomes. In an effort to prevent further depletion of the oyster stock, they imposed a range of restrictions, including licensing fees,

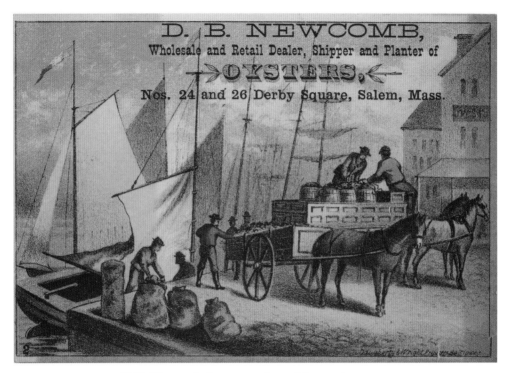

D.B. Newcomb Oysters, trade card, late 19th century

limits on who could harvest oysters, as well as where and when harvesting could take place, and a ban on newfangled dredging apparatuses. The net results of these limitations were the Oyster Wars of the Chesapeake Bay—a classic clash between tradition and modernity. Regional poachers, pirates from the northeast, legitimate watermen, newly rich dredgers, and armed law enforcement officers came to blows, often and violently.

In 1879, after fighting broke out between old-world oystermen using hand tongs or rakes and their wealthier compatriots with new English-inspired dredgers, Virginia banned oyster dredging altogether. Nonetheless, well-ordered, armed dredgers from neighboring Maryland ignored the ban and continued their endeavors.

William E. Cameron, the unpopular governor of Virginia at the time, took on the Maryland pirates with little success. After years of skirmishes, Cameron created the Board on the Chesapeake and its Tributaries in 1884, with the goal of improving overall management and providing armed patrolling of the waterways. Although Cameron's policies remained in place for

seventy-five years, illegal dredging continued. When a fisheries police officer shot and killed a Virginia oysterman in 1959, the newly established Potomac River Fisheries Commission ordered the fisheries police disarmed, finally ending the Oyster Wars of the Chesapeake Bay.

While the Easterners were battling it out on the Chesapeake, the oyster industry was expanding from the South Carolina coast down to Florida and around the Gulf. Toward the end of the nineteenth century, cities like Biloxi, Mississippi, grew and prospered around oysters — and shrimp. As it was everywhere along the coast, local citizens were the first to harvest and enjoy the oyster bounty — and the waters around Biloxi were especially bountiful.

In time rail transportation that connected cities in the South and Midwest to the East Coast, along with industrial innovations like canning and refrigeration, made it possible for plump, succulent Gulf Coast oysters to be enjoyed well beyond the region. Visionary entrepreneurs with deep pockets fueled the growth and development. By 1900, twelve of the fourteen shoreline states from New York to Texas reported oysters as their most "valuable fishery product"[16] and, thanks to oysters, Biloxi was referred to as "The Seafood Capital of the World."[17]

The trajectory of the Pacific oyster matches that of the Atlantic. For millennia oysters have been an essential part of the food supply along the Pacific coast. When the first intrepid settlers arrived at the farthest reaches of the North American continent, oysters were a dietary mainstay. The gold rush in 1849 was the impetus to begin shipping oysters from their habitat in the Pacific Northwest down the coast to bustling San Francisco. By the mid-1870s, 750,000 bushels of oysters had been sent from Washington's Willapa Bay to San Francisco — an estimated one billion individual mollusks.[18]

As transportation, refrigeration, and entrepreneurship made it possible to export indigenous Olympia oysters eastward from the bays of the Puget Sound, they became essential offerings on oyster menus everywhere.

Along the timeline of food history, oysters have persisted. In the beginning, oysters were an abundant protein, critical to survival, whether eaten in their natural state or turned into quotidian dishes. Over the centuries they became increasingly cultivated and appreciated. How and where someone ate oysters signaled his place in the world. Oysters have weathered natural disasters, outlasted predators, and endured overharvesting and other human interference, not the least of which has been industrial pollution pouring into our fragile estuaries. Thanks to the tireless oystermen and -women of the United States, oysters are making yet another glorious comeback.

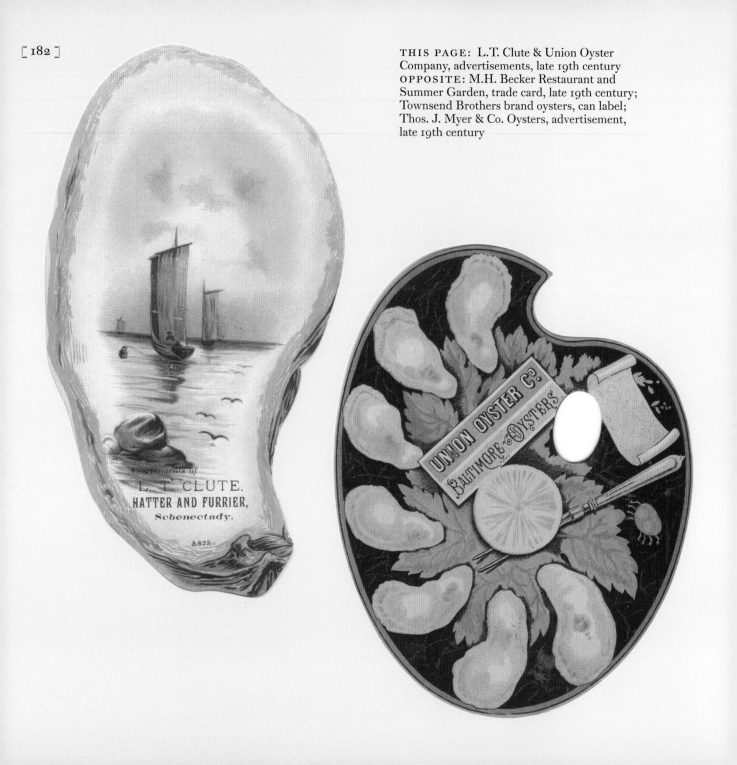

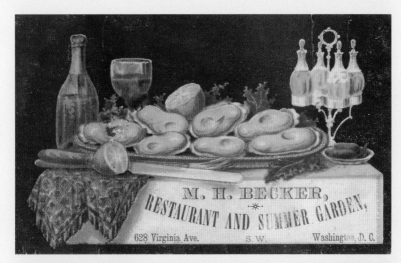

# THE ORIGINAL
# FOOD PORN

*Oysters evoke not only the idea of concealed virtue,*
*since the eatable part is firmly enclosed within the valves,*
*but also — and for the same reason — the power of love.*
— Silvia Malaguzzi,
*Food and Feasting in Art*

enturies before we coined the term "food porn" to describe mouthwatering magazine spreads and seductive Instagram feeds, there were seventeenth-century European still-life paintings. Sumptuous foods were rendered in magnificent detail and splendid banquet tables were depicted, laden with grapes, apricots, lemons, pheasants, venison, lobsters, wines — and oysters.

The Dutch, in particular, were obsessed with depicting oysters, no one more so than Osias Beert (c. 1580–1623/24). Beert is considered one the greatest still-life painters of the period and the single greatest painter of oysters. Among his many gifts was the ability to replicate the play of light on the creamy, lustrous oyster flesh, shimmering oyster liquor, and rigid, pearlescent interior shell.

Considering the array of extravagant representations of oysters in all their glory — Beert's and others — it's easy to imagine the golden age of Dutch still-life painting as an equally golden age of oyster painting. Consistently, oysters were shown as symbols of taste and prosperity. They were also emblems of fertility, sensuality, and sexuality.

Over time grand scenes of lavish feasts of oysters gave way to more intimate, domestic moments, loaded with sexual innuendo. Oysters — and lovers — were put front and center, as the genre evolved from "feast to tryst."[19]

Jan Steen's *Girl Eating Oysters* (c. 1658–60) shows a quintessential seventeenth-century seductress. Innocent and provocative at the same time, she gazes directly at the viewer, seemingly offering the oyster she is salting — and herself. Behind the girl is a bed with closed curtains, as if to accentuate both the artist's and the girl's intent.

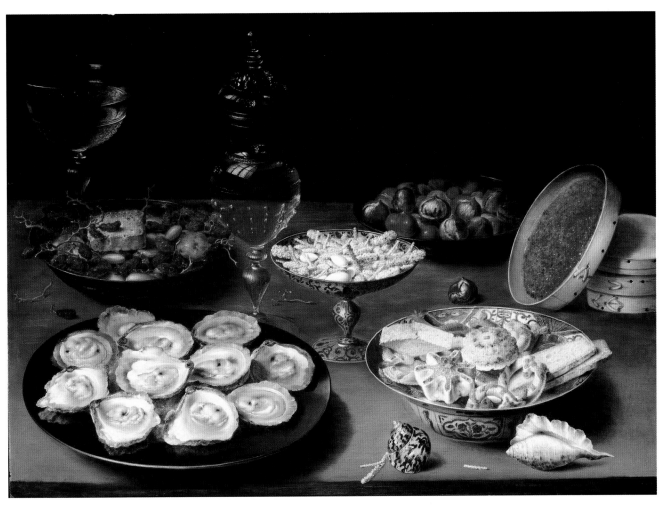

Osias Beert the Elder, *Dishes with Oysters, Fruit & Wine*, c. 1620/25

Jan Steen, *Girl Eating Oysters*, c. 1658–60

Ironically, according to Dutch food writer and chef Geron de Leeuw, "Rendering an oyster was a bit naughty [in the seventeenth century] since they stood for sexual freedom in a time when Calvinism swept the Netherlands."[20]

Two hundred years later Edouard Manet painted *Oysters*, ostensibly for his fiancée. The composition, colors, and perhaps even the meaning of the 1862 still life reflect the Dutch Masters he assiduously studied at the Louvre. With his bolder, more contemporary strokes, Manet achieves an even greater degree of lushness and sensuality in his depiction. Like the works of his forebears, if painted today, Manet's *Oysters* surely would achieve the hashtag #foodporn.

The lure of oysters did not stop with Manet. From Henri Matisse to pop art icon Roy Lichtenstein to today's commercial and decorative artists, there is no shortage of twentieth- and twenty-first-century oyster paintings. Although later artists have been less interested in sexual innuendo, oysters have not escaped them as objects of sheer erotic beauty.

Edouard Manet, *Oysters*, 1862

Roy Lichtenstein, *Still Life with Oysters, Fish in a Bowl and Book*, 1973

Lichtenstein delivers pop eroticism in his 1973 *Still Life with Oysters, Fish in a Bowl and Book*. With the economy of line and hard-edged literalness for which he is famous, Lichtenstein delivers larger-than-life, surprisingly sensual, mouthwatering mollusks.

On a grand scale or a small canvas, from one generation and genre to the next, oysters fascinate, captivate, and rouse the creative spirit.

*Lewdly dancing at a midnight ball*
*We should for hot eryngoes and fat oysters call . . .*
— Juvenal, *Sixth Satire*

*Think of oysters, try not to think about sex.*
— Rebecca Stolt, *Oyster*

**M**en were eating oysters to enhance their sexual prowess long before pharmaceutical companies began developing drugs for the same reason.

Roman physician and philosopher Galen of Pergamon (129–c. 216) was one of the most accomplished and influential medical practitioners of the ancient world. He attended to many wealthy Romans, including royalty. When Galen's rich and powerful patients confided about waning sexual desire and other libidinous matters, he prescribed oysters. Not surprisingly, oysters were consumed in vast quantities by the emperors and their courts, notably at imperial Roman orgies where they were piled by the thousands on banquet tables.

From the late first-century poet Juvenal through the Jacobeans and Elizabethans to the pop star Lady Gaga, oysters have epitomized pleasures of the flesh and sparked intimacy between lovers.

C. H. Chartier's *Delectable Demaundes* (1566) asked, "Why were oysters consecrated by the auncient to venus? Bycause oysters do prouoke lecherie." Decades later John Jones, in his play *Adstrata* (1635), referred to oysters as "self-swallowing provocatives."[21]

Voluptuous oyster sellers were fixtures on the streets of seventeenth- and eighteenth-century London, with baskets of oysters strapped to their backs or balanced on their heads, their ample bosoms heaving under the weight. In the eyes of passersby, oyster sellers were one with their wares—objects of erotic gratification.

The legendary eighteenth-century Venetian adventurer and lothario Giacomo Girolamo Casanova reportedly downed fifty oysters every morning

to ensure his fabulous sexual stamina. In his memoirs, Casanova boasted of 122 liaisons and offered erotic tales of seduction and oysters. To wit:

> *I placed the shell on the edge of her lips and after a good deal of laughing, she sucked in the oyster, which she held between her lips. I instantly recovered it by placing my lips on hers.*[22]

Casanova's amatory prose was echoed a hundred years later in *The Oyster,* a scandalous underground magazine of erotica published in Victorian England. The title alone promised eager readers that tales of sex and seduction lay between the covers.

The seductive power of oysters was also showcased in Henry Fielding's comic novel of 1749, *Tom Jones*, which was adapted for the screen in 1963. That cinematic rendition featured one of the most memorable, bawdiest food scenes ever filmed, with the raffish young Tom lasciviously slurping oysters for the benefit of the randy wench at his side.

Across the Atlantic, the United States has had her fair share of risqué oyster seductresses as well.

Michael Ondaatje describes one such woman in his 1976 novel *Coming Through Slaughter,* set in early twentieth-century New Orleans:

> *The best [whore in New Orleans] was Olivia the Oyster Dancer who would place a raw oyster on her forehead and lean back and shimmy it down over her body without ever dropping it.*

Oysters and sex have mingled for decades in New Orleans, perhaps most notably in the character of Evangeline the Oyster Girl. An illustrious Bourbon Street burlesque dancer in the 1940s and '50s, Evangeline seductively emerged from a giant oyster shell to perform her audacious striptease all the while holding an enormous pearl. For a time Evangeline dyed her hair seaweed green to complete her oysterly persona.

The idea for the Oyster Girl comes from a Bayou legend about a beautiful "supernatural seductress" named Evangeline who slept undisturbed at the bottom of the ocean. Every 100 years she'd rise from her oyster bed in search of earthly pleasures.[23]

In real life, Evangeline was the creation of Abbie Jewel Slawson, also known as Kitty West, a poor girl from Mississippi who, at the age of sixteen, made her way to New Orleans in search of fame and fortune. She hit

Evangeline the Oyster Girl, New Orleans, Louisiana, late 1940s

the oyster-as-aphrodisiac jackpot with the sultry Evangeline. New Oyster Girls have reprised Kitty's fabled act ever since.

Today's marketers and magazine editors make their own indelible contributions to the oyster-as-aphrodisiac mythology, especially around Valentine's Day. Raw oysters are presented as the quintessential offering for modern lovers, with romantic couples shown entangled over platters of oysters, enjoying a hedonistic moment.

Modern scientists have also been taken with oysters, though they have sought a biological answer to the timeless question, *Are oysters aphrodisiacs?* In 2005, Antimo D'Aniello of the Stazione Zoologica Anton Dohrn in Naples and George Fisher, a professor of chemistry at Barry University, Miami, reported a connection between oysters and increased testosterone in animals.

Studying mollusks, the researchers found that oysters are rich in rare amino acids that trigger increased levels of sex hormones in laboratory animals. The scientific jury is out on whether there is enough evidence to suggest a human link, but D'Aniello and Fisher's findings fascinated their associates at the American Chemical Society nonetheless.

Apart from the amino acids noted by D'Aniello and Fisher, oysters are rich in zinc, a key nutrient found in male sperm. Do zinc and the recently identified amino acids make a difference? If you consume enough oysters, they may stimulate your libido — or not.

Whatever the reason, when oysters do titillate, the aphrodisiac effect is less likely connected to your actual body chemistry and more a reflection of your overall sensory experience. The power of suggestion can be strong indeed and should not be underestimated when it comes to oysters, nor should persuasive cultural subtexts reinforced from one generation to the next.

In the long trajectory of love, lust, and oysters, perhaps the fabulous Lady Gaga should have the final say on the subject. With legions of fans hanging on her every note, she minces no words in her 2013 hit song "Venus":

> *Have an oyster, baby*
> *It's Aphrod-isy*
> *Act sleazy*[24]

When all is said and done, written and sung, it may be that oysters are aphrodisiacs simply because we say they are.

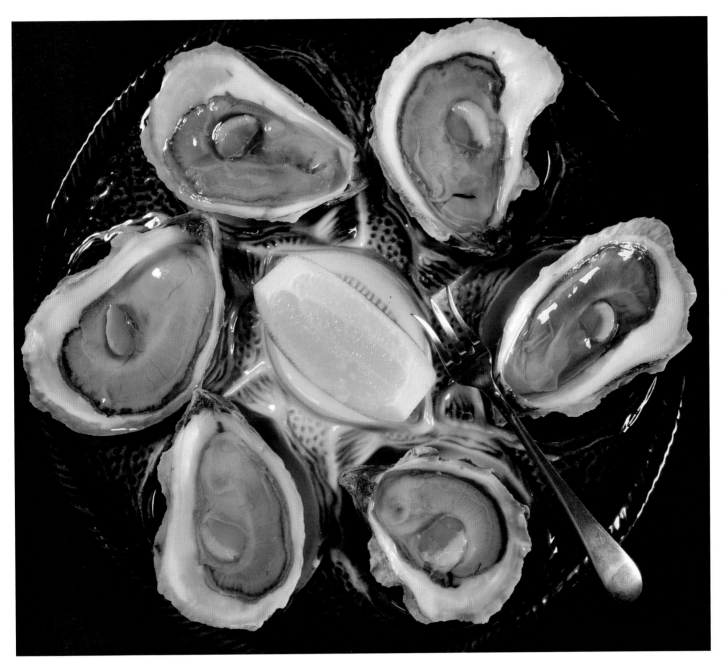

Antique oyster plate, France, 1930s

# PEARLS

*A woman needs ropes and ropes of pearls.*
— Coco Chanel

Queen Elizabeth I, unknown artist, c. 1575

Not all oysters are created equal. Those belonging to the Ostreidae family produce the sumptuous morsels that delight our palates; they rarely, if ever, produce pearls. It is the Pteriidae family of bivalves that is responsible for the wide variety of lustrous gems that adorn us.

Pearls are the most opulent reminder that oysters are exceptional. From earliest times, pearls were as prized, sometimes even more so, than the extraordinary oysters that produced them.

The most rare and treasured natural pearls develop spontaneously in the wild and have enchanted people for millennia. Archeological evidence dating back six thousand years indicates people in the Persian Gulf region were buried with "pierced pearls in their hands."[25]

As trade routes across Asia and Europe expanded, the exquisite, luminescent treasures were introduced to new audiences. Increasingly pearls were prized as symbols of affluence, importance, and even religious significance.

For centuries, queens and courtesans, divas and icons have been pictured in pearls, none more extravagantly than actress Elizabeth Taylor, who dazzled in La Peregrina, one of the world's largest and most famous pearls.

Discovered by an African slave in the Gulf of Panama in the early 1500s, La Peregrina was owned by European royalty for four centuries. In 1969 La Peregrina passed to Hollywood royalty when Richard Burton purchased it as a Valentine's Day gift for his wife, Elizabeth Taylor. When Taylor's jewels were auctioned at Christie's in 2011, La Peregrina fetched an epic eleven million dollars.

Cultured pearls, the more affordable and readily available variety, are artificially seeded in several species of marine pearl oysters and other mollusks. The growing process for these pearls was developed in Australia by a British biologist named William Saville-Kent and patented in Japan in 1916. In the West cultured pearls gained popularity slowly. Fashion icon Coco Chanel changed all that in the 1930s when she declared, "A woman needs ropes and ropes of pearls." Cultured pearls became all the rage after that.

Pearls develop when the tiniest food particle or bit of debris finds its way into a tightly encased oyster. Trapped inside, the debris irritates the oyster's mantle, the tissue that produces the oyster shell. The mantle then creates protective layers of nacre, the substance that lines the oyster shell. The layers of nacre wrap around the debris and, voilà, a pearl is born.

Natural pearls are shaped by the elements. As a result, more often than not they are subtly irregular and varied in size. To satisfy the market for a more "perfect" look and larger sizes, pearl farmers seed mollusks with spherical beads so the layers of nacre can form perfectly round cultured pearls.

As with the flavor of oysters, the look of natural and cultured pearls reflects the environment in which they grow. Saltwater, freshwater, and different types of mollusks produce different sizes, hues, and shapes. Colors range from white, cream, and gold to blue, purple, green, gray, and black. They can be as small as two millimeters and as large as twelve.

Whatever the size and color, it is the composition and quality of the nacre that determines the most important attribute of the pearl: its luster. The more lustrous the pearl, the lovelier and more valued it is.

Whatever their shape, pearls are distinctive as the only gems produced by living creatures. Authentic, cultured, or entirely manufactured, they remain objects of desire for affluent "ladies who lunch," struggling young fashionistas, and everyone in between.

Coco Chanel, Adolf de Meyer, 1930s

# THE "R" MONTH AND OTHER MYTHS DEMYSTIFIED

Oyster on ice, Island Creek Oyster Bar, Boston

here may be more mysteries and myths surrounding oysters than almost any other food. Beyond the mythology of oysters-as-aphrodisiacs, most of the questions exist around whether it is safe to eat raw oysters at all.

Oyster aficionados have long been dogged by the advice to eat raw oysters only in months that contain the letter "R." Historically, this advice was a practical and essential precaution. Lack of reliable refrigeration meant oysters — along with other raw fish and meat — would quickly spoil when the weather was hot. Consuming oysters that had been sitting on the docks in wooden barrels, baking in the sun, was a recipe for intestinal disaster. Today, whatever the weather, state-of-the-art refrigeration keeps oysters fresh from the water's edge to oyster bars hundreds — even thousands — of miles away.

Another perennial consideration for oyster eaters was tied to spawning. In traditional oyster breeding grounds, wild oysters spawn in the summer months when the water is warmer. In the process the oysters become watery, runny, lacking in flavor, and just plain nasty — hardly worth eating. Today farmed oysters are raised throughout the year, often in colder waters. Many

breeds spawn in months other than summer and are plump and juicy when you least expect it. Still other breeds have been developed not to spawn at all. These sterile oysters are called triploids and remain full, firm, and tasty in summer and in winter.

Thanks to overall food safety practices, sophisticated monitoring and stringent government regulations, it's considered okay to eat oysters anytime as long as they are fresh and come from a reliable source.

No matter how careful you are ordering, shopping for, and preparing your oysters—and despite extensive state and federal regulatory programs—the system is not perfect. The risk of foodborne illness from raw oysters, and raw foods of any kind, is higher than for cooked foods.

According to the Food and Drug Administration, the culprit in oysters is *Vibrio vulnificus*,[26] a naturally occurring bacteria that thrives in warm coastal areas and cannot be seen, smelled, or tasted.

Though the Centers for Disease Control and Prevention estimate approximately one hundred people in the United States are infected with *Vibrio vulnificus* each year, the bacteria is exceptionally rare. In fact, your chances of finding a pearl in one of the 2.5 billion oysters eaten in the United States each year is one hundred times greater than your chance of contracting *Vibrio vulnificus*.[27]

The FDA has debunked some additional myths about oyster safety:

- Drown your oysters in hot sauce and you'll be safe from bacteria, because hot sauce kills everything. FALSE. The hot sauce might kill your taste buds, but not bacteria like *Vibrio vulnificus*.
- Alcohol destroys harmful bacteria, so you can slurp safely if you drink. FALSE. The only thing the alcohol will do is make you tipsy.
- Bacteria grow only in polluted waters, so oysters from certified waters are safe. FALSE. *Vibrio vulnificus* thrives in brackish coastal waters that are clean.
- An experienced oyster eater can tell a good oyster from a bad one. FALSE. No matter how keen your senses, you'll not detect *Vibrio vulnificus* in the unlikely chance it's there.

As with most things you eat or drink, be mindful of your oysters—where they come from, how they've been kept, and the condition they are in when they get to you. Once you bring them home, store oysters safely and eat them soon. Perhaps most important, when in doubt, throw it out.

# BEYOND DELICIOUS

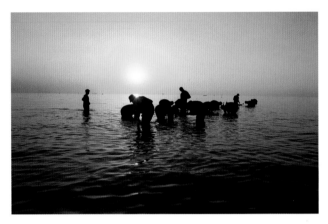

Ballard Fish & Oyster Company, Cheriton, Virginia

eyond the sensory pleasures oysters provide—the delicious surprise of each bite, the unexpected beauty and complexity of every shell—lies their importance as a keystone species. As natural filtration systems, oysters maintain strong coastal ecosystems and are vital forces therein. They reflect the overall health of their habitats, enable sea grasses and marine life to thrive, and form essential barriers with their reefs that prevent erosion and protect our shorelines.

Undaunted by a century of decimated reefs[28] and the trifecta of quotidian threats—overfishing, pollution, and global warming—national, regional, and local environmental organizations are on the front lines, rebuilding oyster reefs today to protect us from potentially ravaging storms and rising seas tomorrow.

The Billion Oyster Project is restoring one billion live oysters in New York Harbor, where the once vast oyster population has all but disappeared. In partnership with public schools, businesses, and not-for-profits, BOP is turning the tide on decimation, transforming the harbor and fostering a culture of stewardship.

Similarly, the Massachusetts Oyster Project is dedicated to recycling oyster shells, reestablishing oyster reefs, and restoring once native, water-cleansing oysters to Boston Harbor.

Large-scale efforts are underway in the Chesapeake Bay, where, during the 1880s — the golden age of oyster production — billions of bushels of oysters were harvested annually. Organizations from the National Oceanic and Atmospheric Administration to state and local entities are reinvigorating the Chesapeake ecosystem. Oysters steadily are coming back to the Chesapeake, where they remain deeply embedded in the culture and collective sense of the bay.

The Nature Conservancy is hard at work with local entities from North Carolina to Texas, and on the West Coast. Conservancy scientists and partners are experimenting with location-specific restoration programs designed to meet the challenges of unique habitats — among them erosion, rising sea levels, intense storms, even harmful wakes from recreational boats.

Rob Brumbaugh, lead scientist on the Nature Conservancy's global marine team, summed up the situation: "Like a lot of things, it is far easier to take things apart than to put them back together again. . . . [Oyster reef restoration] is a process, a journey, that we need to keep on."[29]

Oyster reclamation champions like Brumbaugh and his many colleagues around the globe, along with passionate oyster farmers, aquaculture entrepreneurs, cutting-edge chefs, and their myriad cohorts in oysterdom are the heroes of this story.

In their good hands, we will be celebrating oysters for generations to come.

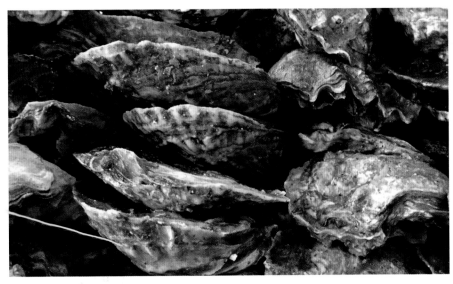

Oysters piled high, Aquagrill, New York City

# ACKNOWLEDGMENTS

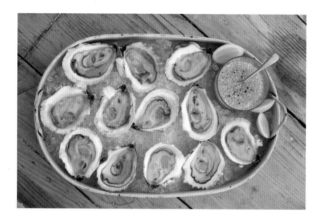

I would much rather eat an oyster than write about one, but working on this book was fun. I must really thank Marion and everyone at Abbeville for seeking me out to work with them. Marion made it fun and easy. All the oyster farmers, and those others that work just as hard on a farm that we never hear about, need a special thanks for what they do. Thanks to Bill Walton for sharing his knowledge and sourcing of southern oysters. Jess, Dana, and the entire Island Creek Oyster team: thank you for all the help tracking down oysters and for helping me research all the little fun details about each oyster. Scott for his beautiful pictures. Ellen for all of her assistance on all sides of the book — oysters, pictures, and more — thank you. Phil for running around picking up and shipping oysters, and to all my BOH and FOH teams, you guys kill it everyday! To Ben and his team at Pangea: thanks for answering our endless requests. Of course thanks to Skip, Shore, and Garrett for being great business partners and lovers of oysters, and mostly to Lisa, for letting me go play chef everyday.

— Jeremy Sewall

**W**hile writing may be a solitary pursuit, writing a book definitely is a collaborative effort. Thanks to wonderful colleagues, *Oysters: A Celebration in the Raw* has been an effortless collaboration.

Bob Abrams, Abbeville's founder and publisher, had the initial idea, not surprisingly, over a shared platter of oysters. He also had the temerity to let me run with it and was supportive from beginning to end. I am exceptionally grateful for his trust, and for a lifetime of friendship.

Bob put me in the hands of Shannon Lee Connors, a talented young editor with a clear eye, deft touch, and smart, spot-on edits.

The entire Abbeville team has been terrific. Thanks, especially to Misha Beletsky and Patricia Fabricant for designing a gorgeous book, David Fabricant for teaching me a thing or two about the economics of publishing, Nicole Lanctot for nimbly managing the finishing touches, Louise Kurtz for making it all happen, and Nadine Winns, who has been my trusted cohort at Abbeville for years.

When I told restaurateur Kathy Sidell I was looking for a partner who knew a lot more about oysters than I, she immediately suggested Jeremy Sewall. "Island Creek. Jeremy's your guy." It was a home run.

Working with Jeremy has been an enormous gift. His breadth of knowledge, passion for all things oysters [and food], generous spirit, and overall enthusiasm for the project made for a terrific collaboration.

Huge thanks to Ellen Benson, Jeremy's right-hand woman. Smart and resourceful, Ellen kept all the balls in the air with ease and good humor.

From the start, *Oysters: A Celebration in the Raw* was intended to celebrate the sheer physical beauty of oysters. Scott Snider made that intention — and more — a reality. Scott is one of the most gifted natural history filmmaker/photographers working today, and his exquisite visual instincts and sheer love of the natural world made this book more beautiful than I ever imagined.

Through Jeremy I met oyster farmers around the country who were most generous with their time and wisdom. Many thanks to Skip Bennett (Island Creek Oysters), John Finger (Hog Island Oyster Co.), Adam James and Lissa James Monberg (Hama Hama Oyster Company), Steve Wright (Chatham Shellfish Company), Tim Rapine (Ballard Fish & Oyster Company), and Lane Zirlott (Murder Point Oysters).

Early on, I visited Kitchen Arts & Letters in Manhattan, my go-to source for food in print. Nach Waxman, the legendary founder offered little-known oyster tomes, access to his collection of rare oyster images, and a greatly appreciated market perspective.

Finally, I asked two discerning people in my life to read the manuscript, my sister Elizabeth Pinsky and my friend and occasional muse Mitchell Levitt. Liz is the family editor-in-chief and, as always, was precise and constructive. Mitchell, an elegant thinker, can spot excess verbiage and murky ideas a mile away. He also is brutally honest, which makes for spirited conversations and first-class fixes. I'm indebted to you both.

Whenever I mentioned this project to friends — which was often — they indulged my stories and shared their own, gave me oyster books, and offered obscure literary quotes and trivia. One or two raised an eyebrow and groaned. No one is neutral about oysters. Most important, they cheered me on, as they always do, a reminder that I am truly blessed in their company.

— Marion Lear Swaybill

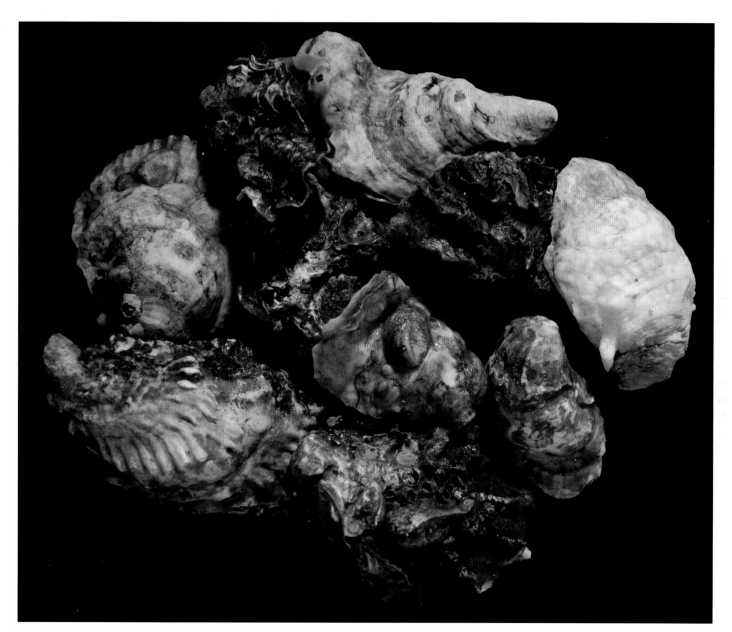

Bivalve beauties from both coasts, Island Creek Oyster Bar, Boston, MA

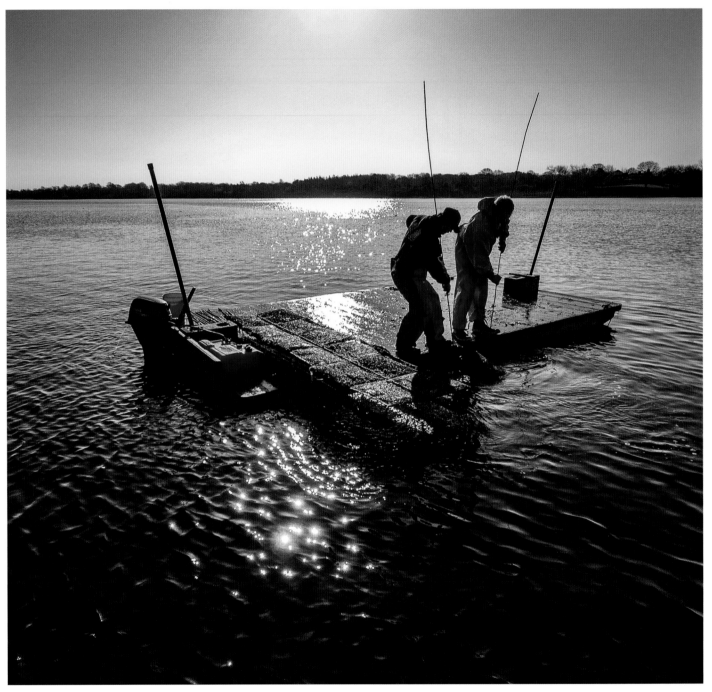
Checking the stock, Chatham Shellfish Company, Chatham, Massachusetts

Stephen Wright, Chatham Shellfish Company

Lane Zirlott, Murder Point Oysters, Irvington, Alabama

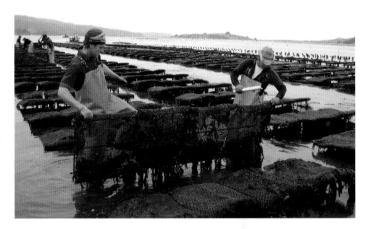

Harvesting at Chatham Shellfish Company

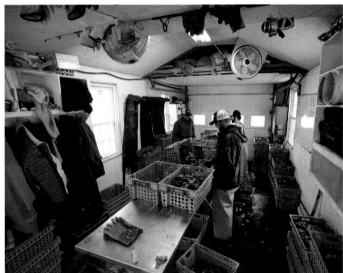

Culling shack at Island Creek Oysters, Duxbury, Massachusetts

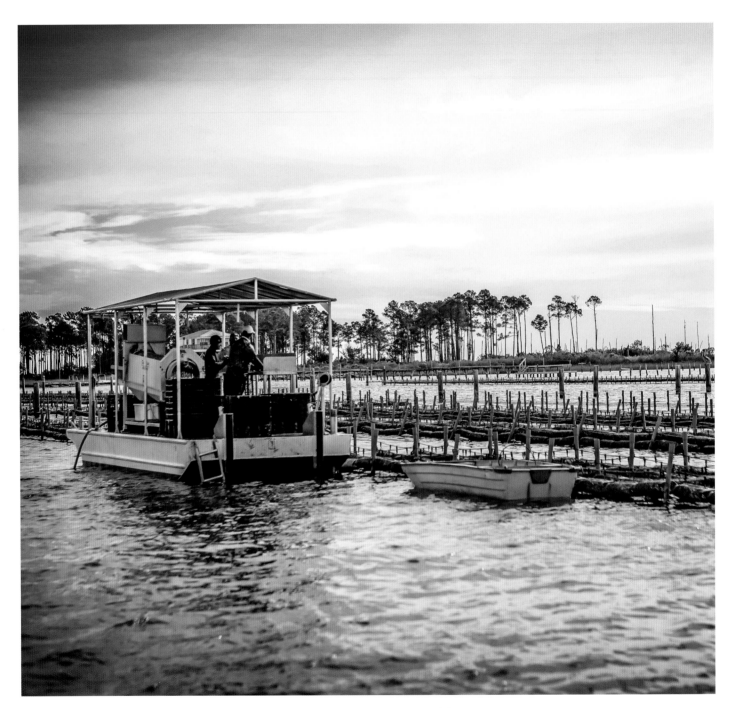

Murder Point Oysters, Irvington, Alabama

1. Imported Japanese oysters, accustomed to the cold, were more successful, although it took two decades for them truly to take hold. Eventually the Japanese Kumamoto became a mainstay of oyster plates in America.

2. Paul Greenberg, "Why Are We Importing Our Own Fish," *New York Times*, June 20, 2014.

3. The term *merroir* was coined by Rappahannock River Oysters in the Chesapeake Bay.

4. Duxbury Bay is notably shallow. The tide washes in and out twice a day bringing more fresh plankton and cold water for the maturing oysters. This, in turn, means firm and briny oysters throughout the year.

5. The U.S. Department of Fish and Wildlife and the Food and Drug Administration establish policy and enforce regulations around oyster imports.

6. South Carolina Department of Natural Resources, *Oyster Biology & Ecology,* http://score.dnr.sc.gov/deep. php?subject=2&topic=15.

7. Our selection of oysters reflects the overall distribution of oysters in North America—approximately 85 percent are farmed on the East and Gulf Coasts; 15 percent on the West Coast.

8. Felipe Fernández-Armesto, *Near a Thousand Tables: A History of Food*, p. 57.

9. T. C. Eyton, *A History of Oysters and the Oyster Fisheries*, 1858.

10. Ibid.

11. James G. Gertram, *The Harvest of the Sea*, 1865.

12. Today, the Billion Oyster Project "aims to reverse these effects by bringing oysters and their reef habitat back to New York Harbor."

13. The Massachusetts Oyster Project, similar to New York's Billion Oyster Project, compiled the *History of Oysters in the Estuaries of Boston Harbor,* 2013.

14. Kelby Ouchley, *Flora and Fauna of the Civil War: An Environmental Reference Guide,* 2010.

15. Mary Johnson Bailey Lincoln, *Mrs. Lincoln's Boston Cook Book: What to Do and What Not to Do in Cooking,* 1884.

16. Emory Richard Johnson et al., *History of Domestic and Foreign Commerce in the U.S.,* 1915.

17. Deanne Stephens Nuwer, *The Seafood Industry in Biloxi: Its Early History, 1846–1930,* in *Mississippi History Now* (Winter 2004).

18. Lee Wiegardt, *A Short History of the West Coast Oyster Industry with Emphasis on Willapa Bay,* Conference Paper, International Institute of Fisheries and Economic Trade, 2001.

19. Liana De Girolami Cheney, *The Oyster in Dutch Genre Paintings: Moral or Erotic Symbolism*, 1987.

20. Jason Coleman, *The Wildest of Wild Oysters,* University of Virginia Press, 2013.

21. Gordon Williams, *A Dictionary of Sexual Language and Imagery in Shakespearean and Stuart Literature,* 1935.

22. Giacomo Girolamo Casanova, *Histoire de ma vie jusqu'à l'an 1797,* 1789 onward.

23. http://neworleansburlesque.wix.com/oystergirl#!legend /c161y.

24. Lady Gaga, *Artpop,* 2013.

25. American Museum of Natural History *Pearls* exhibition website, www.amnh.org/exhibitions/pearls.

26. According to the Centers for Disease Control and Prevention, *Vibrio vulnificus* is a bacterium in the same family as those that cause cholera and *Vibrio parahaemolyticus.*
It normally lives in warm seawater and is part of a group of vibrios that are called "halophilic" because they require salt.

27. Joe Satran, *Vibriosis, Deadly Disease Associated with Raw Oysters May Get More Common As Ocean Warms,* Huffington Post, February 7, 2013.

28. According to the Nature Conservancy, 85 percent of oyster reefs around the globe have vanished.

29. Peter Fimrite, *Once Abundant West-Coast Oysters Near Extinction,* SFGate, 2012.

# GLOSSARY

ADDUCTOR MUSCLE: The muscle that runs through the oyster and holds the top and bottom shells together. It keeps the shells closed. When it relaxes, the shells open.

ALGAE: Part of a large group of nonflowering plants that includes seaweeds and single-celled organisms such as phytoplankton. Microscopic phytoplankton and macroalgae such as seaweed and kelp are the basis of oysters' diet.

AQUACULTURE: Farming of aquatic organisms such as fish, crustaceans, mollusks, and aquatic plants and cultivating them under controlled conditions.

BELON OR EUROPEAN FLAT: One of five oyster species, *Ostrea edulis*, available in North America. Native to Europe, Belons are cultivated in small quantities in the United States on the East and West Coasts. They are larger and flatter than most oysters, often with metallic flavor notes.

BIOREMEDIATOR: Bioremediation uses naturally occurring organisms to break down hazardous substances into less toxic or nontoxic substances. As filter feeders that clean the waters in which they grow, oysters are natural bioremediators.

BIVALVE: Marine or freshwater mollusks with laterally compressed bodies enclosed by a shell in two hinged parts.

BOTTOM CULTURE: A means of growing oysters where the spat is distributed directly onto the ocean floor over existing oyster beds, similar to the way oysters grow in the wild.

BOTTOM SHELL: The cupped side of an oyster, also known as the left valve.

BROADCAST SPAWNERS: Marine animals, including oysters, that procreate by releasing huge quantities of eggs and sperm into the water—five to eight million eggs at one time for adult female oysters.

CLUSTERS: Two or more oysters growing together and the building blocks of oyster reefs.

FILTER FEEDERS: Aquatic animals that feed on particles or small organisms strained out of the water by circulating the water through their system. Oysters are particularly famous filter feeders. Others are clams, barnacles, corals, sea squirts, and sponges.

FLOATING CULTIVATION: Diverse cultivation systems that allow oysters to float on the surface of the water, thus benefiting from the natural tumbling caused by the waves.

HATCHERY: A facility that produces oyster larvae and/or seed, which typically involves growing lots of algae to nourish the seed.

KUMAMOTO: One of five oyster species available in North America, *Crassostrea sikamea* is native to Japan and cultivated on the West Coast of the United States. Closely related to Pacific oysters, Kumamotos are small and deep cupped with a mild, buttery flavor.

MANTLE: The interior tissue that produces the oyster shell and particularly significant in the production of pearls. When a bit of debris is trapped inside the oyster, it irritates the mantle. The mantle,

in turn, creates protective layers of nacre that wrap around the debris and form the pearl.

MERROIR: A riff on the wine world's use of *terroir*, describing the specific combination of growing location and water conditions including salinity, mineral content, algae, water temperature, and the nature of the current. *Merroir* determines the flavor and character of oysters.

MIDDENS: Huge, ancient mounds of oyster shells, some dating back to prehistoric times.

OFF-BOTTOM: A method of cultivating oysters that uses bags, racks, or cages that are suspended above the seafloor.

OLYMPIA OYSTERS: One of five oyster species in North America, *Ostrea lurida* is native to the West Coast from Baja to southeast Alaska. Olympias are intensely flavored despite their small size.

PACIFIC OYSTER: One of five oyster species in North America, *Crassostrea gigas* is native to Japan. Pacifics were introduced on the West Coast in the early 1900s. Because they are particularly easy to cultivate and produced in many places, they are available in a wide range of flavor profiles.

PHYTOPLANKTON: Microscopic plantlike organisms that form the base of the marine food chain.

PLANKTON: Any organisms that live in the water column, including zooplankton (animals) and phytoplankton (plants).

RACK AND BAG: A method of cultivation in which oysters are grown in bags that are raised up off the seafloor and can be rolled over from side to side and otherwise tumbled manually.

SEED: Baby oysters, typically younger than six months old, that are produced by a hatchery and raised elsewhere on an oyster farm.

SPAT: Spat, also known as seed oysters, are free-swimming larvae that have developed a shell and attached themselves to hard surfaces, enabling them to grow into adult oysters.

TOP SHELL: The flat side of the oyster, also called the right valve.

TRIPLOID: A sterile oyster that has three chromosomes instead of two. Triploid oysters grow more quickly than regular oysters (diploids) because they don't spend energy reproducing. One of the advantages of triploids is that they stay firm and enjoyable all summer.

TUMBLING: A method of cultivation in which oysters are grown in bags with attached buoys enabling them to roll with the tide. The tumbling action pares the oyster shells so they achieve a rounder, deeper-cupped shape.

UMBO: The pointy end of an oyster's shell, also known as the hinge, where the top and bottom shells come together.

VIBRIO VULNIFICUS: Naturally occurring saltwater bacteria found worldwide that can cause severe illness or death if consumed.

VIRGINICA: One of five oyster species in North America, *Crassostrea virginica* are also known as Atlantic or Eastern oysters and native to the East Coast from Maine to the Gulf of Mexico. Often stronger and brinier than Pacifics, Virginicas are cultivated in many more areas and produce a much greater range of flavor profiles.

Aunt Dotty's live here, Saquish, Massachusetts.

## ORDERING OYSTERS ONLINE

If you want fresh oysters shipped to your door, you can order them online from these farms.

Andersons Neck Oysters
Shacklefords, VA
www.andersonsneck.com/shop

Chatham Shellfish Company
Chatham, MA
www.chathamoysters.com

Grassy Bar Oyster Company
Morro Bay, CA
www.grassybaroyster.com

Hama Hama Oysters
Lilliwaup, WA
www.hamahamaoysters.com

Island Creek Oysters
Duxbury, MA
shop.islandcreekoysters.com

## ORDERING KNIVES ONLINE

You can get oyster knives at kitchen supply and hardware stores as well as most housewares departments. However, if you want to find something special or buy directly from the source, these are the places to visit online for beautiful and often handcrafted knives made in the United States.

Carolina Shuckers
www.carolinashuckers.com

JB Prince
www.jbprince.com

R. Murphy Knives
www.rmurphyknives.com

Williams Knife Company
www.williamsknife.com

## IN-DEPTH READING

Of the many books you may find on oysters, there are a number of classic tomes, if you want to read more.

*The Big Oyster: History on the Halfshell* by Mark Kurlansky
*Consider the Oyster* by M.F.K. Fisher
*Consider the Oyster: A Shucker's Field Guide*
    by Patrick McMurray and Sandy Ingber
*A Geography of Oysters: The Connoisseur's Guide*
    *to Oyster Eating in North America* by Rowan Jacobsen
*Meet Paris Oyster: A Love Affair with the Perfect Food*
    by Marielle Guillano
*The Oysters of Locmariaquer* by Eleanor Clark
*Sex, Death and Oysters* by Robb Walsh
*Shucked: Life on a New England Oyster Farm* by Erin Byers Murray

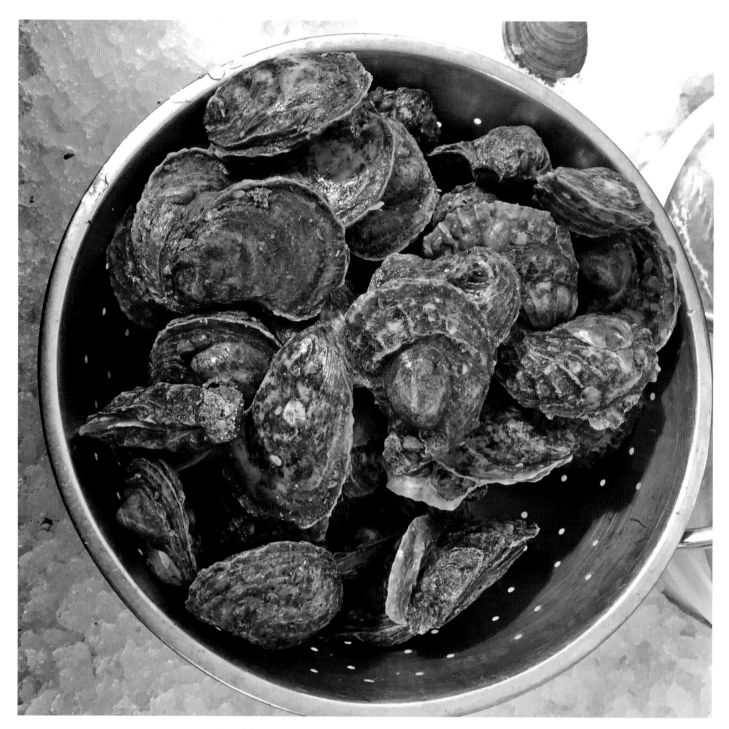

North Fork oysters at the farmers' market, New York City

*Italic* pages refer to illustrations, gray pages
    to the glossary.

adductor muscle, 27, 200
Alabama, 43, 45, 50
algae, 18, 49, 53, 200
Amboy oysters, 12
America, history of oysters in, 12–15, 175–81,
    196
American Indians, 175
American Revolution, 178
aphrodisiacs, oysters as, 174, 191–92
aquaculture, 200
Aquagrill, New York City, *35, 199*
Aristotle, 172
Arnoux, Jim, 122
Atlantic Ocean, 17
Atlantic oysters, 16, 21
Auburn University Shellfish Laboratory, 43
Aunt Dotty's oysters, *10, 15, 20, 34, 78–79, 202*

baby oysters, *47,* 201
bags of oysters, *2, 22, 39, 54,* 175
Baker, Jay, 74
Ballard, Chad, 134
Ballard Fish & Oyster Company, Cheriton,
    Va., *39, 40, 45, 46, 47, 56,* 198
Baltimore, Maryland, 179
Barker, Greg, 34, 106
Barnstable, Mass., 34, 94, 110, 114
Bayou La Batre, Ala., 144
Beard, James, 169
Beausoleil oysters, 23
Beert, Osias, 184
    *Dishes with Oysters, Fruit & Wine, 185*
Belon oysters, 16, 21, 23, 70–71, 200
Bennett, Skip, 34, 48, *48–50, 48, 51,* 78, 92,
    108
Besse, G. M., 98, 152
Billion Oyster Project, 198
Biloxi, Miss., 181
bioremediators, 20, 200
bivalve, 200
Bloom, Norm, 124, 126
Blue Pool oysters, 16, 34, 150–51
Board on the Chesapeake and its Tributaries,
    180–81
Boston, Mass., oyster beds in, 176–78, 198

bottom culturing, 56, 200
bottom shell, 27, 200
breeding stock, *49*
British Columbia, Canada, 17, 146
Broderick Family, 82
Brumbaugh, Rob, 199
Bucci, Ted, 34, 128
Burns, Peter, 84
Burton, Richard, 195

cages, *15, 49*
Cameron, William E., 180
Caravana, Steve, 100
Casanova, G. G., 189–90
Cedar Key, Fla., 140
Chanel, Coco, 194, 195, *195*
Charlestown, R.I., 122
Chartier, C. H., 189
Chatham, Mass., 80
Chatham oysters, 16, 53–54, 80–81
Chatham Shellfish Company, Chatham,
    Mass., 22, 50, *205*
Chelsea Gems, 152–53
Chesapeake Bay, 17, 179–81, 199
Chicago, Illinois, 179
Chilmark oysters, 82
Chincoteague, Va., 132
    oysters from, 132–33
Cincinnati, Ohio, 179
Civil War, 178
Clark, Kris, 86
Clarks Cove, Maine, 34, 72
cluster, 200
Connecticut Blue Points, 124–25
Connecticut coast, 124
Conway Royals, 60–61
Copps Island oysters, 126–27
*Crassostrea gigas,* 21, *23,* 201
*Crassostrea sikamea,* 21, *23,* 200
*Crassostrea virginica,* 21, *23,* 201
culling, *205*
culturing
    in ancient times, 172–74
    choice of grow-out methods, 39, 49, 56

Dabob Bay oysters, 154–55
Damariscotta Flat oysters, 23
D'Aniello, Antimo, 191

Dauphin Island, Ala., 142
Davis Family, 140
D.B. Newcomb Oysters, Salem, Mass., *180*
de Leeuw, Geron, 187
Denver, Colo., 179
Diamond Jim oysters, 34, 128–29
diseases of oysters, 13–14
Drakes Bay oysters, 23
dredging, 180
Driver, Bill, 88
Dutch painting, 184–87
Duxbury, Mass., 17, 34, 48–49, 92, 108

East Coast oysters, 60–139
Eastham, Mass., 84, 112
Edwards, Simon, 96
Eld Inlet, Wash., 152
Eli's Manhattan, *24*
Elizabeth I, Queen, *194*
environment, oysters' benefit to, 20–22,
    52–55, 198–99
environmental organizations, oyster projects,
    198–99
European Flats, 21, 70–71, 200
European oysters, 13
Evangeline the Oyster Girl, 190–91, *191*

Fanny Bay oysters, 23
Fargue, Léon-Paul, 37
Fat Dog oysters, 74–75
feeding by oysters, 48–49, 53
Feigenbaum, Mitchell, 62
Fernández-Armesto, Felipe, 24, 172
Fielding, Henry, *Tom Jones,* 190
filter feeders, oysters as, 17, 20, 53, 198,
    200
Fin de la Baie oysters, 62–63
Finger, John, 34, 54, *55,* 166
First Encounters, 84–85
First Lights, 86–87
Fisher, George, 191
Fisher, M.F.K., 16
Fisherman's Island, Va., 34, 136
fish markets, 24
Fitzgerald, Annie, 154
flavor of oysters, 16–19
    words to describe, 19
floating cultivation, 56, 200

flood-prone areas, oysters' protecting of, 20–22
foodborne illness, 197
food porn, 184–88
Franford, Ben and Diane, 34, 118
Fulton Market, New York City, *12, 175*

Galen of Pergamon, 189
gathering oysters, 56
Gigamoto oysters, 146–47
Glacier Bay oysters, 16
Glidden Flat oysters, 23
gloves for shucking, 27
Great Bay, N.H., 74, 76
Greeks, ancient, 172–73
Grizzle, Ray, 76
grow-out methods, 39, 49, 56
Gulf Coast, 181
Gulf of Mexico, 43
Gulf oysters, 43–45, 140–45, 181

Haddon, Cat, 146
Half Moon Bay, Ga., 34, 138
Half Moon Select oysters, 34, 138–39
Hama Hama Oysters, Lilliwaup, Wash., 40–43, *41, 42, 52*
  oysters of, 16, 23, 156–57
Hammersley Inlet, Wash., 164
hatcheries, 49, 200
hibernation, 18
Hog Island Oysters, Tomales Bay, Calif., 54, *54, 55*
Hog Island Sweetwater oysters, 16, 23, 34, 166–67
Hood Canal, Wash., 34, 150, 154, 156
Howland's Landings, 88–89
Hurricane Sandy, 22
Hurston, Zora Neale, 32
Huxley, Aldous, 11

Ichabod Flats, 90–91
Industrial Revolution, pollutants from, 14
Irish Point oysters, 64–65
Island Creek Oyster Bar, Boston, *19, 27, 196, 203*
Island Creek Oysters (company)
  Duxbury, Mass., *36, 38, 49, 50*
  Saquish, Mass., Aunt Dotty's grow-out site, *10, 15, 20*
Island Creek oysters (type), 16, 17, 23, 34, 49–50, 92–93

Jamaica oysters, 12
James, Adam, 34, 40, 42–43, *42,* 150, 156, 164
Jeffery, Troy, 60, 66, 68

Jonathan Island Pearly White oysters, 34, 118–19
Jones, John, 189
Juvenal, 189

Ketcham, Matt, 130
Kingston, Mass., 34, 88, 106
knives, oyster, 27, 32–33, *33,* 211
Koehler's Ladies' Oyster & Lunch Room, New York, *177*
Kratchman, Barry, 62
Kumamoto oysters, 16, 21, 33, 158–59, 200
Kusshi oysters, 23, 148–49

Lady Gaga, 192
La Peregrina pearl, 194–95
Laurie, Scott and Tina, 110
Lesvos (Greek island), 173
licenses for oyster harvesting, *43,* 179–81
Lichtenstein, Roy, 187–88
  *Still Life with Oysters, Fish in a Bowl and Book, 188*
Lilliwaup, Wash., 40
Linkletter, Scott and Margie, 64
Little Grizzlies, 76–77
London, England, 189
Long Island Sound, 124
Louisville, Ky., 179

Maine, 70
Malaguzzi, Silvia, 184
Malpeque oysters, 66–67
Manet, Edouard, *Oysters,* 187, *187*
mantle, 200
Martha's Vineyard, Mass., 82
Martin, Jon, 94
Maryland, 180
Mashpee, Mass., 86
Massacre Island oysters, 142–43
Massachusetts Oyster Project, 198
matching of oysters for sale, 50
Matisse, Henri, 187
McGee, Mike, 132
*merroir,* 16–17, 201
middens, 18, 172, 201
mignonette sauce, recipes, *31*
Misty Point oysters, 134–35
Miyagi oysters, 160–61
Monberg, Lissa James, 40, 42, 52, *52*
Moon Shoal oysters, 34, 94–95
Moonstones, 120
Moreno, Aldemar, *28*
*Mrs. Lincoln's Boston Cook Book, 178*
Mucianus, Gaius Licinius, 174
Murder Point Oysters, Irvington, Ala., 43–45, *43, 44, 45,* 50, *205, 206*

oysters from, 144–45
Myers Family, 142
Myrtle Point, Ala., 45

nacre, 195
Nantucket Harbor oysters, 96–97
Nantucket Island, Mass., 96
Nantucket Sound, 53
Narragansett, R.I., 34, 118
Nature Conservancy, 199
Nelson, J. R., 98
New Brunswick, Canada, 62
Newell, Carter, 34, 72
Newman, John, 84
New Orleans, La., 190–91
New York City
  farmer's market in, *212*
  history of oysters in, 12
New York harbor, oyster beds in, 20, 175–76, 198
New Zealand Flats, 21
Norfolk, Long Island, N.Y., 34, 128
Norfolk Oyster Company, Boston, *179*
Northern Cross oysters, 34, 136–37
Northern Prince Edward Island, Canada, 68
North Fork oysters, *212*
Norwalk, Conn., 126

off-bottom culturing, 56, 201
Olympia oysters, 13, 16, 21, 33, 162–63, 201
Ondaatje, Michael, 190
Onset, Mass., 102
Onset oysters, 98–99
Orcutt, Peter and Jeff, 104
Orleans, Mass., 104
*Ostrea chilensis,* 21
*Ostrea edulis,* 21, *23,* 200
*Ostrea lurida (Ostrea conchaphila),* 21, *23,* 201
Ostreidae family, 21, 194
overharvesting of oysters, 13, 179
*The Oyster* (Victorian porn magazine), 190
oyster beds, 20, 175–78, 198
  privatized, 179
oyster establishments, 179
  lunchroom in New York, *175*
oyster farming, workday of, 42–43
oyster forks, 176, *176*
Oyster Line (stagecoach), 179
oystermen, 37–57
  as stewards of the natural world, 52–55
  types of, 39
oyster plates, 27, *30, 193*
Oyster Pond estuary, 53
oyster reefs, as seawalls, 22
oysters

anatomy of, 27
domestic vs. foreign, 21
early ideas about, 172
environmental services of, 20–22, 52–55,
    198–99
food vs. pearl, 21
great men's fondness for, 174
in history, 12–15, 172–81
life cycle, 18, 39, 47, 56
location of, and taste, 16–17
myths about, 197
population crash, 13–14
population rebound, 14–15, 199
resources on, 203
species and varieties of, 16, 21–23
wild vs. farmed, 15
working class nourished on, 174
oyster shack, 13
Oyster Wars of the Chesapeake Bay, 180–81

Pacific Northwest, 17
Pacific Ocean, 17
Pacific oysters, 16, 21, 181, 201
Padanaram oysters, 100–101
Paravisini, Mary Kate, 112
pearls, 194–95
Peconic Bay, Long Island, N.Y., 130
Peconic Gold oysters, 130–31
Pelican Reef oysters, 140–41
Pelli, John, 34, 138
Pemaquid oysters, 16, 23, 34, 72–73
Penn Cove Shellfish, 160
Peter's Point oysters, 16, 102–3
Philadelphia, Pa., 179
phytoplankton, 201
pigs in blankets, or huitres au lait, 178, 178
Pittsley, Dennis, 102
plankton, 48, 49, 53, 201
Pleasant Bay oysters, 104–5
Pliny the Elder, 173
Plymouth, Mass., 34, 78, 90
Point Judith Pond, R.I., 120
Potomac River Fisheries Commission, 181
predators on oysters, 49
preparation of oysters, 178, 178
Prince Edward Island, Canada, 60, 66
Pteriidae family, 194
Puget Sound, Wash., 160

Quonie Rock oysters, 122–23

rack and bag, 201
Rapine, Tim, 34, 40, 45, 136
raw oysters, 196–97
refrigeration, 25–26, 196

Reid, Keith, 148
Rhodes, ancient Greek, 172
R months, eating oysters in, 196
Robbins, Bart, 40, 41
Robbins, Daniel Miller, 40
Rockaway oysters, 12
Rocky Nook oysters, 34, 106–7
Roman Empire, 173–74, 189
Row 34 oysters, 108–9
Row 34 Restaurant, Boston, 14, 28, 58
Royal Miyagi oysters, 23
Rustico Harbour, Prince Edward Island,
    Canada, 64

Saccostrea glomerata, 21
safety of eating oysters, 196–97
St. Louis, Mo., 179
Sandblom, Russ, 112
San Francisco, Calif., 181
Saquish, Mass., 13, 57, 78
sauces for oysters, 31
Saville-Kent, William, 195
Sawyer, Terry, 55
Sea Cow oysters, 164–65
seawater, saltiness of, 17
seaweed, 17, 20
seed, 47, 201
Sergius Orata, 174
serving platters, 26–27, 29, 29, 30
sexual allusions, oysters and, 187–88
sexual prowess, oysters and, 174, 189–93
Shakespeare, William, 170
shells, 18, 171
    anatomy of, 27
    closed tight, 25, 26
    growth of, 18
Shelton, Wash., 34, 158, 162
Shigoku oysters, 34
shipping of oysters, 25
shopping for oysters, 24–25, 203
shucking
    method, 27–29, 28, 32–33
    tools for, 26–27, 26
Slawson, Abbie Jewel (Kitty West), 190–91
Smith Island, Va., 134
Snider, Scott, 51
South Dartmouth, Mass., 100
spat or seed oysters, 47, 201
spawning, 47, 49, 196–97, 200
Spring Creek oysters, 110–11
stabbers, 32
Steen, Jan, Girl Eating Oysters, 184, 186
Stolt, Rebecca, 189
storage of oysters, 25–26
Summerside oysters, 68–69

Sunken Meadow oysters, 112–13
surface cultivation, 56
Sydney Rock Oysters, 21

tags and certification, 25
Taunton Iron Works & Co., 168
Taylor, Bill, 34, 158, 162
Taylor, Elizabeth, 194–95
Thatch Island oysters, 114–15
tides, 42–43
Tomales Bay, Calif., 34, 55, 166, 204
tools for shucking, 26–27, 26
top shell, 27, 201
Totten Olympia oysters, 23
Tourigny, Robert, 102
trade cards, 168, 173, 177, 179, 180, 182–183
trade in oysters
    America, 181, 196
    ancient Rome, 174
triploids, 197, 201
tumbling, 44, 201

umbo, 27, 201
Union Oyster House, Boston, 176

Vancouver Island, British Columbia, 148
Van Norman, Bill, 84
Vibrio vulnificus, 197, 201
Virginia, 179–81

Wampanoag Tribe, 86
Wareham, Mass., 98
Washington state, 17
water
    nutrients in, 16
    temperature of, 16, 47
Wellfleet, Mass., 116
    oysters from, 23, 33, 116–17
West, John and Cindy, 120
West Coast oysters, 13, 146–67
Westfall, Chuck, 114
Whebble, John, 34, 106
wild oysters, 24, 70, 124
Wilkinson, Don, 90
Withington, Sean, 90
"world's my oyster," 170
Wright, Stephen, 48, 50, 53–54, 80, 205
Wysocki, Shina, 152

Young, William "Chopper," 116

zinc, 192
Zirlott, Brent and Rosa, 43, 44
Zirlott, Lane, 43–45, 43, 45, 50, 205
Zirlott Family, 144

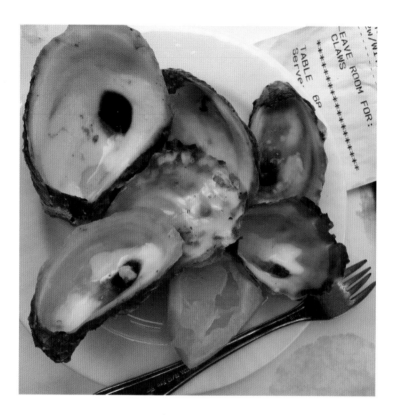

## ABOUT THE AUTHORS

Marion Lear Swaybill is an Emmy Award–winning television producer, writer, and pioneering media executive who introduced New York public television audiences to luminary chefs such as Madhur Jaffrey, Lidia Bastianich, Martin Yan, and Jacques Pépin.

Jeremy Sewall is a two-time James Beard Award nominee, chef, and restaurateur based in Boston. His restaurants Eastern Standard, Island Creek Oyster Bar, and Row 34 have received acclaimed from the *New York Times*, *Esquire*, *Gourmet*, and *The Boston Globe*, among other publications.

## ABOUT THE PHOTOGRAPHER

Scott Snider is an award-winning natural history filmmaker and cinematographer whose major credits include National Geographic, PBS Nature, Discovery Channel, Animal Planet, the National Park Service, and many others.